DRAWING ANIMALS

DRAWING ANIMALS

By Norman Adams
and Joe Singer

WATSON-GUPTILL PUBLICATIONS/NEW YORK
PITMAN PUBLISHING/LONDON

Dedicated to Leila

First published 1979 in the United States and Canada by Watson-Guptill Publications,
a division of Billboard Publications, Inc.,
1515 Broadway, New York, N.Y. 10036

Library of Congress Cataloging in Publication Data

Adams, Norman.
 Drawing animals.
 1. Animals in art 2. Drawing—Technique.
I. Singer, Joe, 1923- joint author.
II. Title.
NC780.A3 743'.6 79-4087
ISBN 0-8230-1361-8

Published in Great Britain by Pitman Publishing Ltd.,
39 Parker Street, London WC2B 5PB
ISBN 0-273-01206-1

Manufactured in U.S.A.

First Printing, 1979
Second Printing, 1980
Third Printing, 1981

CONTENTS

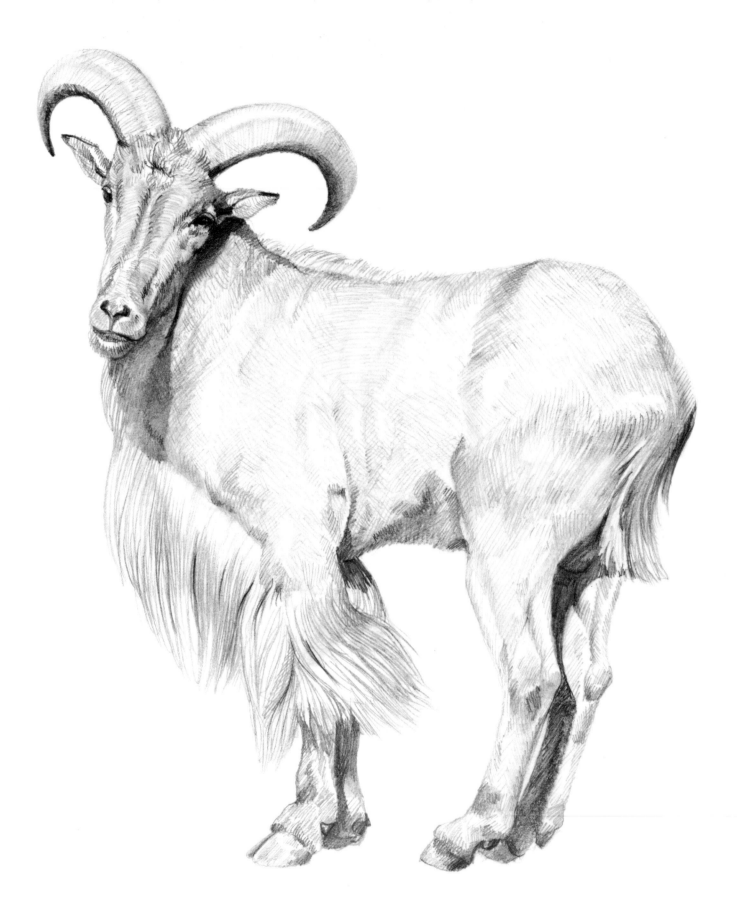

AOUDAD
This wild sheep of Africa has a magnificent fringe of hair in front, a mane, and a hairy tail. I use short strokes to depict its relatively short coat, longer strokes for the fringe, scraggly strokes for the poll, and tiny sharp strokes for the bristly hair of its chin. The aoudad shares the characteristics of both sheep and goats.

INTRODUCTION

To draw an animal well, it is necessary to know and understand its personality and behavior in order to express its individual features. The purpose of this book, then, is to demonstrate, using a sequence of studies, step-by-step drawings, and anatomical progressions, various types of animals—showing their similarities, differences, and unique characteristics.

I have arranged all ten chapters in the following manner: front, side, and three-quarter view of fully drawn animals; form sketches; skeleton; musculature; surface anatomy; step-by-step demonstrations showing a line drawing, indication of tone, and the completed drawing; typical actions; the young; head views; and forms of similar animals. Generally, I have omitted habitats.

Artists who have an interest in wildlife need not go far afield. The house pet or domestic farm animal is an excellent subject for observation. A trip to the local museum, zoo, or animal farm is a good substitute for stalking in the wilds.

Materials

A painter has the benefit of a palette with a complete range of color, while a draftsman is limited to the use of black and white. To make successful drawings, a draftsman must rely on values and textural relationships; therefore, it is very important to use the proper tools.

Erasers. I use a variety of erasers. With a kneaded eraser, the kind I use most often, I can clean or erase large areas of the drawing, and I can knead (shape) the eraser to a sharp point and pick out minute details to highlight. Sometimes it is impossible to remove all of the value from an unwanted area with a kneaded eraser. In this case, I use either a pink or a sand eraser. These erasers leave crumbs on the drawing that can be blown or dusted off with a flat sable brush.

A metal eraser shield is also useful as a mask for picking out small highlights or erasing a flat edge on a drawing. (A sketch of this shield appears in the chapter on horses.)

Fixatives. All pencil drawings can easily be smeared. The finished drawing can be protected either by framing it under glass or by coating it with a fixative. Fixatives can be used either from a spray can or blown from a bottle through a mouth atomizer. I prefer a matte finish fixative from a spray can. The matte quality of the spray does not change the character of the pencil drawing.

French Stump. Sometimes I use a French stump, which is a rolled, pointed paper stick for softening and blending pencil strokes.

Paper. Papers come in endless varieties and sizes. My preference in paper is Strathmore two-ply medium surface, in a sheet size 23 x 29 (58 cm × 74 cm). This is a cotton fiber paper that is quite sturdy and will handle a good deal of abuse.

Pencils. Pencils come in a wide range of selections. The leads vary from very soft to extremely hard: graphite, charcoal, carbon, and lithograph. Leads also come in round and flat shapes.

For my drawings, I favor H and HB graphite leads, and occasionally a 2H for the lighter areas. I do not use the traditional wood pencil; I use a draftsman's mechanical pencil. This pencil can be loaded with leads that come in different grades of hardness or H-HB softness—whichever I need. These leads are interchangeable in the basic pencil, and I keep many on hand. I sharpen the lead to a conical point on a sandpaper block.

Razor Blades. I use a razor blade for picking out very fine details like eye highlights and single strands of hair. The Strathmore paper is especially good for this.

Reference Aids. Most of my drawings are supplemented by the use of a camera. Since animals seldom cooperate by posing for the artist, the photograph can be used for easy reference. I prefer a 35 mm camera using a 50, 200, or 500 mm lens.

Additional reference material can be obtained from local libraries. Another important source of material is the artist's own picture file which can be gathered from magazine clippings and brochures.

Norman Adams

ELEPHANTS

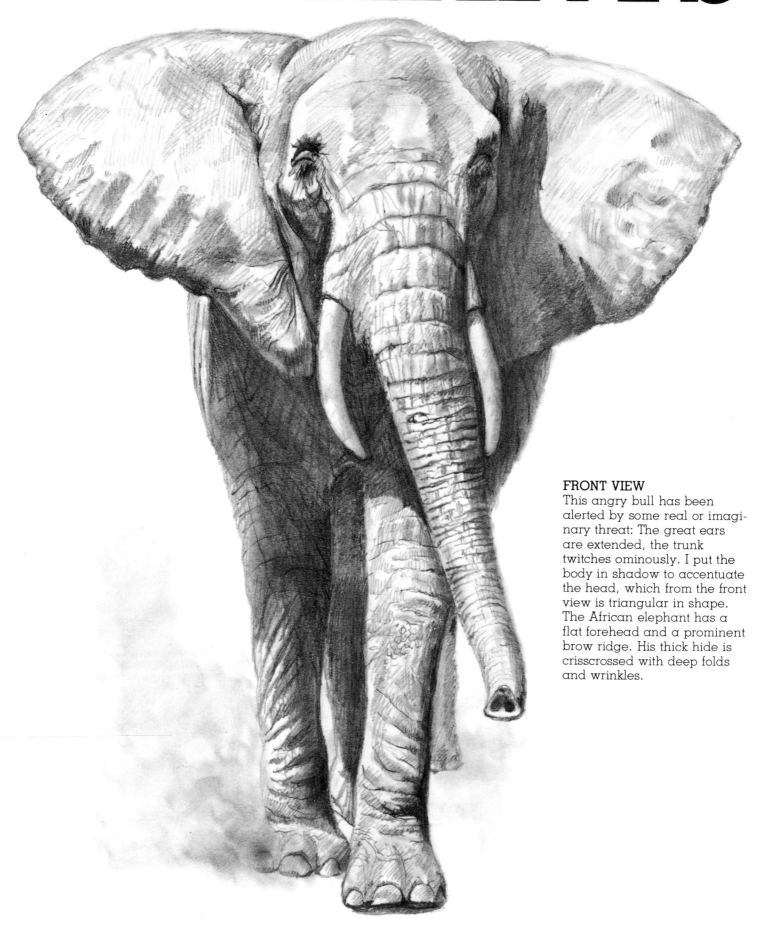

FRONT VIEW
This angry bull has been alerted by some real or imaginary threat: The great ears are extended, the trunk twitches ominously. I put the body in shadow to accentuate the head, which from the front view is triangular in shape. The African elephant has a flat forehead and a prominent brow ridge. His thick hide is crisscrossed with deep folds and wrinkles.

The elephant is the largest living land mammal. A bull elephant can reach a height of 12 feet at the shoulders and a weight of over six tons. Tusks are the elephant's incisor teeth and at maturity may be as long as 12 feet and weigh over 200 pounds.

There are two species of elephant—the African and the Asian. The African elephant is bigger, with rougher skin, larger ears, and two fingerlike projections (prehensile grippers that can pluck a leaf or act as a powerful hand) at the tip of its trunk; the Asian elephant has only one projection. An African elephant is rarely domesticated while the Asian elephant is domesticated and put to work. Also, African male and female elephants are tusked, and the Asian elephant often has no tusks. I use the African elephant as my example, except for the Asian elephant on page 21.

Aside from having tusks, an elephant has four other teeth that are replaced during its lifetime, which can run 60 or more years. The trunk, which can be over ten feet, serves as its nose, hands, and vacuum hose. The elephant uses the trunk to spray itself down with dust, to lift anything from a blade of grass to a fallen tree, and to suck up food and water which it deposits into its mouth. An elephant is capable of eating enormous amounts of food—several hundred pounds a day. Sadly, this magnificent creature is on the verge of extinction.

In this chapter, I have also included drawings of several other animals that are not related to the elephant except for their large size.

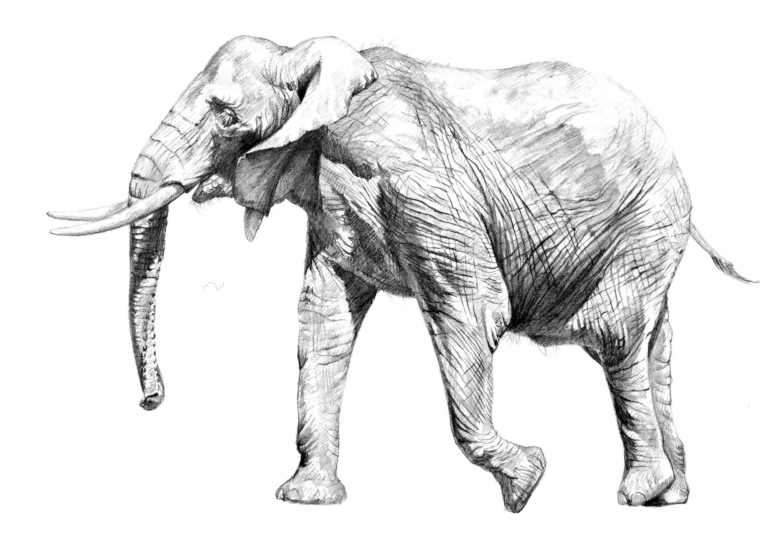

SIDE VIEW

Here, the elephant strides along. The action bears on the network of wrinkles in the animal's leg and shoulder, which makes the ears flap. Despite its bulk and apparent indolence, the elephant can attain a running speed of up to 30 miles per hour. Note the twist of the trunk that shows the ribbed understructure of this flexible appendage. The elephant has coarse hair scattered upon its hide. To depict the smooth surface of the tusks, I use the French stump.

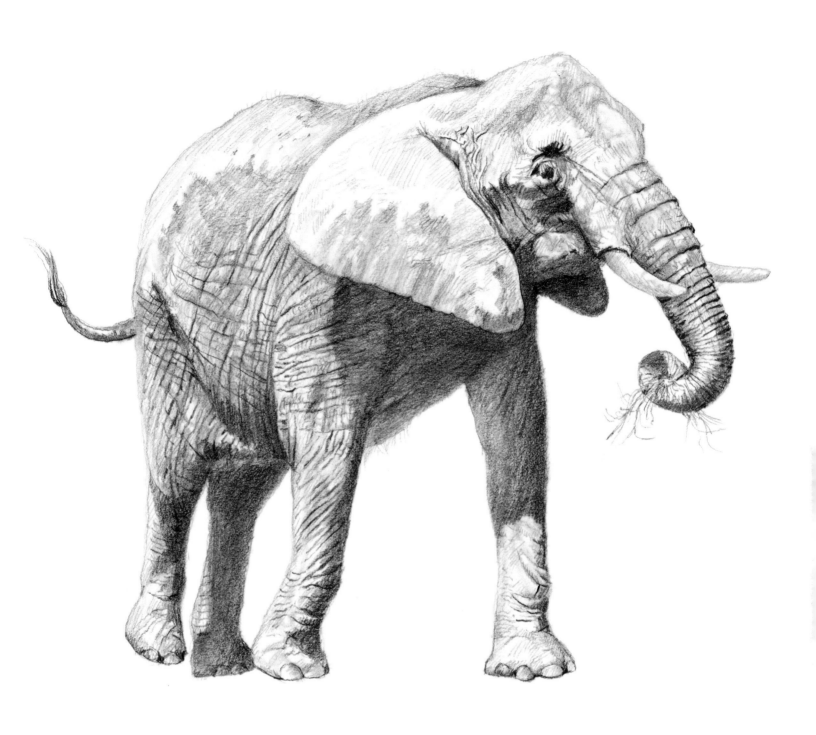

THREE-QUARTER VIEW
Here the elephant uses its trunk to deposit some wisps of hay into
its mouth. Note the size of the ears—they may reach a length of
five feet and a width of four feet. To keep cool, the animal uses its
ears as fans. The tusks are deeply imbedded in the skull—they
seem to reach the eyes. Also note the switch of hair at the tip of
the tail.

FORM SKETCHES

The torso is an oval with the highest point at "A" as marked in the uppermost right drawing. An elephant's neck is a thick tubular shape, the head is egg-shaped, and the trunk is a coiled, tapering tube. Elephant legs are cylindrical, broken at the wrist in the forelegs and at the heel marked "B" (below) in the hind. The forelegs meet the torso at their elbows, and the hind, at the hips.

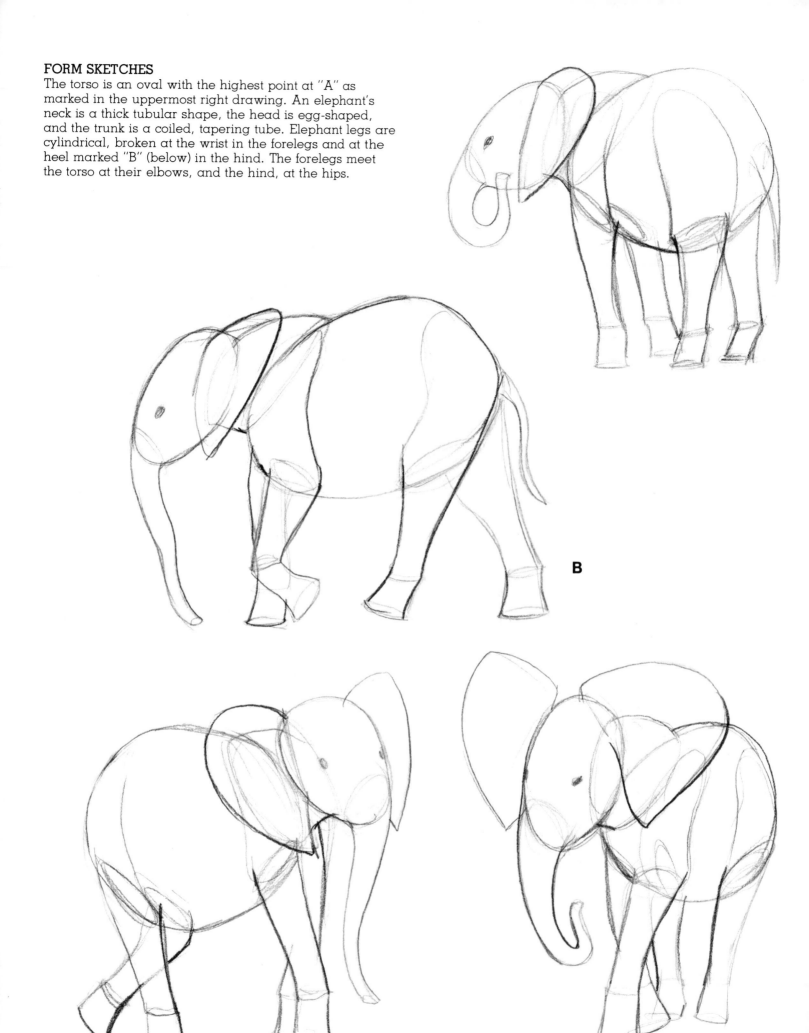

B

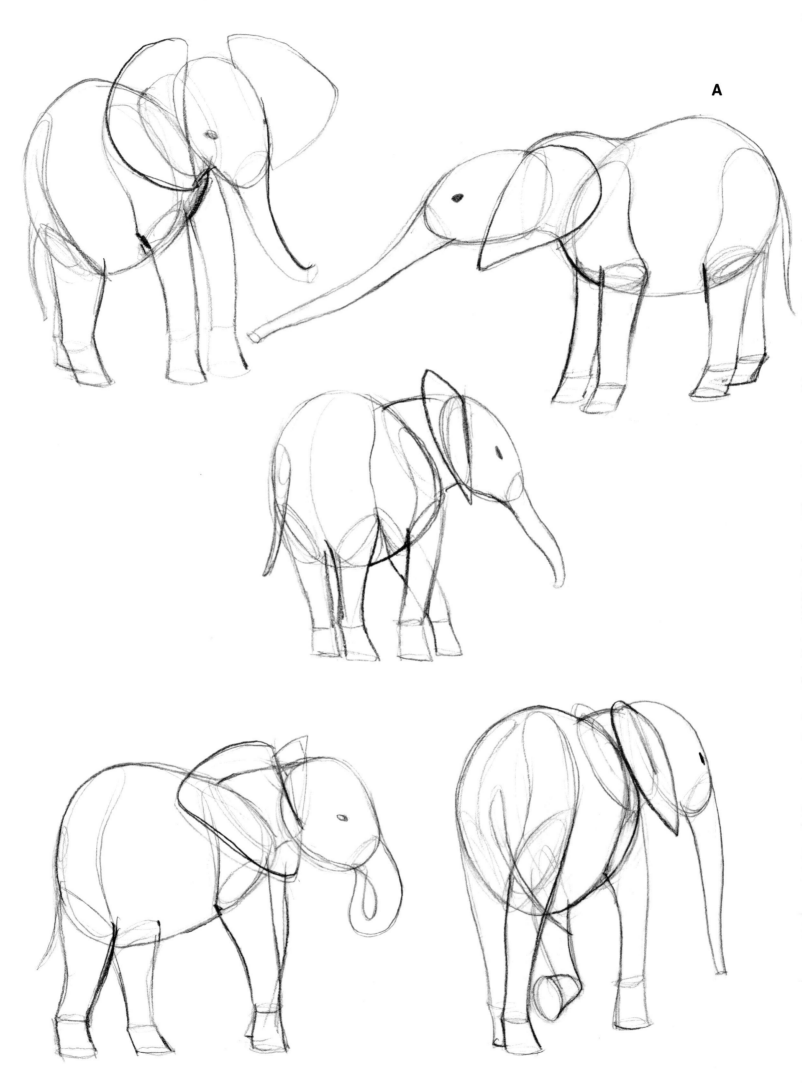

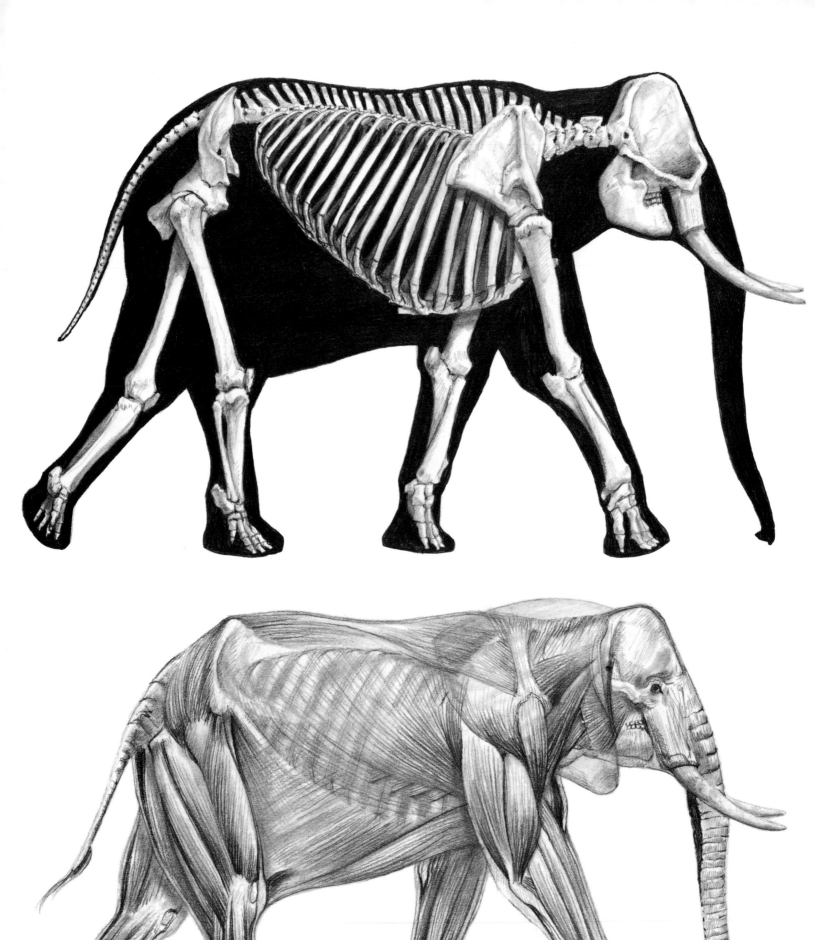

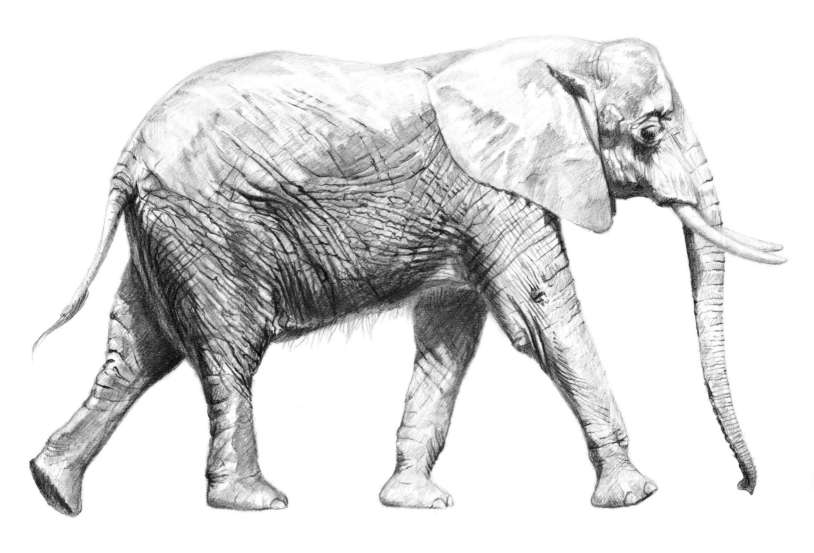

SKELETON (ABOVE LEFT)
Elephant bones are massive. The African elephant shows four nails on the forelegs and three on the hind legs. Note the slant of the toes—the elephant actually walks on tiptoe. Here, the deep cheek cavities are most apparent. While the Asian elephant's spine is convex, the African's is concave.

MUSCULATURE (LEFT)
The elephant is one of the strongest, if not *the* strongest, animals on earth. It weighs hundreds of pounds at birth and possesses incredible lifting, pulling, and pushing power. Nature has, therefore, wisely endowed the species with thick, bulky muscles that are concealed by the animal's loose, inch-thick skin. Strangely enough, for all its speed, strength, and agility, an elephant is unable to jump over the smallest hurdle.

SURFACE ANATOMY (ABOVE)
The wrinkle patterns are more pronounced on the lower part of the animal—he is relatively smooth on top and on the lower legs. The dark shadows on the animal's underparts accentuate its bulk and massiveness. Note the deep cheek indentation below the eye. The tail is bare except for the tip, and the ears are smooth except for veins. Hair is evident on the underbelly. On the trunk the rings grow progressively closer together as they approach the tip.

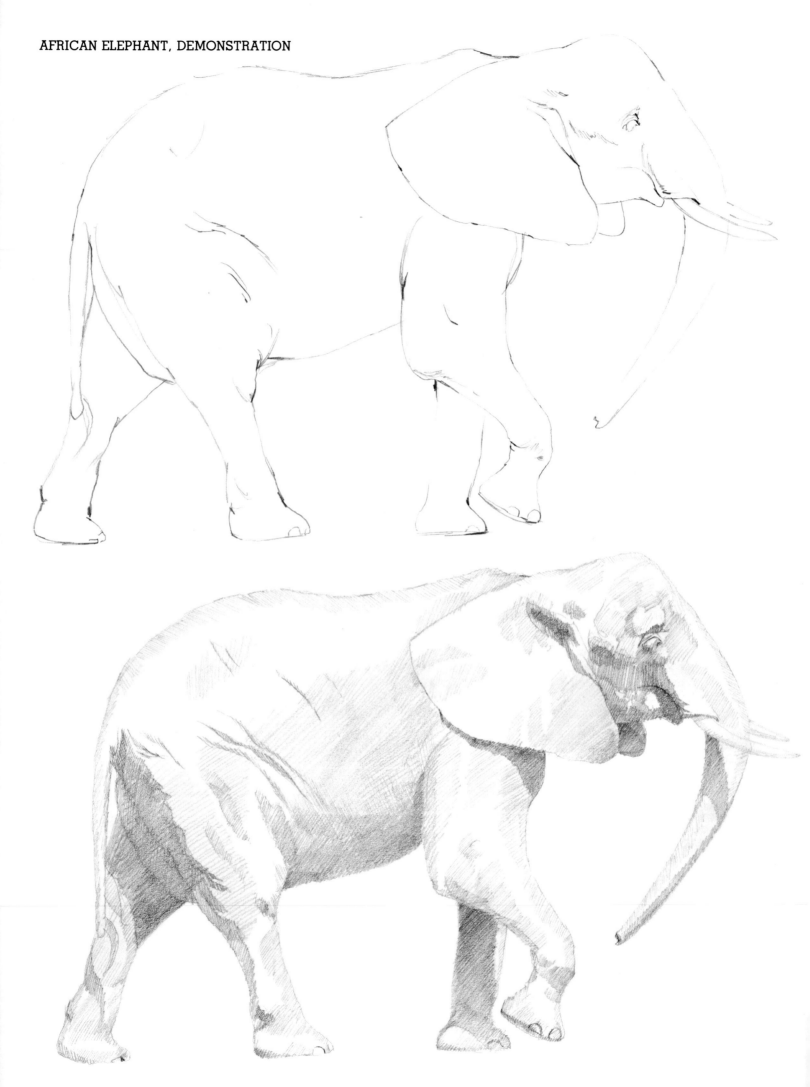

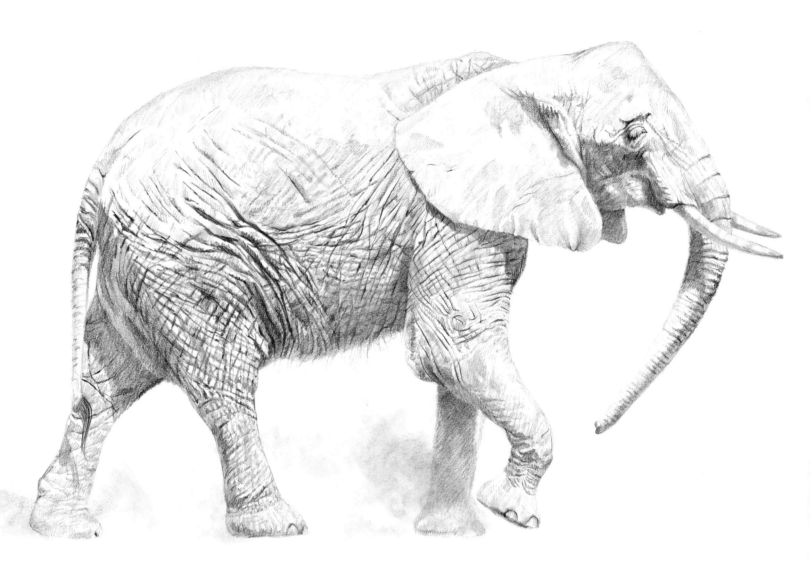

STEP 1. *(ABOVE LEFT)*
This is an African elephant walking. I begin by drawing a complete outline of the animal. Then I accent the areas produced by the walking action, such as the folds in the hips. I place all the features where they belong and mark a few indentations in the head and front leg to accent important value or form variations.

STEP 2. *(LEFT)*
Now I break up the light values and pencil in all the shaded areas of the animal's form. The frontal lighting helps promote the feeling of forward motion. I include accents such as the shadows cast by the tusks on the trunk and that of the tail on the hind leg. At this point, I have not begun the surface anatomy, which consists mainly of wrinkle patterns.

STEP 3. *(ABOVE)*
Now begins the process of refinement and the inclusion of surface detail. I carefully observe and record the tracks of the wrinkles and shade around them as indicated. To render the hair on the belly, I use scraggly strokes that are pulled out and away from the lower contour of the body. Then, I shade the ear to show its smooth, pliable quality. Beneath the animal, I lay dust by sprinkling on some graphite and blending it with the French stump. Finally, I place the long dark hairs in the switch of the tail.

THE DUST BATH *(RIGHT)*
To keep itself free of the hordes of
annoying insects and parasites that
pervade Africa and feed on mam-
mals, the elephant regularly washes
down with water, mud, and dust. Be-
cause its tail is too short for such pur-
poses, this procedure is the animal's
only means of relief from annoying
pests. To create the effect of the dust,
I sprinkle some graphite powder and
rub it with the French stump. I in-
clude some darker particles to pro-
mote the sense of soil and pebbles the
animal may have sucked up with its
trunk.

TOUCHING *(BELOW)*
An elephant lives in a herd and is a
social, gregarious animal within the
confines of its little family of perhaps
20 to 30 members. Part of this social
interaction entails touching, fondling,
giving and receiving support and as-
surance. These elephants could be a
mother and child, or merely two
members of the herd who happen to
feel affectionate toward one another.
Note the characteristic curl of the
older animal's ear.

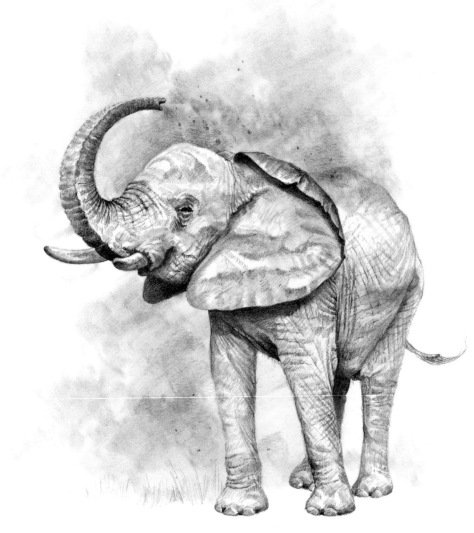

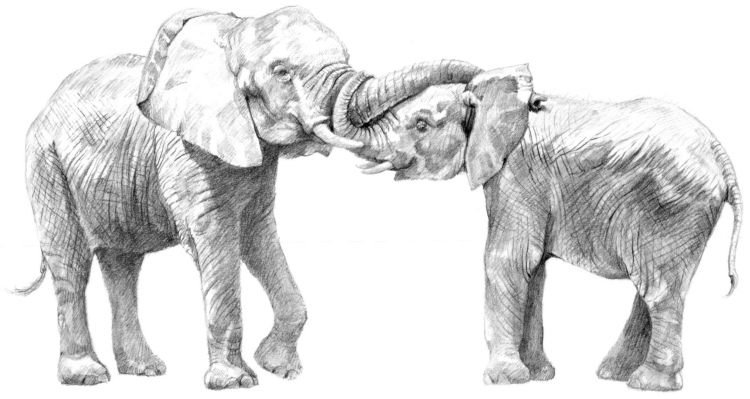

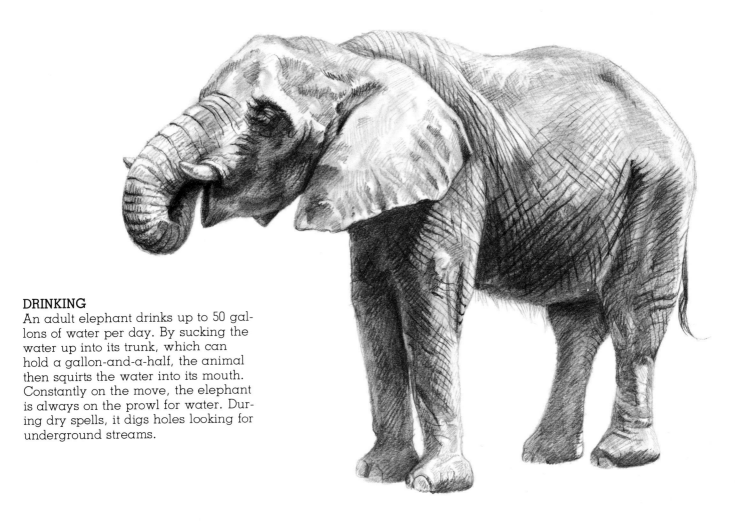

DRINKING

An adult elephant drinks up to 50 gallons of water per day. By sucking the water up into its trunk, which can hold a gallon-and-a-half, the animal then squirts the water into its mouth. Constantly on the move, the elephant is always on the prowl for water. During dry spells, it digs holes looking for underground streams.

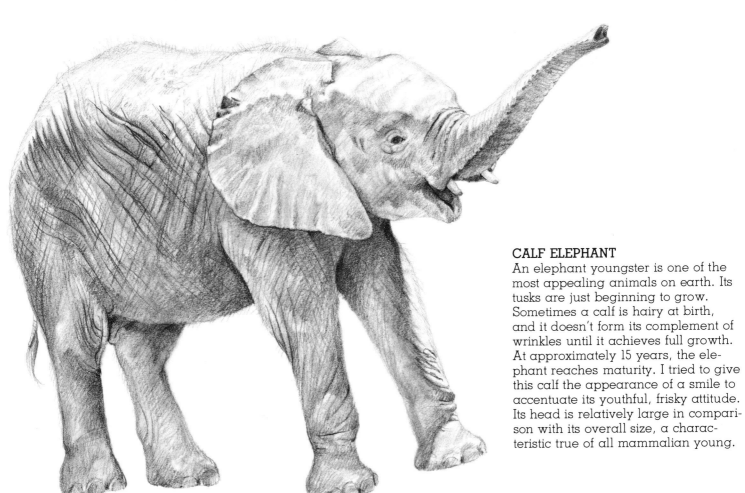

CALF ELEPHANT

An elephant youngster is one of the most appealing animals on earth. Its tusks are just beginning to grow. Sometimes a calf is hairy at birth, and it doesn't form its complement of wrinkles until it achieves full growth. At approximately 15 years, the elephant reaches maturity. I tried to give this calf the appearance of a smile to accentuate its youthful, frisky attitude. Its head is relatively large in comparison with its overall size, a characteristic true of all mammalian young.

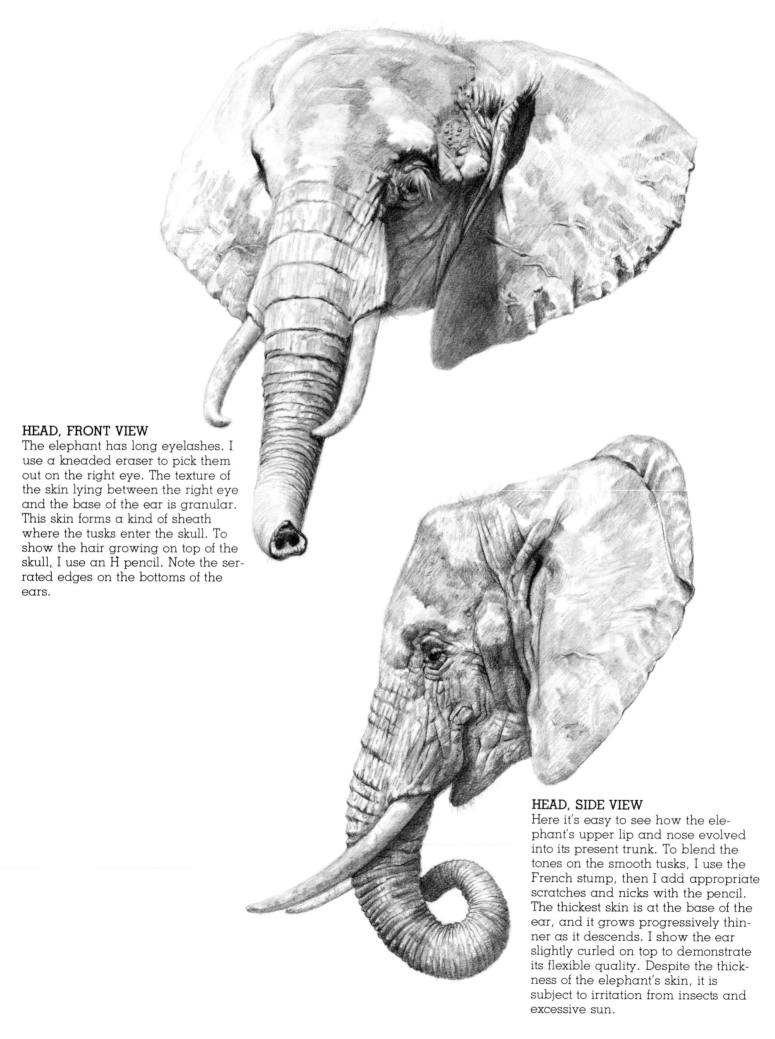

HEAD, FRONT VIEW

The elephant has long eyelashes. I use a kneaded eraser to pick them out on the right eye. The texture of the skin lying between the right eye and the base of the ear is granular. This skin forms a kind of sheath where the tusks enter the skull. To show the hair growing on top of the skull, I use an H pencil. Note the serrated edges on the bottoms of the ears.

HEAD, SIDE VIEW

Here it's easy to see how the elephant's upper lip and nose evolved into its present trunk. To blend the tones on the smooth tusks, I use the French stump, then I add appropriate scratches and nicks with the pencil. The thickest skin is at the base of the ear, and it grows progressively thinner as it descends. I show the ear slightly curled on top to demonstrate its flexible quality. Despite the thickness of the elephant's skin, it is subject to irritation from insects and excessive sun.

ASIAN ELEPHANT (RIGHT)

Compare the differences between this elephant and the African one shown in all the previous drawings in this chapter. The ears are smaller, the spine is convex, and the tusks are generally shorter. It has fewer rings on the trunk and a generally smoother overall skin pattern. Usually, it is the Asian elephant we see in our zoos, and almost exclusively, performing in the circus. The hair along the ridge of the spine helps soften what would have emerged as an otherwise hard edge.

GREAT INDIAN RHINOCEROS (BELOW)

This strange looking animal appears to be armor-plated, which makes him lots of fun to draw. A particular challenge to depict are the tubercles or knobs studding much of its body. I outline each one, then accent it to lend form and value. Because I want to show the rhinoceros with wet feet, I tone them a darker shade. The Great Indian Rhino has only one horn while the African and Sumatran species have two. This horn is the chief reason for the rhino's near extinction since it is valued by superstitious folk for its alleged aphrodisiac propensities.

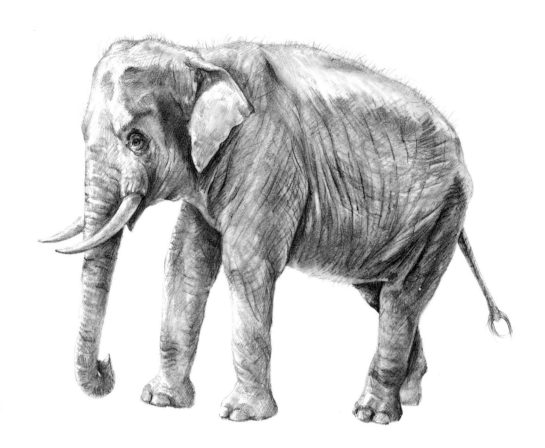

HIPPOPOTAMUS (BELOW)

Since this animal spends most of its daylight hours in the water, I chose to show it in its natural environment. Note the scars and scratches in the battered hide. The eyes and nostrils are raised above the head, which allows the animal to submerge nearly all of its body and still breathe and see. Spiky hair in the muzzle provides an interesting textural accent. To depict the water, I use the French stump over a light tone and pick out highlights with the kneaded eraser.

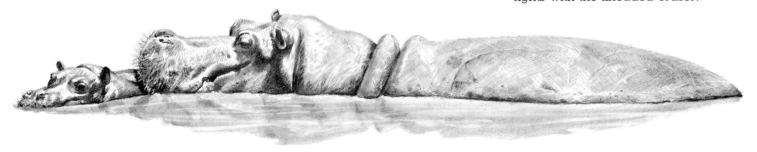

BEARS

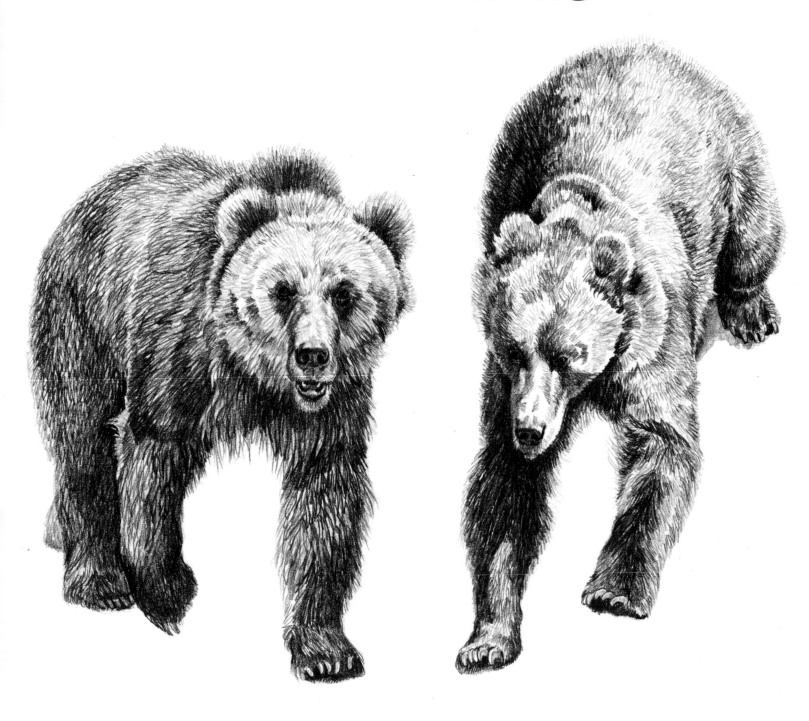

FRONT VIEW

I want to show the grizzly on the left in a threatening attitude. To do this, I darken his body behind the head, which I left lighter to bring it forward. Many dark, firm strokes are used for the shaggy body. Dark circles represent the deepset eyes. By pulling the lines out from the body, the effect of a hump is achieved. I darken this bear's feet since dark feet and legs are a natural coloration of the grizzly. The bear on the right shows the typical, long muzzle emerging from the flat, concave face. To render bushy ears, I leave a lighter area around the rims of the ears.

The bear is a sturdy, powerful animal who is basically peaceful, but when provoked, it can be an extremely dangerous fighter. A bear is omnivorous and feeds on both vegetation and flesh. It is a plantigrade, which means a bear walks on its palms and soles like a primate, not on its toes like most of the other mammals described in the book. Despite its apparent clumsiness, the bear is agile and fast when the need arises. It is said that a person cannot escape a bear since it can run, swim, and climb trees.

As my protagonist, I have chosen the grizzly, which is a Brown Bear that inhabits sections of Alaska, Western Canada, and the national parks of the United States. The grizzly is a large animal with long claws on its front feet, long hair of brown or silver-tipped color, weighing up to 800 pounds in the wild and well over 1,000 pounds in zoos. It has a pronounced hump on its shoulders, a short tail, and a flat, concave "dished-in" face.

Out of the thousands of grizzlies that populated the western portion of the United States, just several hundred survive in national parks.

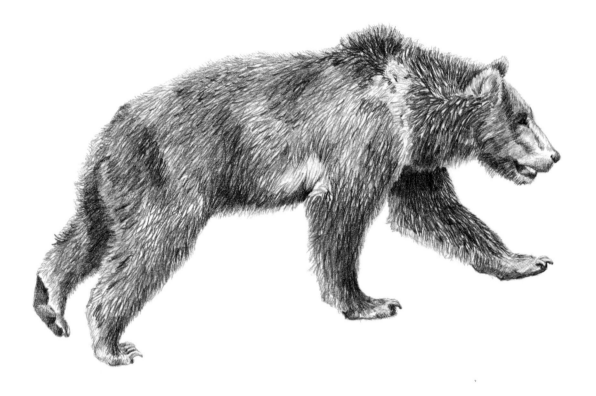

SIDE VIEW

This drawing shows a younger grizzly (top) in his shorter summer coat, and his elder brother (below) in the longer, shaggier winter coat. The young bear still has the light cub marking around his shoulders. The older bear, who tips a rock looking for grub, has fur tracks running in every direction. Despite these animals' bulk, an effort must be made to show the form that exists below the heavy pelage.

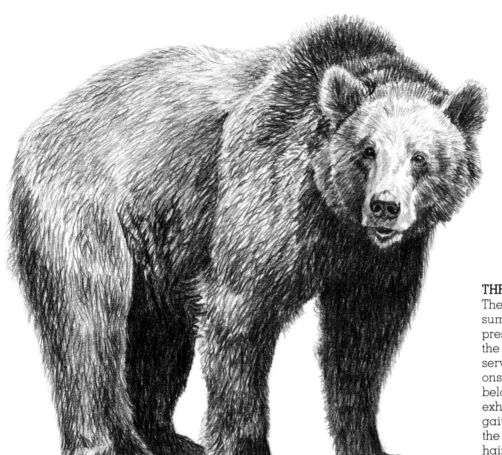

THREE-QUARTER VIEW

The grizzly on the left in his short summer coat wears a quizzical expression. It is standing flat, displaying the long, curved front claws that serve it in a variety of ways as weapons or burrowing tools. The bear below is equipped for the winter and exhibits the species' typical rolling gait. Note the whirl at the elbow of the right fore-limb from which the hair radiates to all sides. In drawing bears, I lightly mark their outer contours, then go over them with strokes running out of the body.

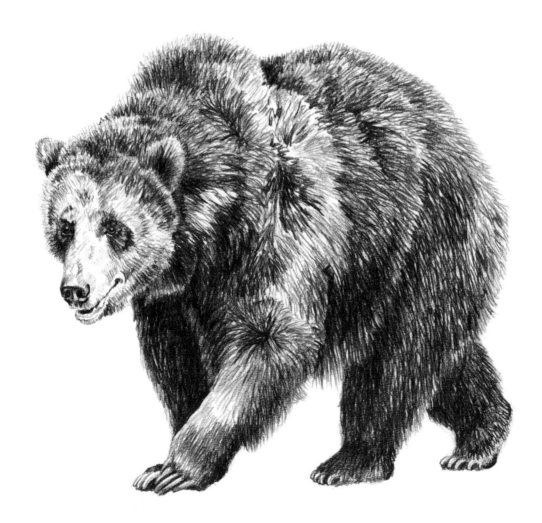

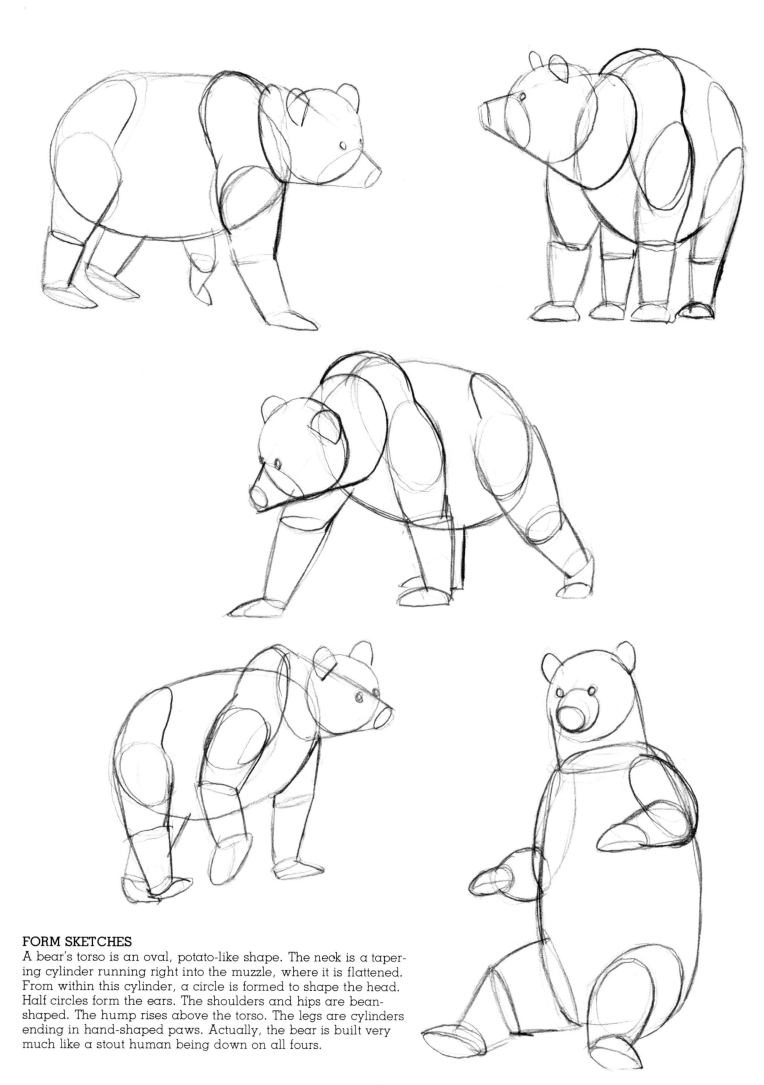

FORM SKETCHES

A bear's torso is an oval, potato-like shape. The neck is a tapering cylinder running right into the muzzle, where it is flattened. From within this cylinder, a circle is formed to shape the head. Half circles form the ears. The shoulders and hips are bean-shaped. The hump rises above the torso. The legs are cylinders ending in hand-shaped paws. Actually, the bear is built very much like a stout human being down on all fours.

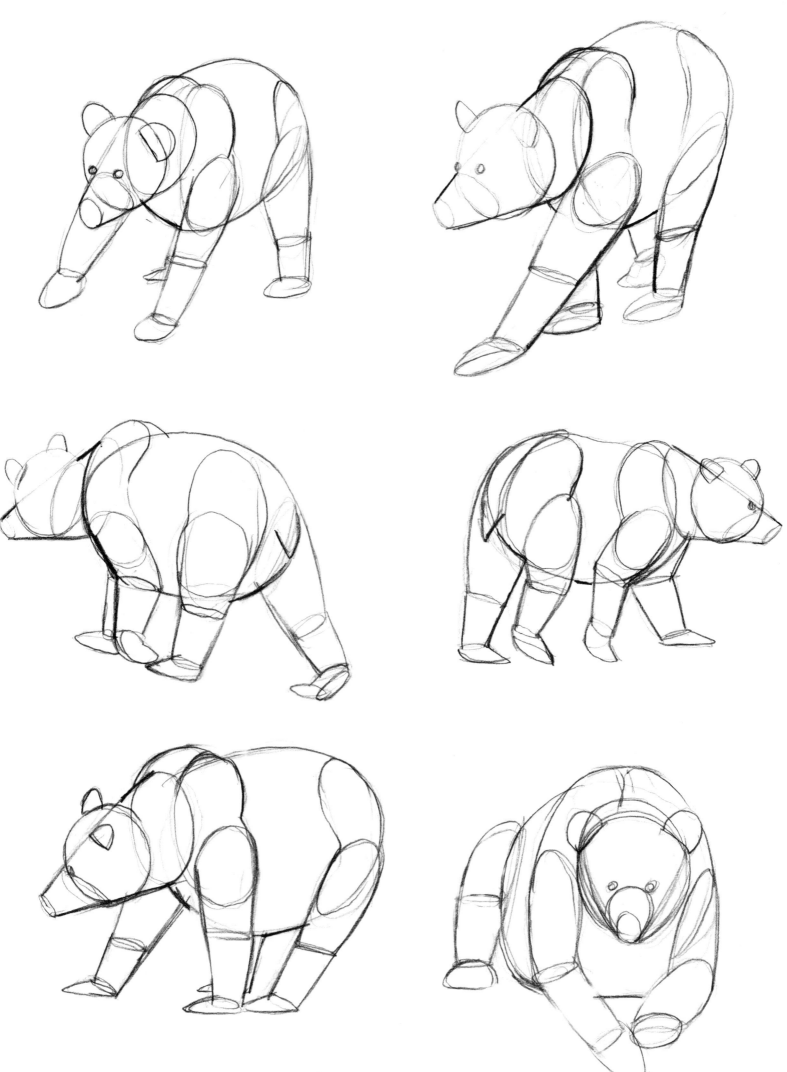

27

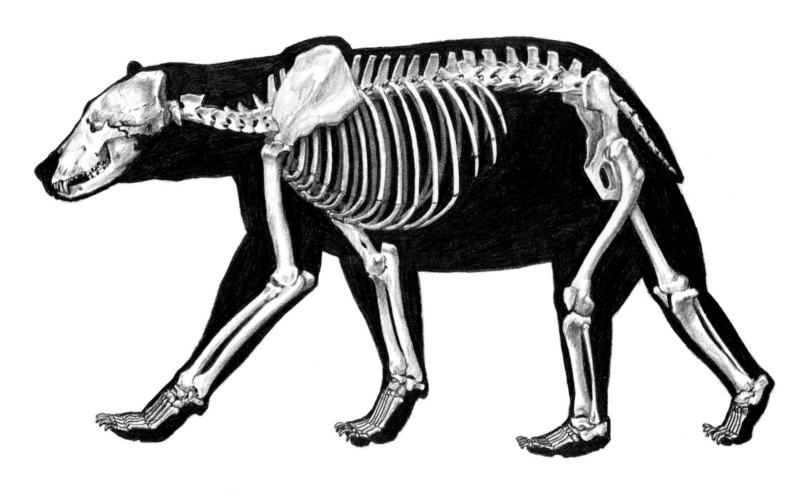

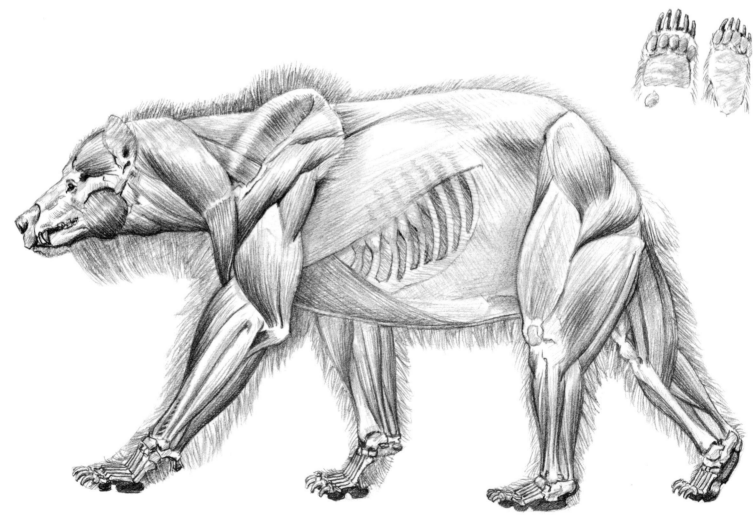

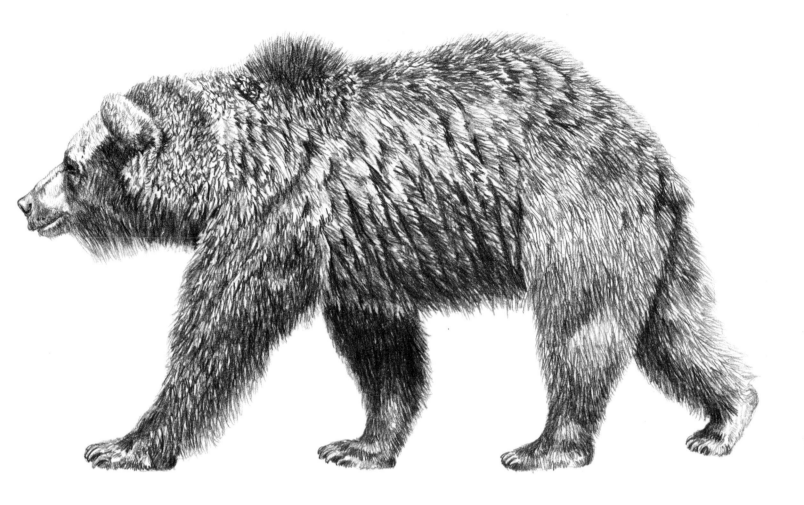

SKELETON (ABOVE LEFT)

The bear's bones are massive and dense, powerfully hinged and joined. Note how the hind legs resemble a man's. The scapula is large, and the canines overlap. The grizzly's claws can run as long as five inches; however, its considerable digging and scratching wear the claws down quite a bit. Because of the bear's anatomical resemblance to man, it was revered by many primitive people.

MUSCULATURE (LEFT)

If any creature is said to be powerfully built, the bear rates as the "Mr. Universe" of the animal kingdom. His muscles, ligaments, and tendons are as strong as steel and as flexible as rubber. The shoulder and hip muscles, in particular, are massive. In the diagram left, I show the configuration of the front and the hind paws (left to right). A full-grown male grizzly can crack the skull of the biggest steer as if it were a ping-pong ball.

SURFACE ANATOMY (ABOVE)

The grizzly actually has two coats—one of soft, dense underfur, and another of long, coarser hair over it. To depict the fur on the body, I use many V-shaped accents. I place the darks in the valleys of these V's and lights along their ridges. The hair on the hump is softer than the body fur and I compress the strokes to capture the hair's erect, radiating quality. The same applies to the animal's beard. All outer contours are feathered and the only hard edges I use are in the muzzle and claws.

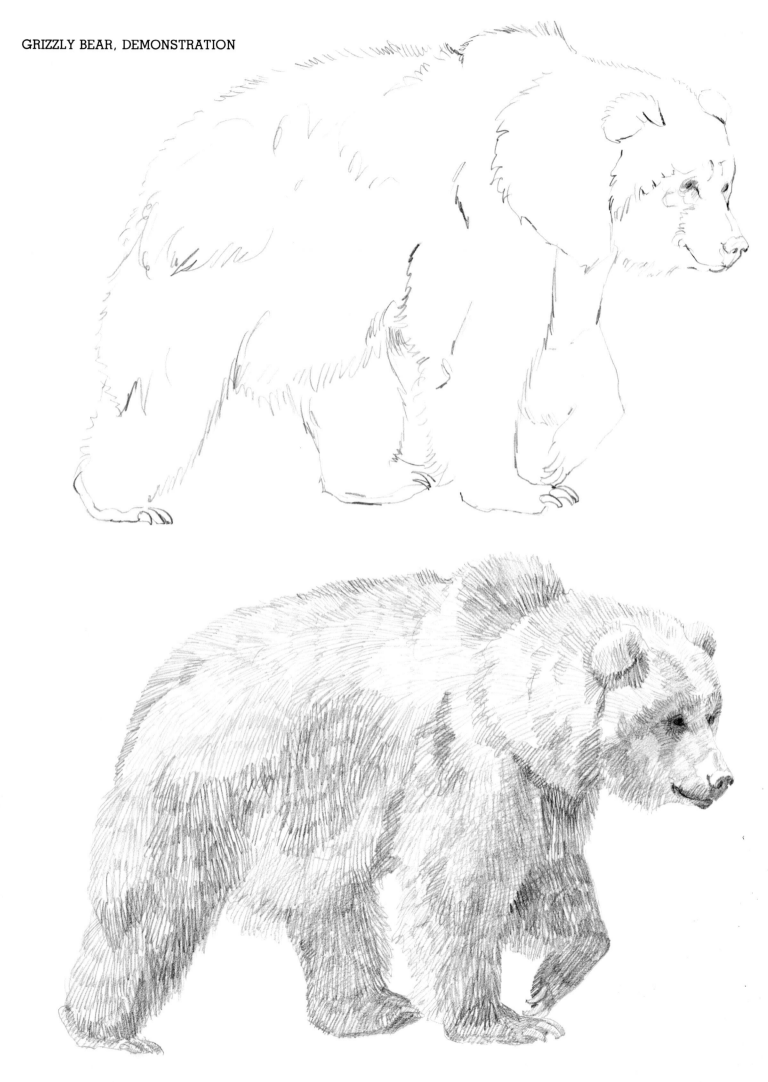

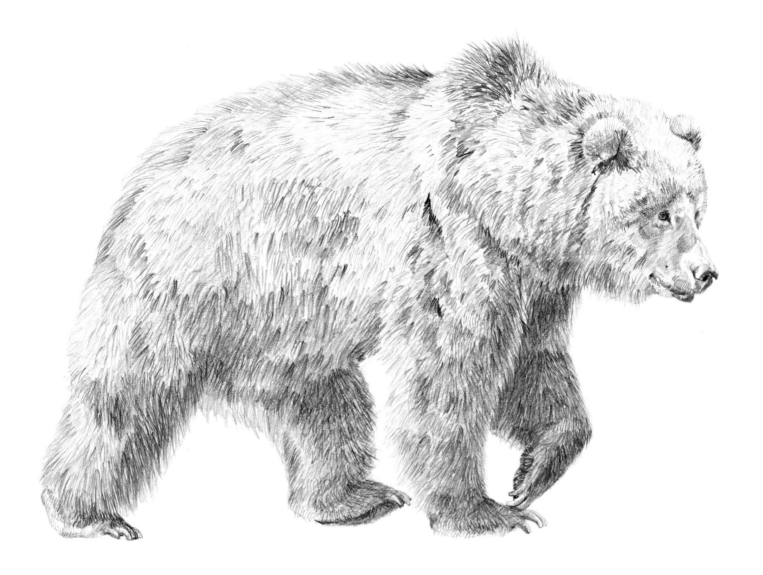

STEP 1. *(ABOVE LEFT)*
Here, the bear strides. Among grizzlies, there are no ob-
vious marks to distinguish the sow from the boar. After
drawing the complete outline, I lightly indicate the main
breaks in the fur. I try to capture the angle of the left front
paw as it turns at the wrist in the process of shambling
ahead. I give the bear an amiable expression since it is
basically a peaceful animal looking for food—not trouble.

STEP 2. *(LEFT)*
I indicate all the values with brisk, choppy strokes, bearing
down (pun intended) on the pencil in the darker areas. The
eyes, mouth, and nostrils are defined. Generally, the
strokes follow the form of the body; remember, beneath the
dense overcoat, there is muscular structure. In the subse-
quent stage, I will begin to refine the fur tracks and to
indicate the differences in the hair textures.

STEP 3. *(ABOVE)*
Now begins the process of refinement. I use hundreds of
short strokes to show the breaks in the dense, shaggy coat.
This choppy, crisp technique serves best to depict the ani-
mal's scraggly, grizzly fur. On the legs the hair is usually
shorter than on the body, so the bear appears to be wear-
ing a furry throw over its hips and shoulders. The hair of
the hump has a distinctive erect quality, and the ears look
like fuzzy pom-poms.

SITTING

A bear assumes this pose, both in the wild and in captivity. I use lots of dark strokes to give substance to the form of this grizzly and to anchor the animal's brisket to the ground. On the shoulders, the hair bristles out toward the viewer's eye and I punch (pressing hard on the lead pencil) lots of blacks into the white paper to show these small clumps. The underside of the bear, the inner neck, chest, and belly are made up of lighter, softer, longer hair.

RESTING

Bears love to bask in the sun. In order to preserve the attitude of peace and repose, I keep this drawing all-gray with a minimum of strongly contrasting blacks and whites. The bear on the left is in the process of flopping down to assume the posture of his reclining companion. Unlike cats, bears' claws are not retractable.

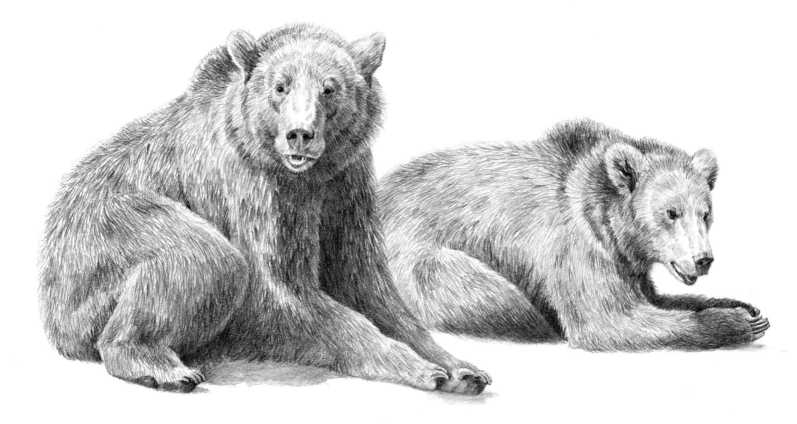

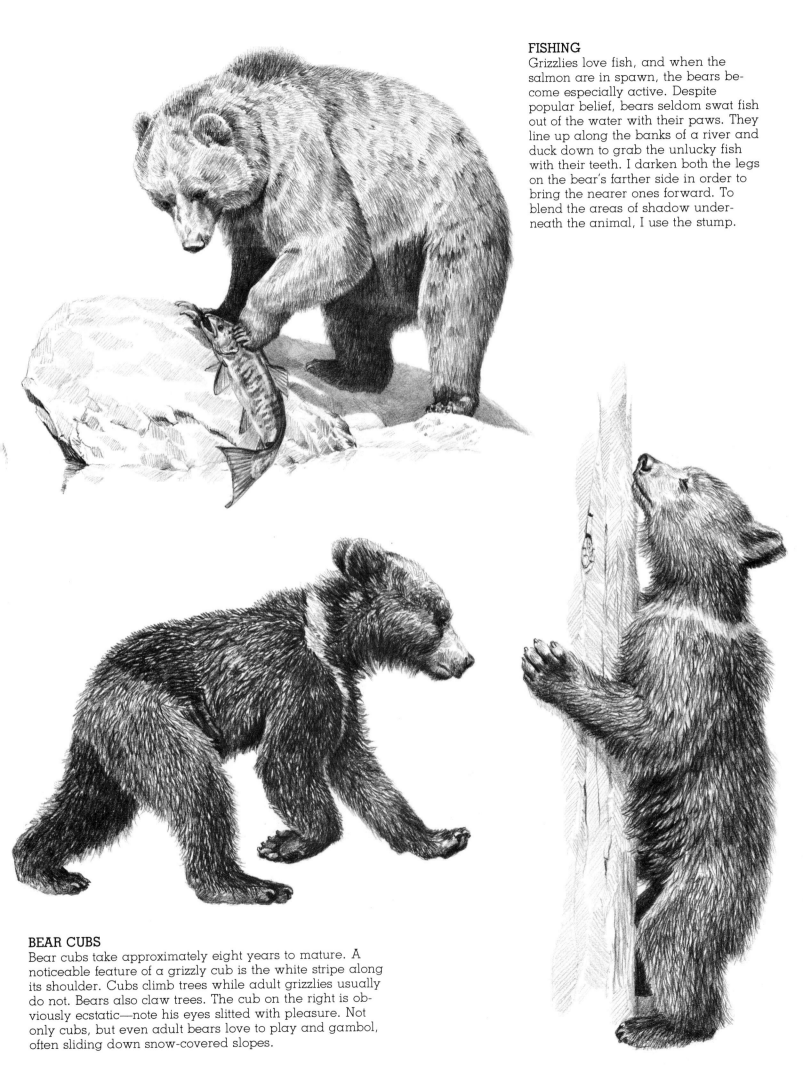

FISHING

Grizzlies love fish, and when the salmon are in spawn, the bears become especially active. Despite popular belief, bears seldom swat fish out of the water with their paws. They line up along the banks of a river and duck down to grab the unlucky fish with their teeth. I darken both the legs on the bear's farther side in order to bring the nearer ones forward. To blend the areas of shadow underneath the animal, I use the stump.

BEAR CUBS

Bear cubs take approximately eight years to mature. A noticeable feature of a grizzly cub is the white stripe along its shoulder. Cubs climb trees while adult grizzlies usually do not. Bears also claw trees. The cub on the right is obviously ecstatic—note his eyes slitted with pleasure. Not only cubs, but even adult bears love to play and gambol, often sliding down snow-covered slopes.

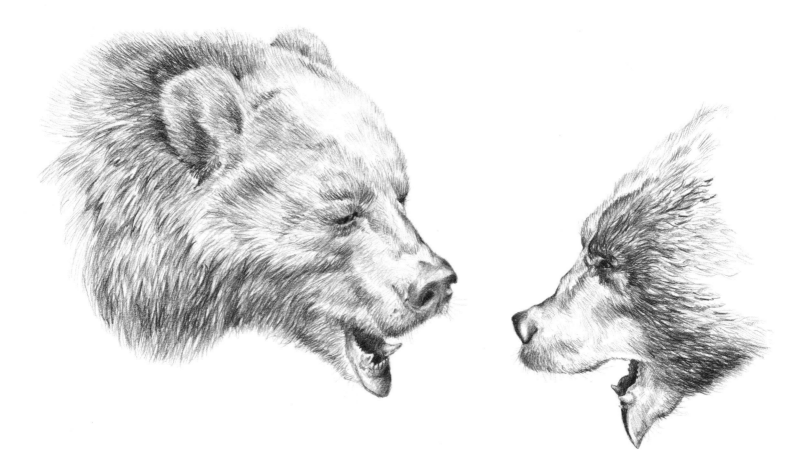

HEAD, SIDE VIEW (ABOVE)

When grizzlies are angry, they draw back their noses so that the nostrils turn up. This action causes the eyes to slit and the lower lip to thrust out and down. These animals are also baring their fangs. Note how the ear canals are covered by hair. I use the V shapes to depict the texture of the left bear's neck fur patterns. The snarling gesture causes a variety of wrinkles to form in both bears' brows and cheeks. Their whiskers are erect and bristle forward in accord with the aggressive expression.

HEAD, THREE-QUARTER VIEW (RIGHT)

This happy bear's mouth is turned up in a half-smile. I use many V shapes in the ruff, long flowing strokes in the beard, short strokes on the crown and ears, and white space to depict the softer hair on the nose and face. The nostrils are shiny and to do this I blend the dark tones with a stump and accent with highlights. The deepset eyes are indicated as dark receding accents, while the ear canals are hidden under the dense fur.

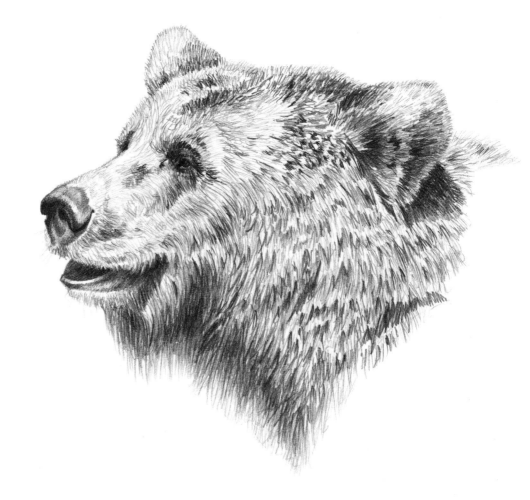

POLAR BEAR (RIGHT)

This powerful fellow spends most of its life on ice floes. The animal's enormous feet act as snowshoes that allow it to travel over snow and ice. To show the characteristically wet fur, I employ a number of V-shaped accents as detailed in the diagram on the upper right part of the page. The polar bear is creamy-white all over, which is the perfect camouflage for its arctic environment. I draw into the white of the paper to capture the essence of the shaggy white coat. I use the white of the paper as the basic value of the fur, therefore, I draw the values around the fur darker. The hair on the left hind leg is so thick it almost resembles a dustmop.

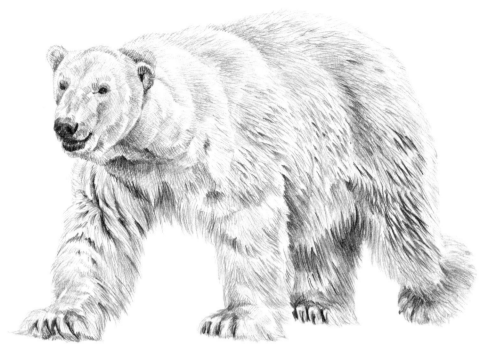

HIMALAYAN OR ASIATIC BLACK BEAR (LEFT)

This bear wears a pale crescent mark on its chest. It has a huge ruff that I draw with a series of very dark strokes radiating out from the head. In this comical position, the bear's underside is fully exposed showing how the thick hair grows in patterns going around the form. The darkest accent in the drawing is the inside of the open mouth, which I achieved by pressing down on my HB pencil. All the outside contours are feathered to capture the essence of the thick, dark fur.

AMERICAN BLACK BEAR (BELOW)

The black bear is smaller and more rounded in shape than the grizzly. Despite its name, its color is not always black. Also, it lacks the characteristic hump, and the coat is shorter, smoother, and less shaggy. Many folds and creases mark this animal's shape. When drawing densely furred animals, one must always keep in mind the underlying structure beneath all that fat and bulk. A knowledge of basic anatomy is even more important when drawing a bear than a lean, short-haired deer.

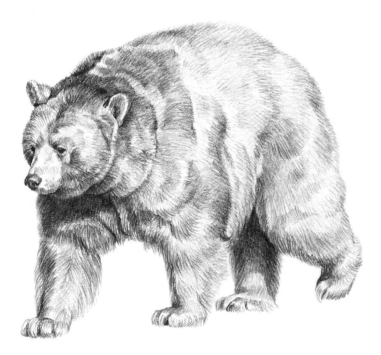

HORSES

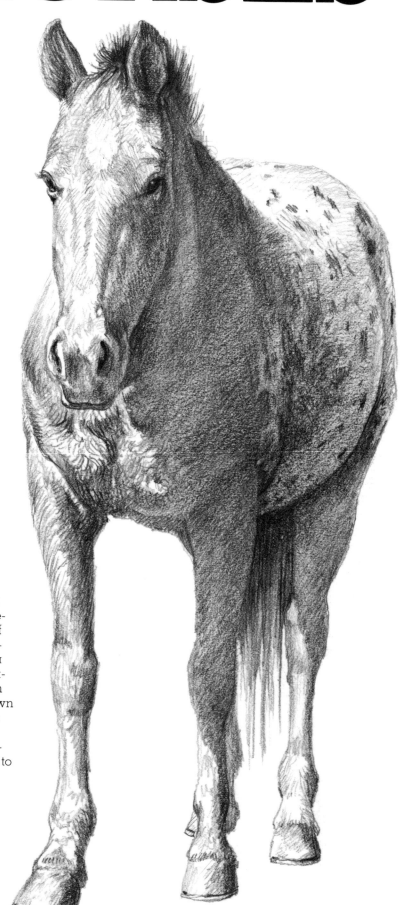

FRONT VIEW

This is an Appaloosa, a handsome horse with an outstanding characteristic: the various-sized spots on its rump, which is usually white. Developed by the Nez Percé Indians of central Idaho and eastern Washington, the popularity of the Appaloosa has been steadily growing. It is a favorite of horse lovers, particularly in the far West. The Appaloosa is known for its speed and endurance. Just as with the tiger, leopard, and other marked animals, I complete the animal's form and value patterns prior to putting in the spots.

It is believed that horses evolved somewhere in Asia, then migrated to the Americas, where they ultimately became extinct. The Spanish conquistadores reintroduced the horse to the New World and the American Indians quickly adopted it for hunting and warring purposes.

The horse is thought to have been domesticated sometime during the Bronze Age, since ever-practical man saw in the species a means of swift and efficient transportation. The modern horse can be roughly divided into three categories: saddle, harness, and heavy draft. There are also ponies, which are smaller versions of the saddle horse. Any horse shorter than 14.2 hands at the shoulders is called a pony. The hand is approximately four inches and is used to indicate the height of horses at the shoulders.

The horse has a life span of approximately 20 to 30 years. It is strictly herbivorous, which accounts for its teeth being adapted for grinding rather than tearing its food. The modern horse stands on a single toe per leg, the third toe of each foot. The average saddle horse stands between 14 and 16 hands high at the withers, or shoulders (this corresponds to about 5½ feet or 1.7 meters), and weighs between 950 and 1250 pounds. Larger draft horses are taller and may weigh up to a ton. Newborn horses of both genders are called foals. After their first birthday and up to their second, they are known as yearlings. Between their second and fourth birthdays, the males are called colts and the females fillies. A mature male is a stallion and mature female a mare.

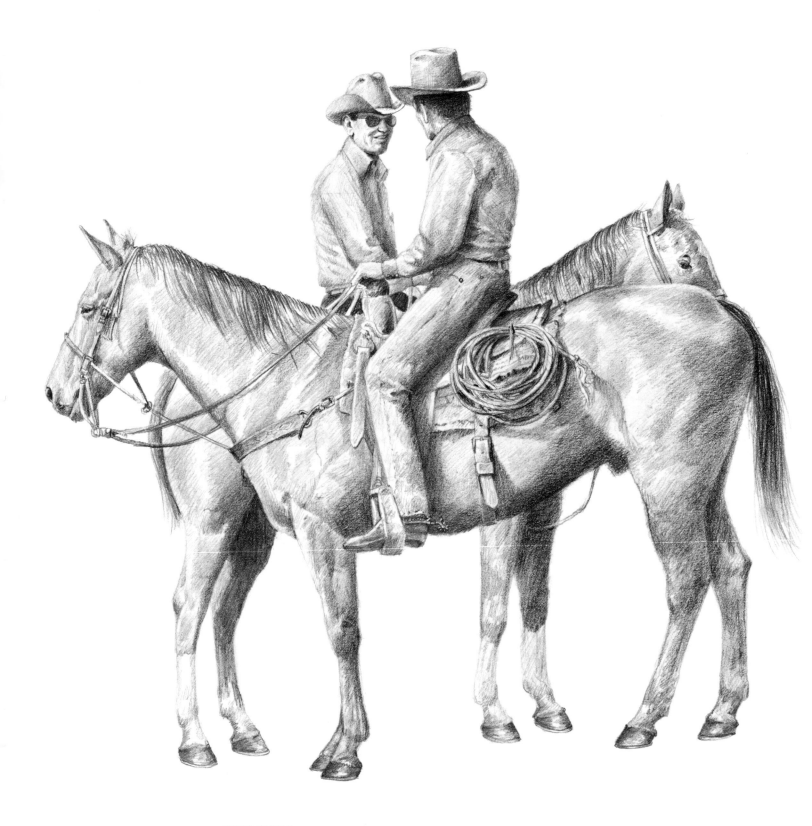

SIDE VIEW
I include the cowboys to show the trappings of Western tack.
Horses, with some exceptions, are short-coated animals and a
contrast of light and dark accents is necessary to show the sheen
of the healthy, well-groomed animal. The French stump and
eraser are valuable tools in drawing the horse's smooth, gleam-
ing coat.

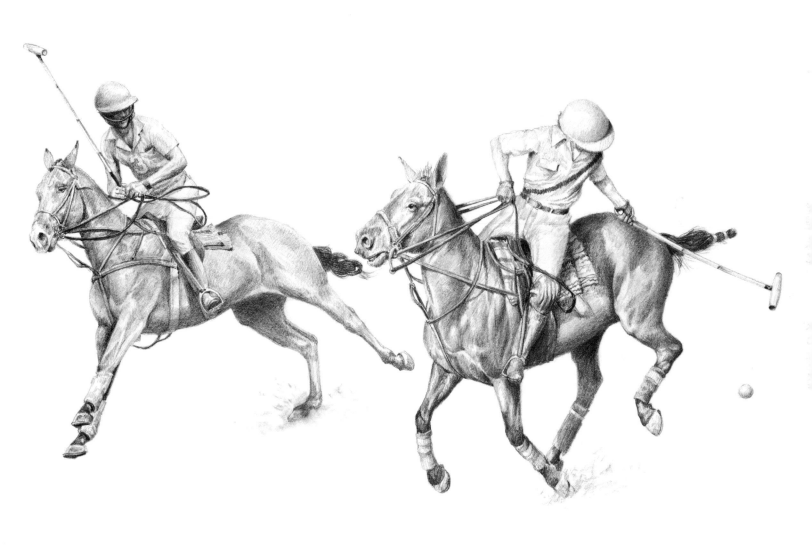

THREE-QUARTER VIEW

Polo ponies are selected and trained with great care. Often they are of the quarter-horse breed. Originally, the height of the animals used for polo was restricted, which resulted in the phrase "polo pony," even though this restriction no longer prevails. To depict the strenuous action assumed by the nearer pony, I put in a series of parallel planes in the shoulder area. Note the angle of the pastern in the back pony's right rear leg—it is almost parallel with the ground.

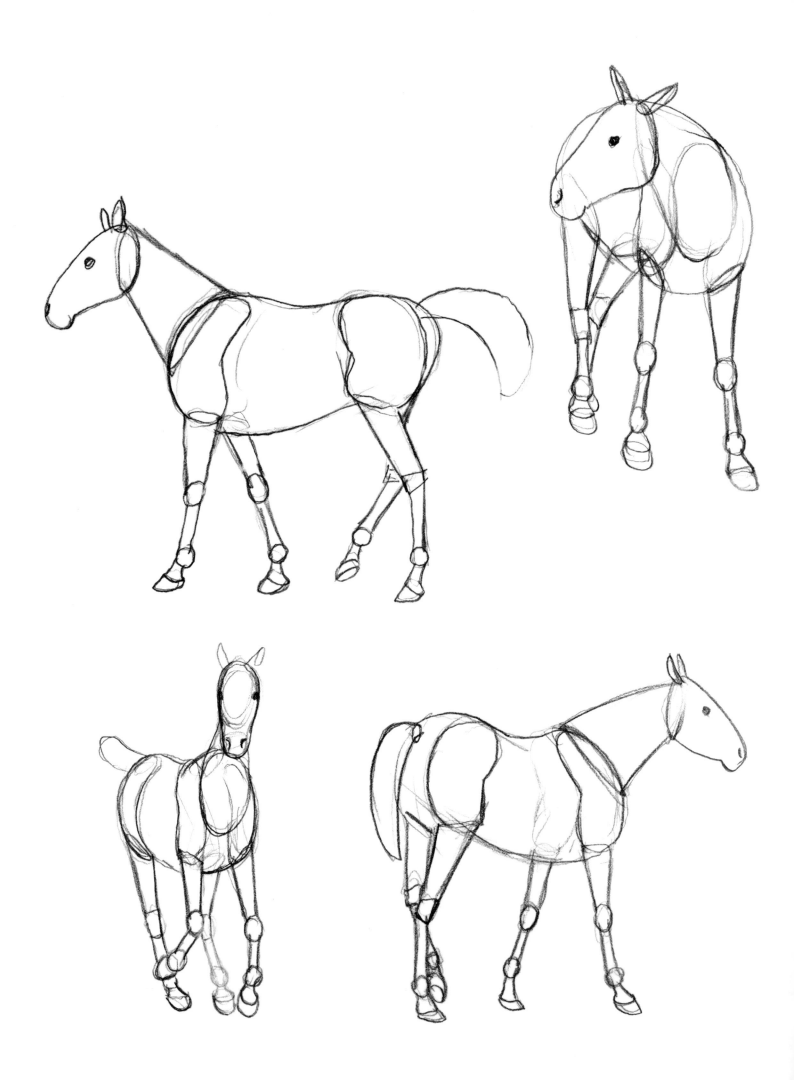

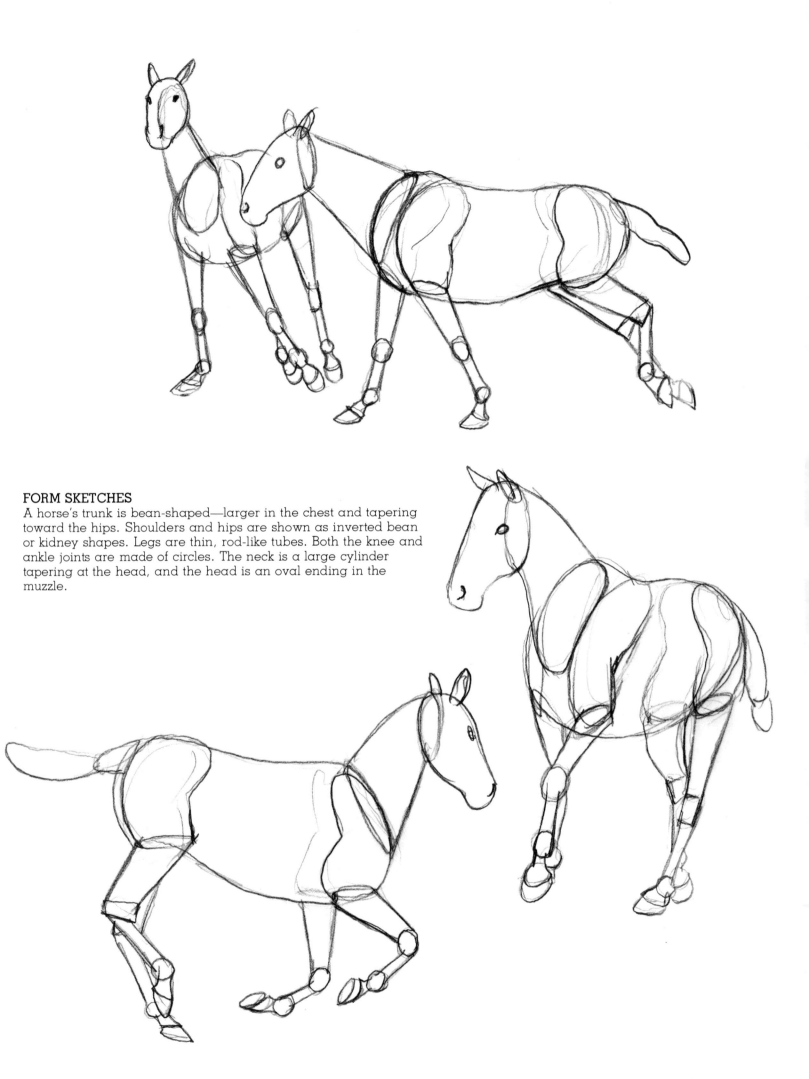

FORM SKETCHES

A horse's trunk is bean-shaped—larger in the chest and tapering toward the hips. Shoulders and hips are shown as inverted bean or kidney shapes. Legs are thin, rod-like tubes. Both the knee and ankle joints are made of circles. The neck is a large cylinder tapering at the head, and the head is an oval ending in the muzzle.

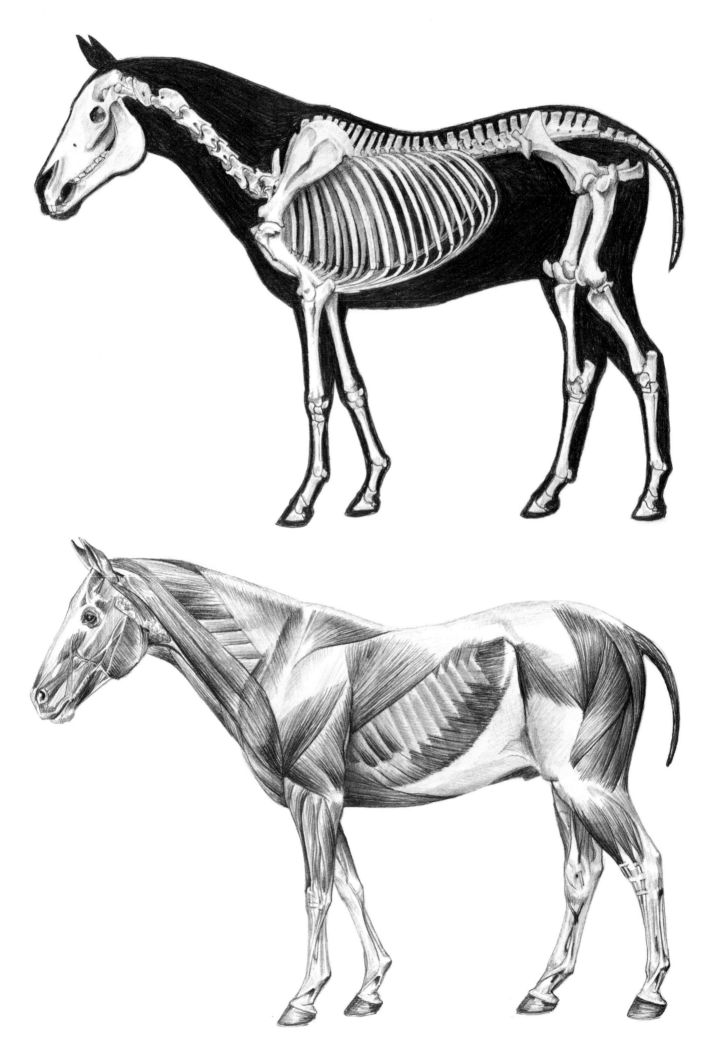

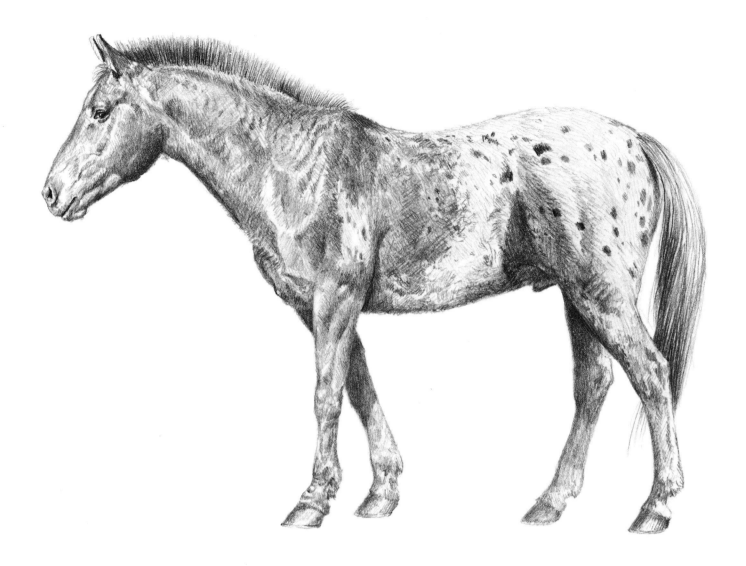

SKELETON *(ABOVE LEFT)*
Originally, a horse was a three-toed animal. With evolution, the other toes became vestigial so that the horse now stands on a single toe that we know as the hoof. Horse legs are long and graceful, designed for speed. In the more powerful draft horses, the leg bones are stronger and more massive. The horse also possesses a capacious ribcage and powerful neck and shoulder bones.

MUSCULATURE *(LEFT)*
Because of the lack of long hair or fur, much of the horse's muscular structure is visible, particularly when he is running, pulling a load, or jumping. Much of the power seems concentrated in the chest, shoulder, and arm areas as well as in the rump, forearms, and gaskins. The type of muscles a horse has depends upon its function. Shorter, bunchy muscles are better suited for turning and pivoting actions while longer, supple muscles are desirable for speed.

SURFACE ANATOMY *(ABOVE)*
Note this Appaloosa's clipped mane with its stiff, bristly appearance. To achieve this effect, I use a series of short dark pencil strokes that grow thinner and lighter as they move farther away from the neck. The parallel dark accents in the shoulder area are a common characteristic. Several tonal contrasts are evident, resulting from the number of color variations this breed exhibits.

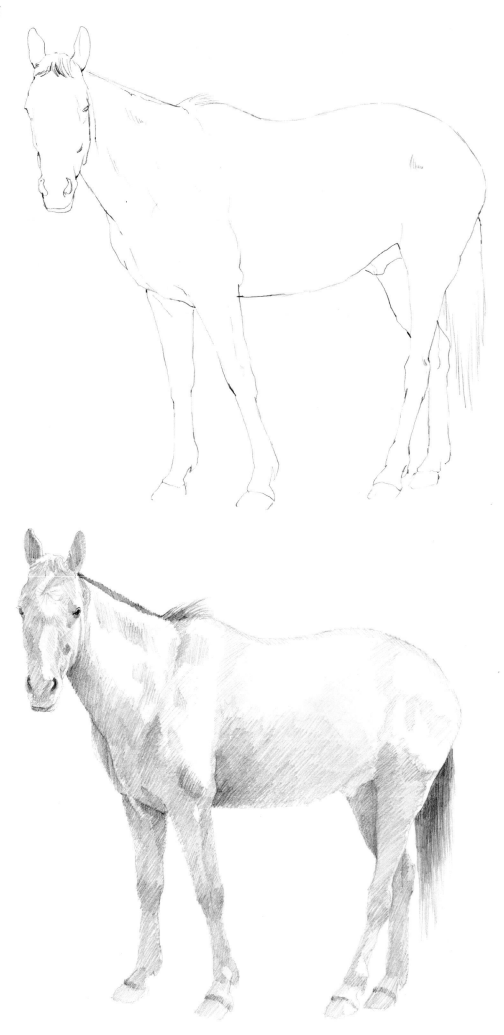

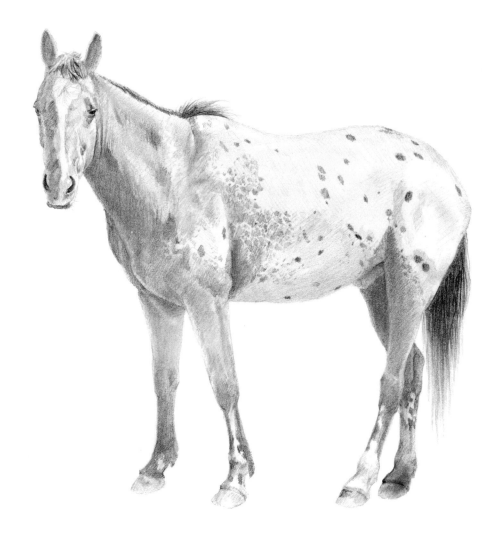

STEP 1. *(ABOVE LEFT)*
To begin, I draw in the outline of the animal. Then I mark a few indentations to indicate bone or muscle groupings such as in the shoulders and the point of the hip. Next, I show the shapes of the tail and the forelock and the placement of the eyes and nostrils. I mark off the junction of the hairline and the hoofs, and I show the protrusion of the elbow.

STEP 2. *(LEFT)*
I now establish the light source and place the shaded areas lightly on the right side of the head, the underneath part of the neck and body, and in the legs. With long strokes of the pencil, I lay in the dark hair of the tail. The roached mane is also indicated with short dark strokes. So far, I have made no effort to show the hair patterns or markings on the coat.

STEP 3. *(ABOVE)*
The two-tone effect of the animal's coat is achieved through contrasts of broken, spotted areas. There are dark spots over the light areas and negative light spots over a dark base such as the hind legs. Again, use the paper value as the light spot and draw the darker value around it. The white patch and streak are placed on the forehead and nose. On the animal's forelock, the hair is shown radiating from a central base. The forelock, tail, and the mane at the withers are the only areas where the hair is of any length; otherwise, the hair is too short to form a noticeable pattern.

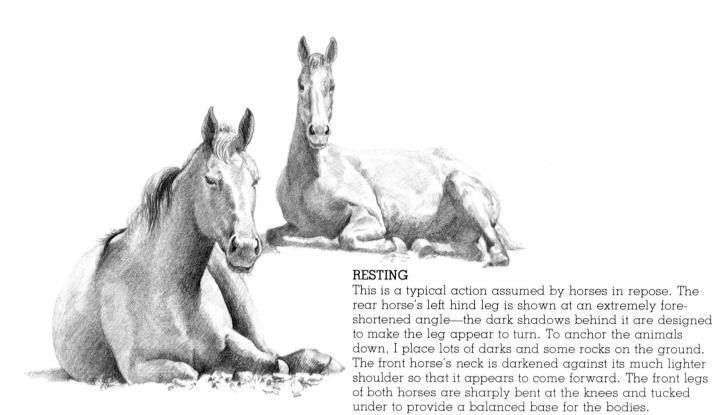

RESTING

This is a typical action assumed by horses in repose. The rear horse's left hind leg is shown at an extremely foreshortened angle—the dark shadows behind it are designed to make the leg appear to turn. To anchor the animals down, I place lots of darks and some rocks on the ground. The front horse's neck is darkened against its much lighter shoulder so that it appears to come forward. The front legs of both horses are sharply bent at the knees and tucked under to provide a balanced base for the bodies.

GRAZING (BELOW)

The horse is equipped with a long neck so that it can graze easily. In this drawing, the most important action is the long sweep of neck as this Appaloosa bends radically forward. To accent this gesture, I darken the neck underneath. I outline the animal's spots and place a dark core inside before proceeding to finish them off. The changes of color in the horse are shown with contrasts of light and dark that have no real sharp edges to separate them.

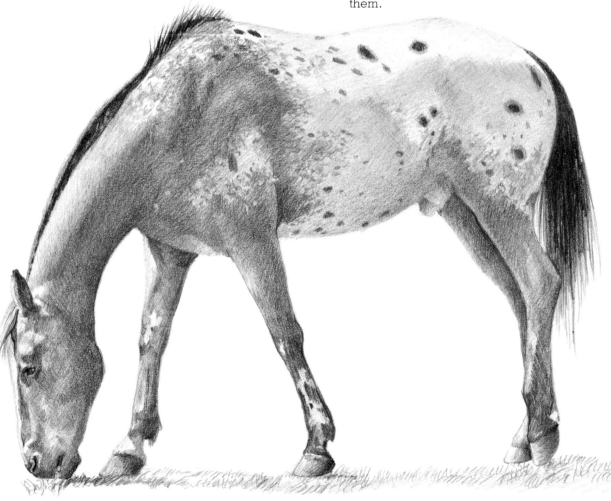

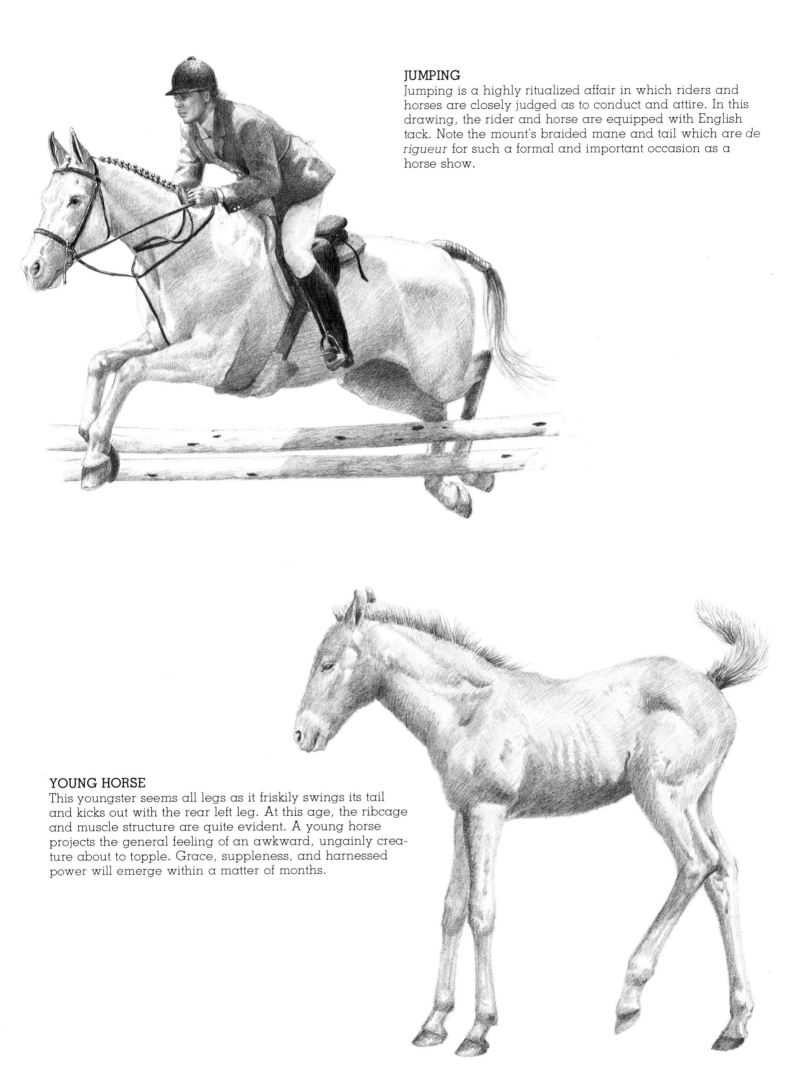

JUMPING

Jumping is a highly ritualized affair in which riders and horses are closely judged as to conduct and attire. In this drawing, the rider and horse are equipped with English tack. Note the mount's braided mane and tail which are *de rigueur* for such a formal and important occasion as a horse show.

YOUNG HORSE

This youngster seems all legs as it friskily swings its tail and kicks out with the rear left leg. At this age, the ribcage and muscle structure are quite evident. A young horse projects the general feeling of an awkward, ungainly creature about to topple. Grace, suppleness, and harnessed power will emerge within a matter of months.

HEAD, THREE-QUARTER VIEW (RIGHT)

I draw the outline of this Appaloosa's head first, then fill in with the black background around it. To render the mane, I draw long dark strokes into the lighter underlying area. The hair patterns on the bottom of the neck produce small islands of light and dark. I use the razor to pull out the whiskers from the muzzle and lower chin, and the right eyebrows out of the dark background. Darks are used to mark the cavities formed by the nostrils, mouth, ears, and eyes.

BURRO (BELOW)

Of the donkey species, this burro is particularly shaggy. I exploit this shagginess as the chief feature of the drawing. The animal's form is somewhat lost under all that growth and the accent is on the direction of the hair patterns. Note how the patterns run down the side of the body, up at the mane, and haphazardly on the legs. The burro's hoofs are blunt and square-shaped. His ears are long and prominent. In drawing such an animal, bold strokes are necessary, or the result will be confusion.

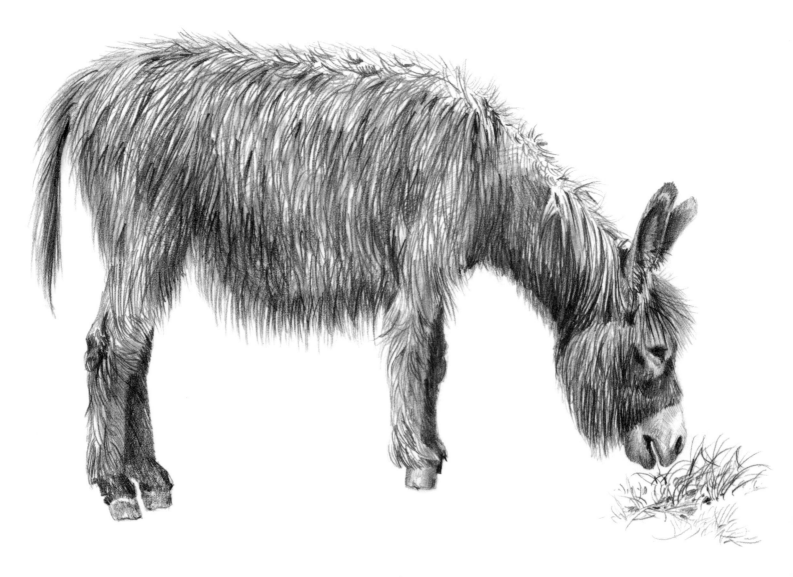

48

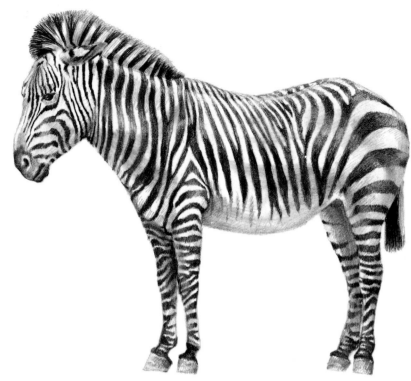

ZEBRA

There are three kinds of zebra: Grevy's, Mountain, and Burchell's. This is a Grant's (bold contrasting stripes), which is a variety of Burchell's or Plains Zebra. As with all marked animals, I first establish its muscle structure. I then carefully draw in the outlines of the stripes. The stripes serve as camouflage and vary according to the type of zebra; the muscular structure underneath should not be lost. Finally, I fill in the stripes and draw the tail, hoofs, facial features, and mane.

CLYDESDALE

This breed of heavy draft horse originated in Scotland in the 18th century. Some stand as high as 18 hands and can weigh up to a ton. It is densely haired on the back of its legs and heavily boned and muscled. Since its coat is not as short or glossy as a saddle horse's, I represent it in a series of varied hair patterns often running crosswise. I use the kneaded eraser to pick out selected highlights on the flanks and sides of the horse. The contours of the animal's legs and torso are feathered to indicate its shaggier coat.

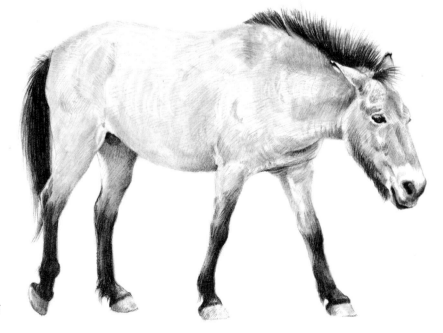

PRZEWALSKI'S HORSE

This breed of wild horse is extremely rare. Of sturdy physique, it stands 12 hands high, with a short and bristly mane, a long black tail, and legs that are black from the knees down. I use a template (see diagram) to draw the mane. Setting its edge at the animal's neck, I pull the strokes away from it to achieve the dark, straight lines I want. I use the HB pencil for the shadowed areas, bearing down on the pencil for the darkest darks.

CATTLE

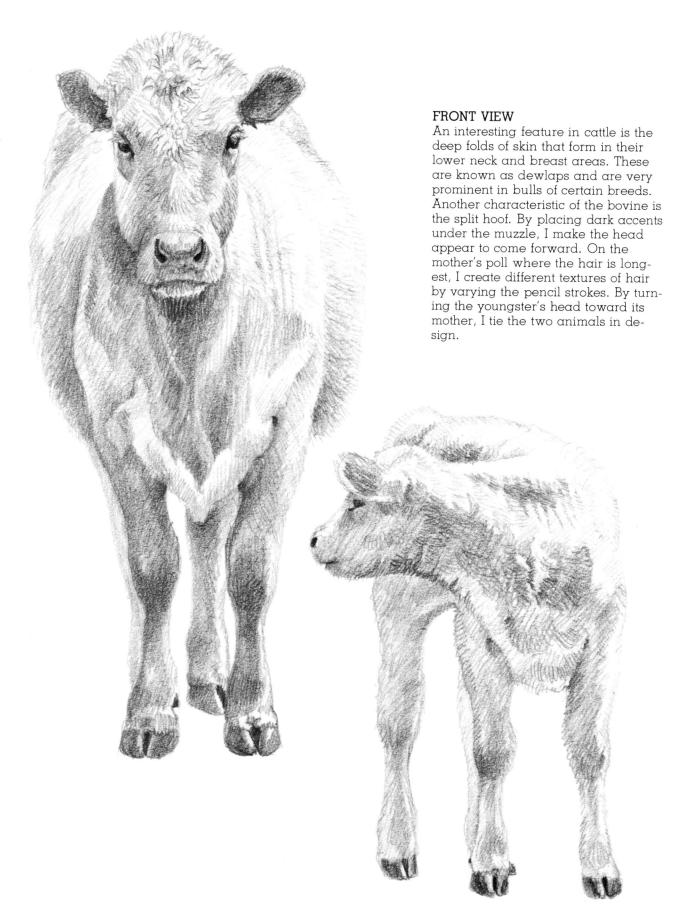

FRONT VIEW
An interesting feature in cattle is the deep folds of skin that form in their lower neck and breast areas. These are known as dewlaps and are very prominent in bulls of certain breeds. Another characteristic of the bovine is the split hoof. By placing dark accents under the muzzle, I make the head appear to come forward. On the mother's poll where the hair is longest, I create different textures of hair by varying the pencil strokes. By turning the youngster's head toward its mother, I tie the two animals in design.

The term cattle is generally employed to embrace the domesticated breeds of milk and beef animals with which we are all familiar, and such close cousins as buffalo, bison, and yaks. Since ancient times cattle have served man as beasts of burden, draft animals, and suppliers of meat, dairy, and leather products. In most breeds, bulls are much heavier and more powerful animals than their female counterparts. There are, basically, three types of cattle: shorthorns, longhorns, and polled (lacking horns). All cattle, however, belong to the so-called even-toed ungulates that have two toes per hoof—unlike the horse, which has one.

In horned breeds, both sexes possess horns that are hollow. Cattle tails are generally long and tufted. Bulls of certain species often develop extensive dewlaps. Some of the breeds also feature large humps. Cattle are ruminants, or cud chewers. They have a digestive system of four-chambered stomachs which allows them to regurgitate food after swallowing it quickly and chewing it again at leisure.

Cattle types range from the gentle dairy cow to the fierce Cape and Water Buffalo, which when provoked are among the most dangerous animals known. Newborn cattle are called calves. During their first year of life, they are known as yearlings. A young female is called a heifer. Bulls that are gelded are called steers or oxen.

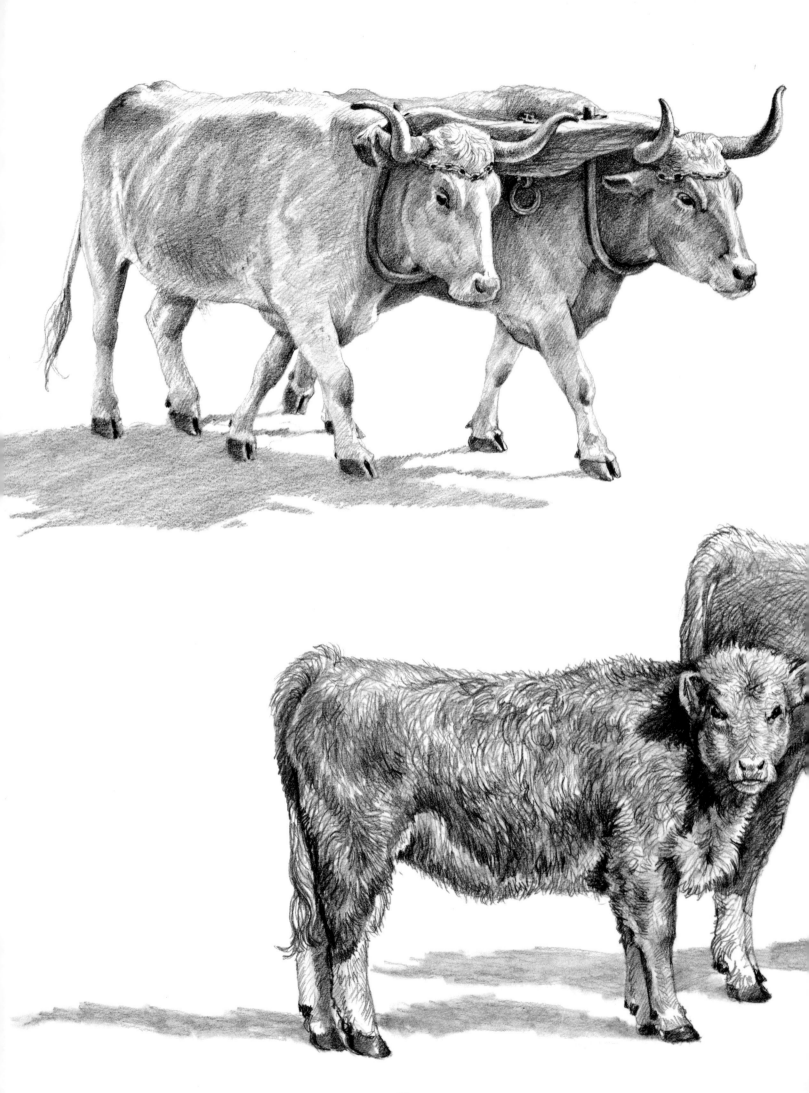

THREE-QUARTER VIEW

This is a team of oxen in harness. Their coats are smooth and glossy and I indicate this feature with contrasts of darks and lights. The longest hairs on these oxen are located in the tufts of their tails and in their topknots. I include the shadow to promote the effect of weight and solidity that these animals project. Oxen are still widely used as draft animals in the underdeveloped areas of the world.

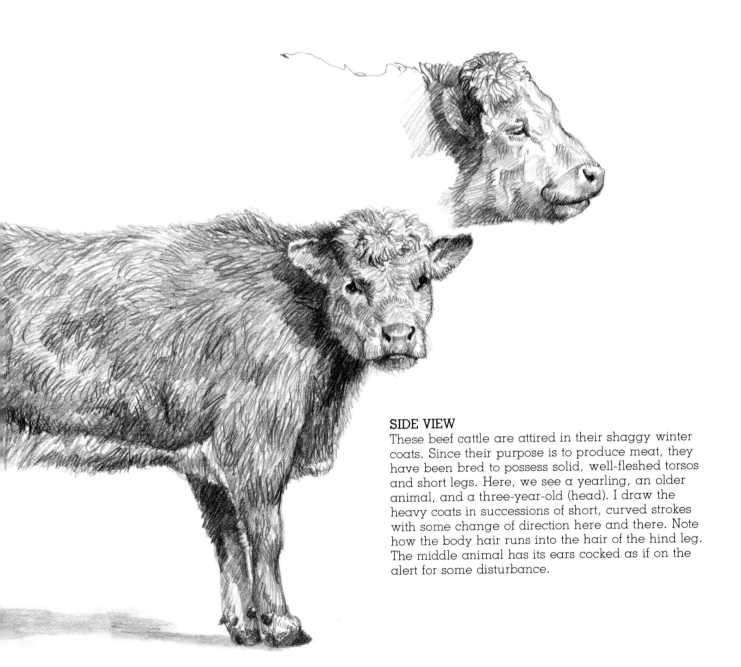

SIDE VIEW

These beef cattle are attired in their shaggy winter coats. Since their purpose is to produce meat, they have been bred to possess solid, well-fleshed torsos and short legs. Here, we see a yearling, an older animal, and a three-year-old (head). I draw the heavy coats in successions of short, curved strokes with some change of direction here and there. Note how the body hair runs into the hair of the hind leg. The middle animal has its ears cocked as if on the alert for some disturbance.

FORM SKETCHES

Cattle are heavy-boned, massive animals built essentially for stability rather than speed. The torso is a non-tapering cylinder. Their heads are conical with a blunted tip for the muzzle. Some cattle are straightbacked, others have a fatty lump at the shoulder. Half-circles represent the ears. I draw the shoulder and pelvic bones as kidney shapes which usually don't protrude above the torso.

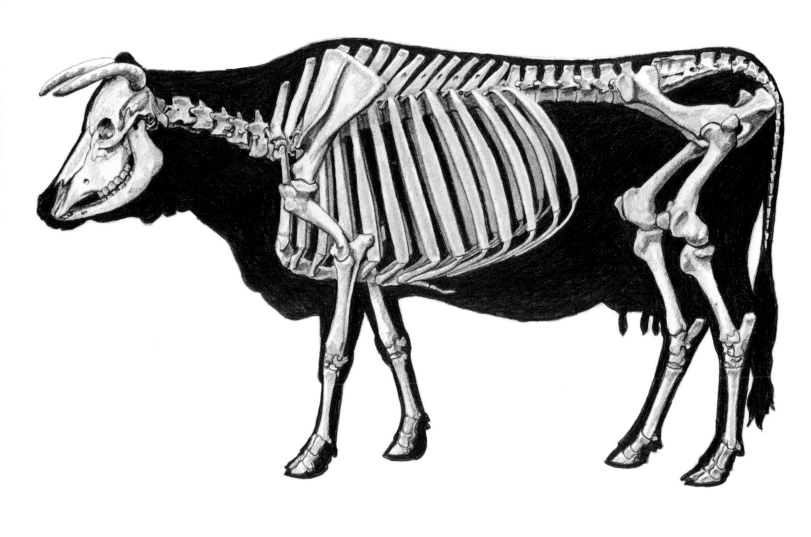

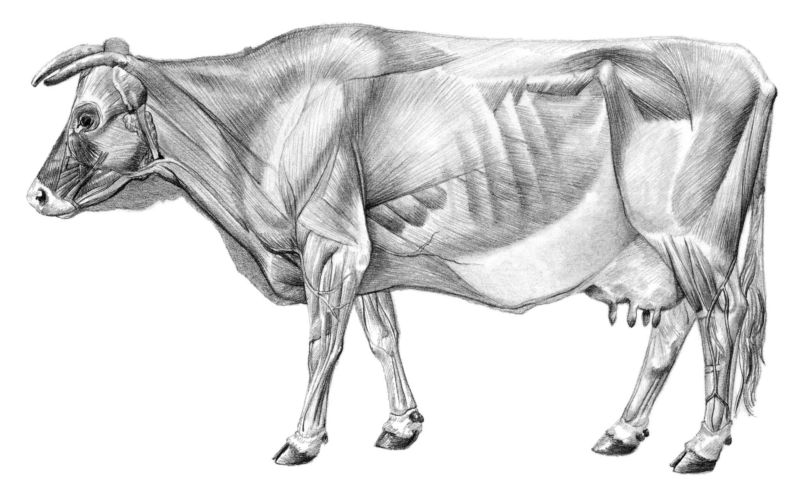

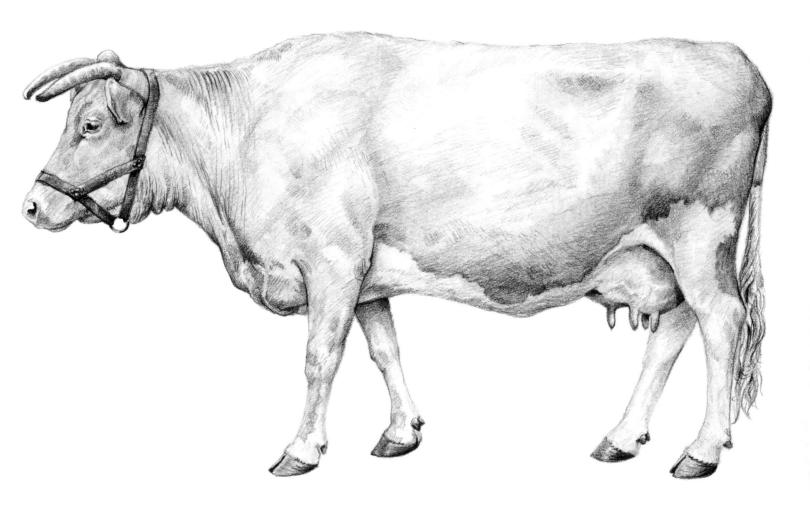

SKELETON (ABOVE LEFT)
Note how low the ribcage descends on cattle. These animals can weigh over a ton and need massive bones to support such weight. The legs are relatively short and not particularly thick. The skulls, which must often support horns of considerable length, are proportionally large in horned breeds. Some breeds of cattle are taller than six feet at the shoulders.

MUSCULATURE (LEFT)
Cattle are thick, bunchy-muscled animals. Much of this muscle is concentrated in the neck, shoulders, breast, and rump. Breeders of beef cattle try to reduce an animal's muscles and tendons, so they can replace them with fat and flesh in order to get maximum value per pound of meat. In cattle used for draft purposes, heavy musculature, of course, is desirable.

SURFACE ANATOMY (ABOVE)
This Guernsey cow is a dairy animal which was developed on the Isle of Guernsey, an island in the English Channel only 24 square miles in area. Guernseys are excellent milk producers. They are yellow or fawn-colored with areas of white often on the legs and underbelly. The vertical lines on the neck represent wrinkles. Veins are seen in the breast and on the udder. To render the lacy texture of the switch of the tail, I use long, interlocking strokes. I include the headstall to accentuate the breed's domestic nature.

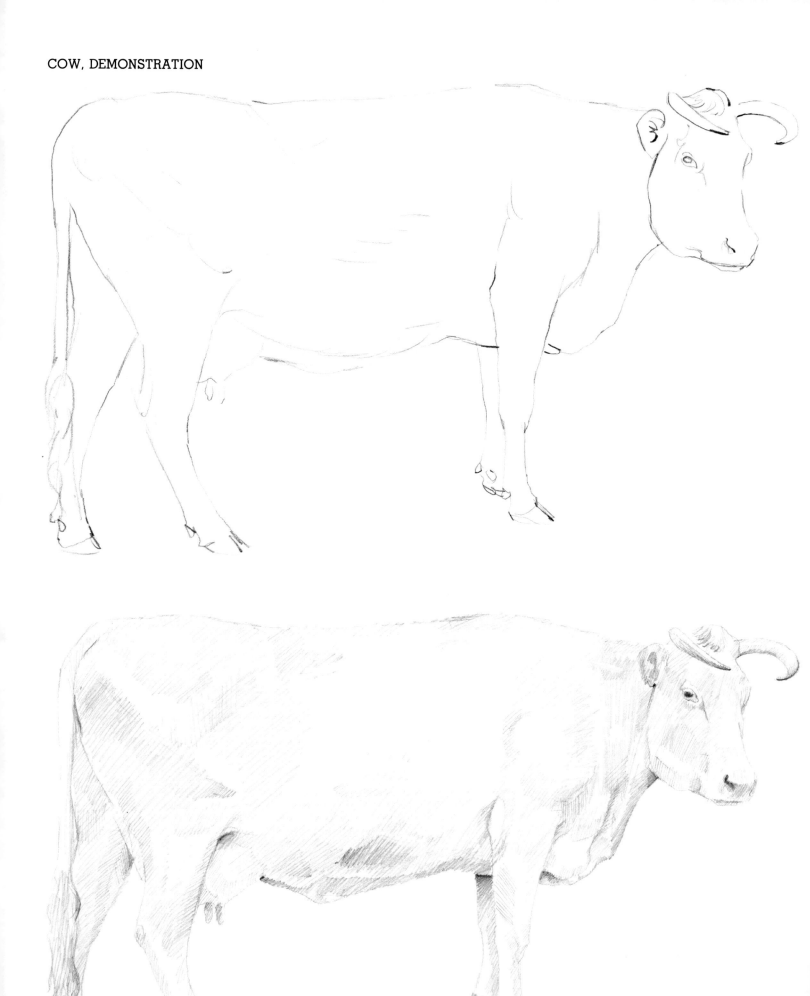

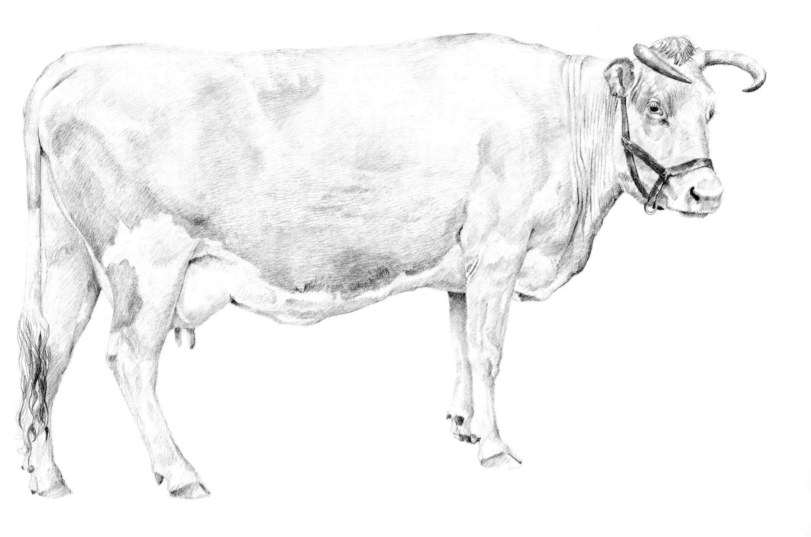

STEP 1. *(ABOVE LEFT)*
I complete the outline of the animal and place several lines to indicate color variations in the body and some of the muscle pattern in the rump and hind. To capture the action of the turning head, I accent the line in the jaw. Since this will be an essentially high-key drawing, I keep my strokes light all over.

STEP 2. *(LEFT)*
I now establish the general tone of the animal. Features are more carefully filled in. The turn of the head away from the body and the horns are more darkly accented. The switch of the tail is shown with its long, tangled hair. I lightly indicate the protruding vein in the udder. Darks are placed in the eye, nostril, and the stifle fold at the juncture of the leg and the torso.

STEP 3. *(ABOVE)*
The headstall adds a dark accent to the drawing. I show the animal's color changes with darker and lighter accents. The coat is drawn with small light strokes that run backwards on the torso and laterally on the legs. By using vertical lines, I show wrinkles in the neck. Intermingling long strokes are used for the switch of the tail. Veins and tendons are drawn in the hind legs. Dark accents mark some of the muscle and bone structures, which are not too evident in such a stout animal.

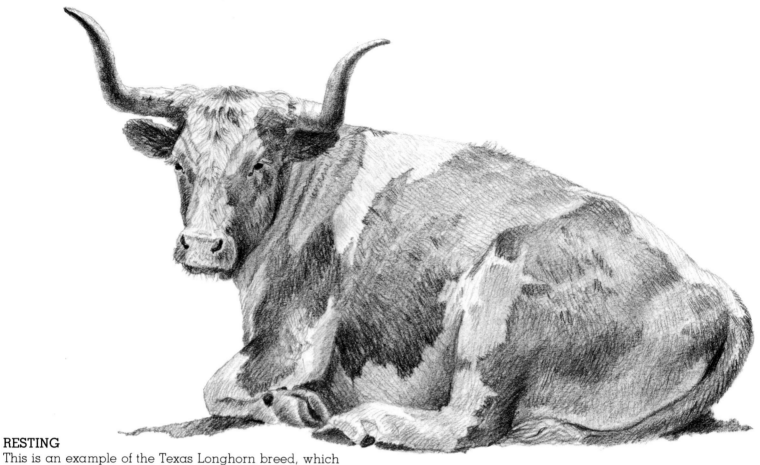

RESTING

This is an example of the Texas Longhorn breed, which descended from Andalusian stock brought to the Americas by the Spanish colonists. This vanishing breed of cattle has been supplanted by breeds that produce better beef. As **symbols** of the Old West, they still survive in rodeos, Wild West shows, and on scattered ranches.

RUNNING

This scene of steers running is taken from a rodeo. The movement of the muscle patterns in these powerful animals is vividly apparent here as they strain to propel the steers forward. I part the hoofs in the steer on the extreme left to promote the feeling of tension and excitement.

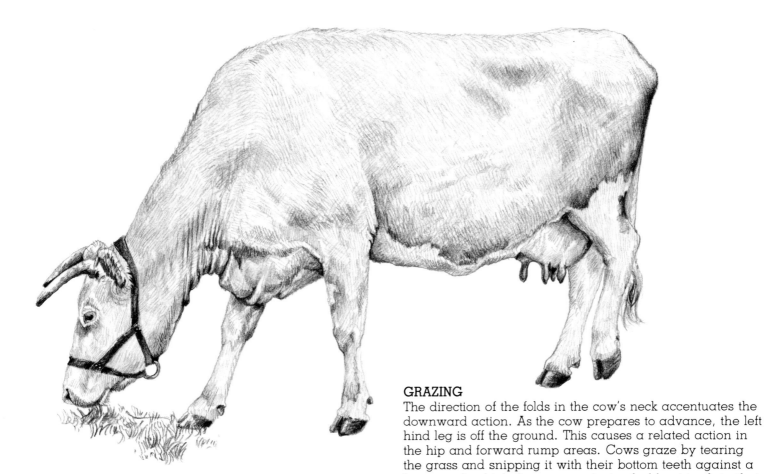

GRAZING

The direction of the folds in the cow's neck accentuates the downward action. As the cow prepares to advance, the left hind leg is off the ground. This causes a related action in the hip and forward rump areas. Cows graze by tearing the grass and snipping it with their bottom teeth against a horny pad, which they possess instead of front teeth in their upper jaws. When chewing, they sway their heads to the side to set their grinding teeth in motion.

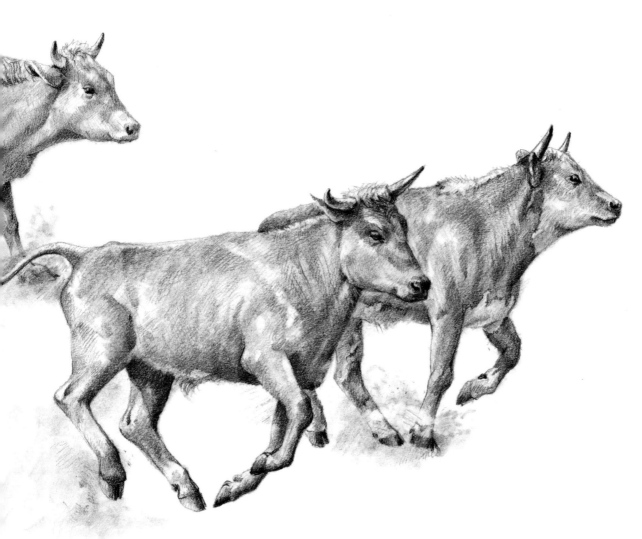

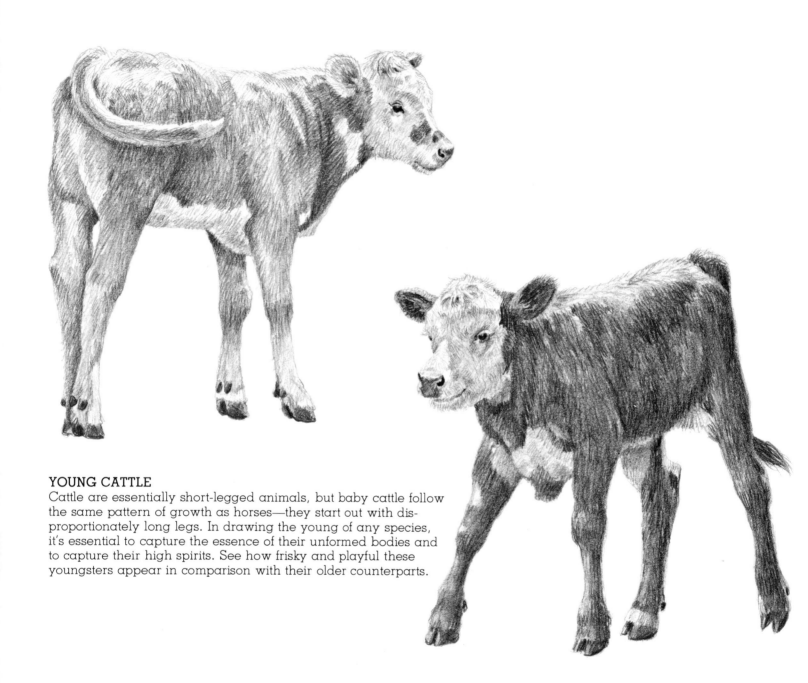

YOUNG CATTLE
Cattle are essentially short-legged animals, but baby cattle follow the same pattern of growth as horses—they start out with disproportionately long legs. In drawing the young of any species, it's essential to capture the essence of their unformed bodies and to capture their high spirits. See how frisky and playful these youngsters appear in comparison with their older counterparts.

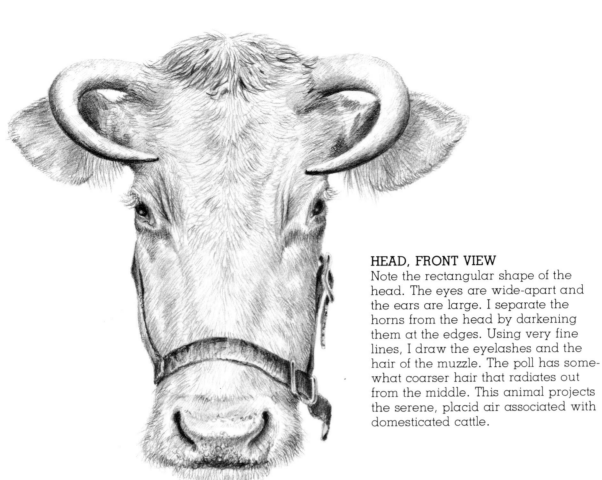

HEAD, FRONT VIEW

Note the rectangular shape of the head. The eyes are wide-apart and the ears are large. I separate the horns from the head by darkening them at the edges. Using very fine lines, I draw the eyelashes and the hair of the muzzle. The poll has somewhat coarser hair that radiates out from the middle. This animal projects the serene, placid air associated with domesticated cattle.

HEAD, THREE-QUARTER VIEW

In this drawing, the variety of hair textures is most evident. I use many small, thin strokes to depict the generally short, glossy quality of the animal's coat. The pupil fills the entire eye and I draw the eyelashes as negative shapes against it, i.e. I use the white of the paper as the shape and value. The edge of the ears is feathered with many delicate strokes. The smooth nose is somewhat mottled. At the base of the ear the long hair conceals the dark area of the ear canal. The texture of the smooth horns is accentuated by their rather dark contours and rubbed halftones.

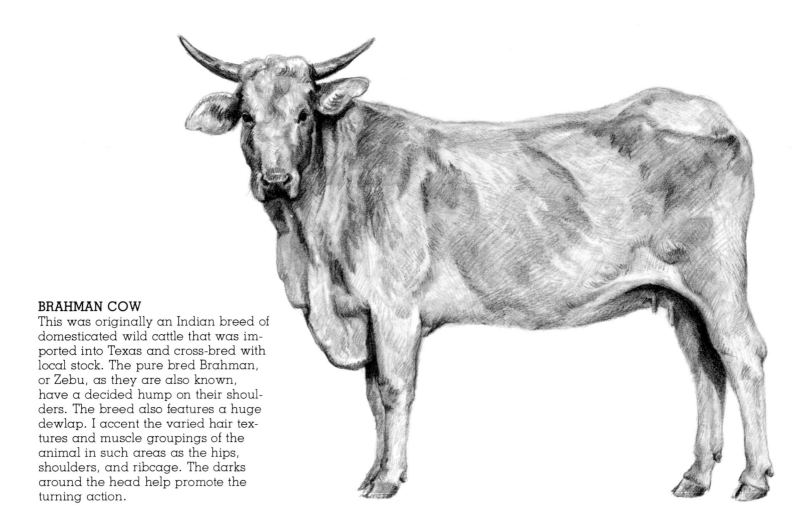

BRAHMAN COW

This was originally an Indian breed of domesticated wild cattle that was imported into Texas and cross-bred with local stock. The pure bred Brahman, or Zebu, as they are also known, have a decided hump on their shoulders. The breed also features a huge dewlap. I accent the varied hair textures and muscle groupings of the animal in such areas as the hips, shoulders, and ribcage. The darks around the head help promote the turning action.

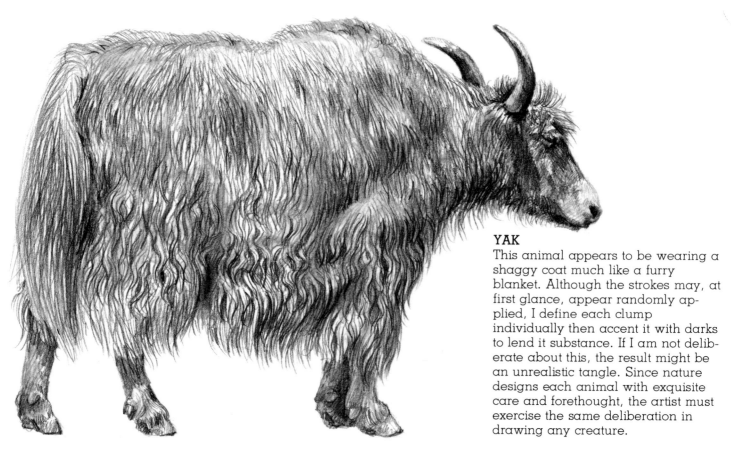

YAK

This animal appears to be wearing a shaggy coat much like a furry blanket. Although the strokes may, at first glance, appear randomly applied, I define each clump individually then accent it with darks to lend it substance. If I am not deliberate about this, the result might be an unrealistic tangle. Since nature designs each animal with exquisite care and forethought, the artist must exercise the same deliberation in drawing any creature.

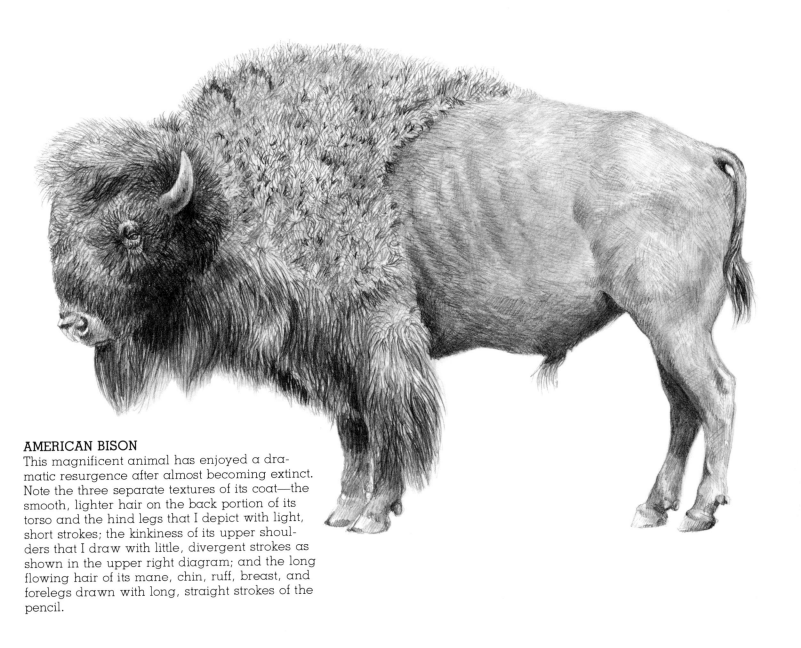

AMERICAN BISON

This magnificent animal has enjoyed a dramatic resurgence after almost becoming extinct. Note the three separate textures of its coat—the smooth, lighter hair on the back portion of its torso and the hind legs that I depict with light, short strokes; the kinkiness of its upper shoulders that I draw with little, divergent strokes as shown in the upper right diagram; and the long flowing hair of its mane, chin, ruff, breast, and forelegs drawn with long, straight strokes of the pencil.

CAPE BUFFALO

This native of Africa is considered by many hunters to be the most dangerous of wild animals when aroused. A huge, powerful beast, the Cape appears menacing even when resting. Its mane and beard contrast with the short smooth texture of its body. The wrinkles on its neck bring to mind a coiled spring—immense strength poised for instant action. The horns, which may reach a total spread of six feet, are joined in a boss at the forehead (on bison, yak, cow, etc. the horns come from the side of the head).

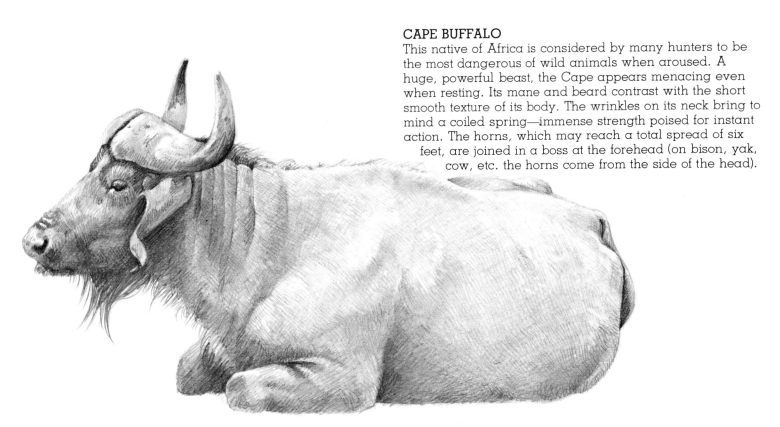

DEER

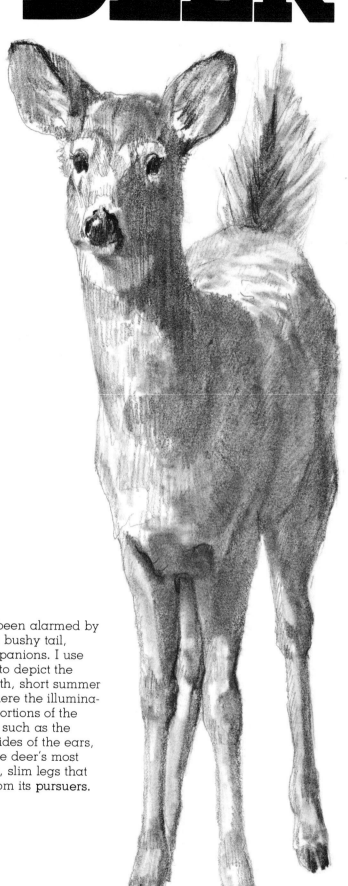

FRONT VIEW

In this drawing, the doe had been alarmed by something and has raised her bushy tail, called a flag, to alert her companions. I use the French stump extensively to depict the shaded side of the doe's smooth, short summer coat. I left lighter areas for where the illumination strikes the form, and for portions of the animal that are white in color such as the rings around the eyes, the insides of the ears, the throat, and the muzzle. The deer's most conspicuous feature is its long, slim legs that allow it to run at fast speed from its pursuers.

Deer are even-toed ungulates and ruminants, or cud chewers. Male deer, or bucks, grow antlers that are covered by a skin called velvet, which is ultimately shed to reveal the bare bone. This coincides with the time of rut (mating season) and the bucks engage in fights prior to selecting a doe for breeding. With the coming of winter, deer shed their summer coats and grow denser, less colorful winter coats. At this time, the buck loses his antlers but soon after, begins growing new ones.

I chose the white-tailed deer as my chief model for this chapter. It is one of the most common and familiar species of deer and often lives very close to centers of human habitation. The underside of its tail is white and when the animal runs, it holds its tail aloft, accounting for its name.

Does are smaller than bucks, and fawns exhibit white spots until the fifth month of their lives. An adult white-tailed buck is up to 40 inches tall at the withers and may weigh up to 300 pounds.

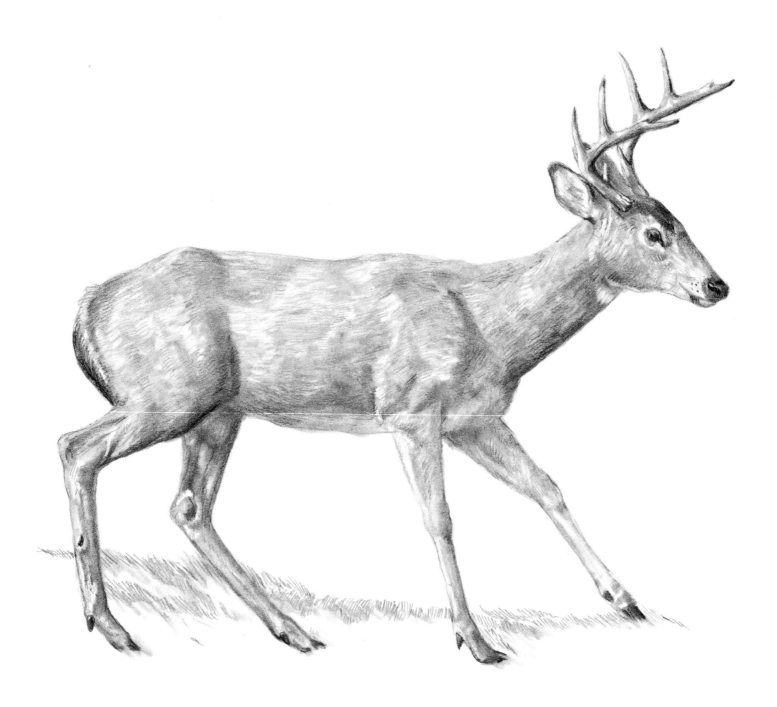

SIDE VIEW

The buck has a dark spot on the lower half of his right hind leg which is a gland that secretes a musky fluid. The antlers of white-tailed deer sweep upward, outward, and forward with all tines growing off a main beam. Its horns are smooth, since the skin or "velvet" has been shed and rubbed off. Usually, a buck does not grow antlers during his first year. In his second year he will develop spikes (straight, unbranched antlers), but diet can affect antler growth and development.

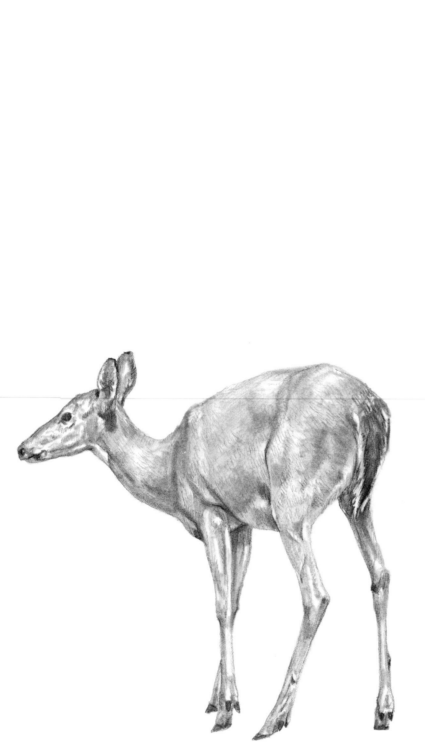

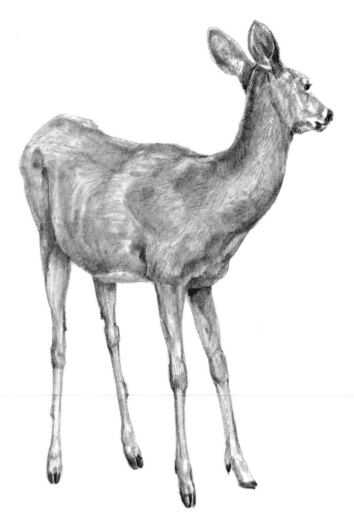

THREE-QUARTER VIEW

These does are shown in the close, glossy coats of their summer apparel; to do this I place short strokes and blend with the French stump. With the kneaded eraser I pick out lights. The white-tailed deer's tail is dark when it is kept in its normal, lowered position. Note the thin legs of these animals—they appear almost too fragile to support them. Indeed, deer suffer accidents to their limbs. On the other hand, they can inflict damage by kicking out with their sharp hoofs.

FORM SKETCHES

A deer's torso is sausage-shaped, and its neck is a tapered cylinder. The head is an oval that ends in a sharp point at the muzzle. Ears are ovals flattened at the base. The tail is a curving triangle. Deer tend to be knobby at the knees. Their shoulders are bean-shaped with the top parts projecting somewhat above the torso.

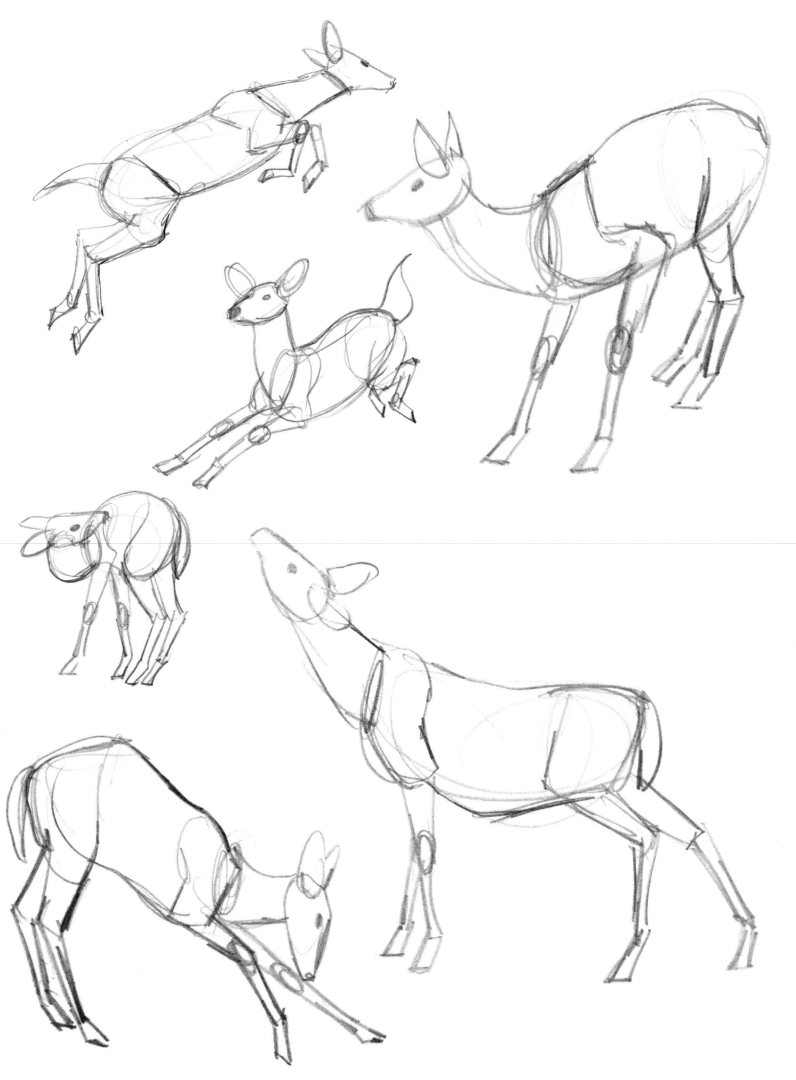

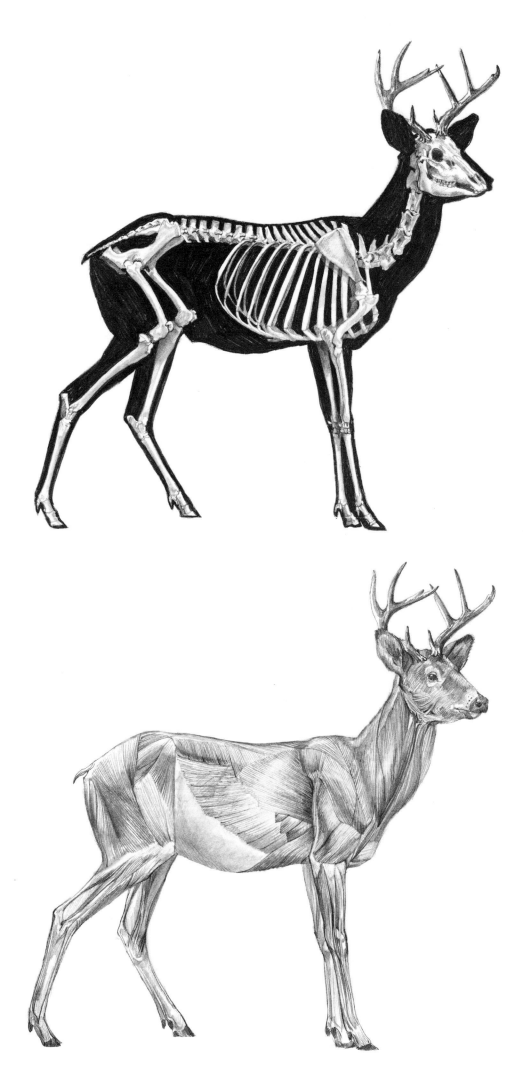

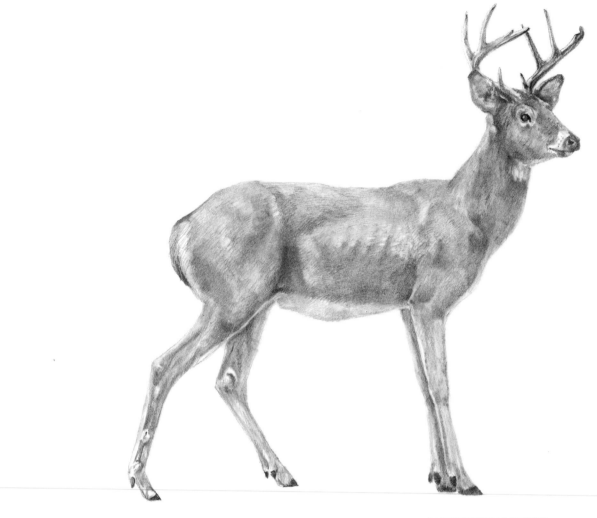

SKELETON (ABOVE LEFT)
The deer is lightly boned with long, very slender legs. Like the cow, it lacks upper front teeth; instead, the teeth have been replaced by a tough pad. The second and fifth toes, which correspond to a human's index and little finger, are in back and appear as rudimentary appendages, or dewclaws. A white-tailed deer's antlers are angled forward.

MUSCULATURE (LEFT)
The white-tailed deer is lightly muscled—built for speed. Because of the deer's essentially lean form and short coat, its muscle patterns are more apparent than those of stouter, denser-haired animals. When breeding time approaches in the late fall, the buck's neck swells appreciably. The mature buck relies largely upon his muscles to overcome his opponents in the annual contest for does, since his fighting method consists of pushing the other off balance.

SURFACE ANATOMY (ABOVE)
The white-tailed deer has short, smooth red or buff-colored hair in the summer, and long, thick gray to grayish-brown hair in the winter. As each season approaches, he molts his former coat, sometimes helping the process along by rubbing himself against bark or rocks. The scent gland on the buck's hind leg is well-defined. The ribs show through the skin. While the front legs are straight in the standing position, the hind legs are curved. Normally, the tail is kept flat against the body. Its rather long ears are continuously moving, always listening for unusual sounds.

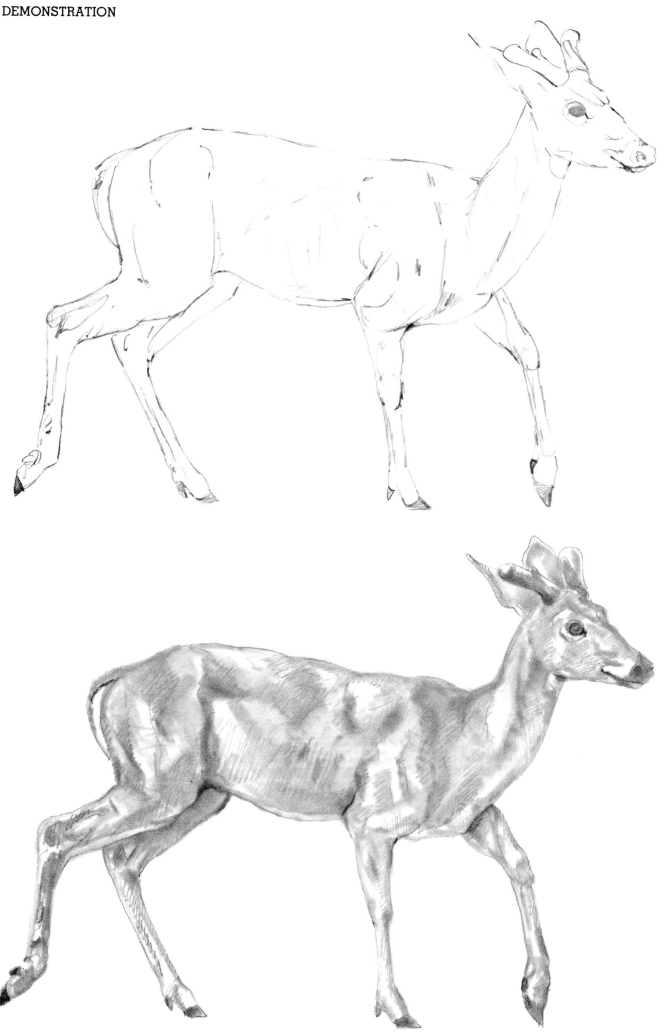

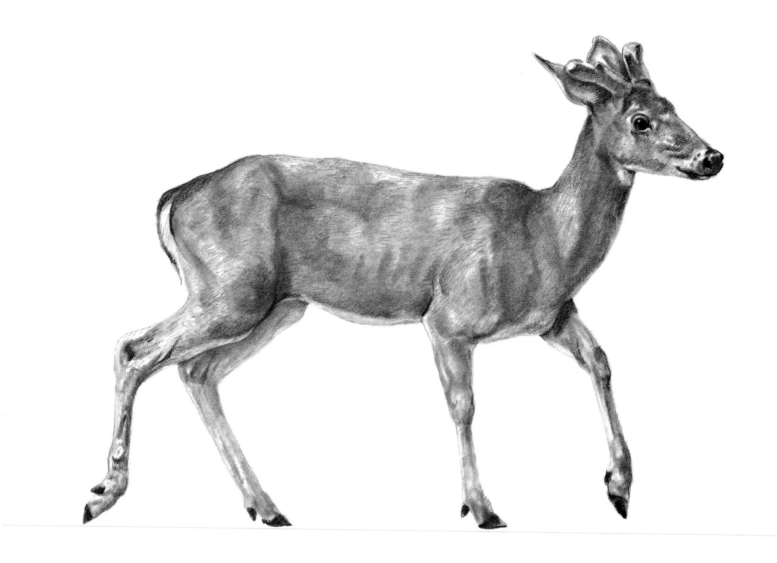

STEP 1. *(ABOVE LEFT)*
This buck in velvet strides along. I lay in the entire outline of the animal, then include such features as the horns, dewclaws, eyes, nostrils, and indentations marking the tendons and ligaments of the legs, the ribcage, the muscles of the chest and rump, and several color demarcations. The deer is a lean animal, and I want to show the considerable muscle and bone patterns that would be visible beneath its skin.

STEP 2. *(LEFT)*
Now I proceed to tone all the value patterns, laying in the darks and stumping vigorously to attain the soft, velvety texture of the hair. At this stage, I leave the light areas alone so that they are represented by blank paper or by blank paper lightly toned. I refine areas such as the eye, the hoofs, the antlers, the nostrils, and the nose.

STEP 3. *(ABOVE)*
Now I darken and blend the entire animal, making sure the lighter and darker areas are more closely related and harmonized. In selected places I add darker accents such as on the tail, ears, and antlers and on the inner contour of areas where two parts of the body come together and need to be visually separated. Generally, the outer contours of the buck are left somewhat smudged and soft. Light pencil strokes are applied in the neck and the arm areas to suggest the texture of the hair. Compare this overall technique with the drawing on page 79—they represent a totally different approach to drawing fur-bearing animals.

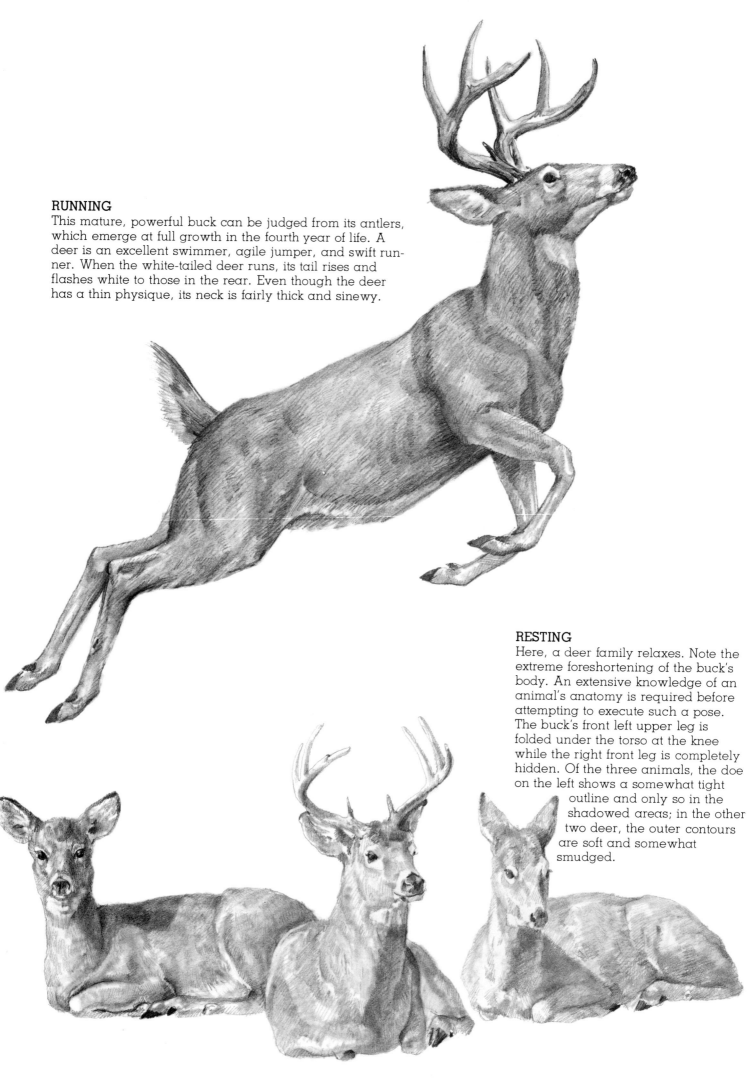

RUNNING

This mature, powerful buck can be judged from its antlers, which emerge at full growth in the fourth year of life. A deer is an excellent swimmer, agile jumper, and swift runner. When the white-tailed deer runs, its tail rises and flashes white to those in the rear. Even though the deer has a thin physique, its neck is fairly thick and sinewy.

RESTING

Here, a deer family relaxes. Note the extreme foreshortening of the buck's body. An extensive knowledge of an animal's anatomy is required before attempting to execute such a pose. The buck's front left upper leg is folded under the torso at the knee while the right front leg is completely hidden. Of the three animals, the doe on the left shows a somewhat tight outline and only so in the shadowed areas; in the other two deer, the outer contours are soft and somewhat smudged.

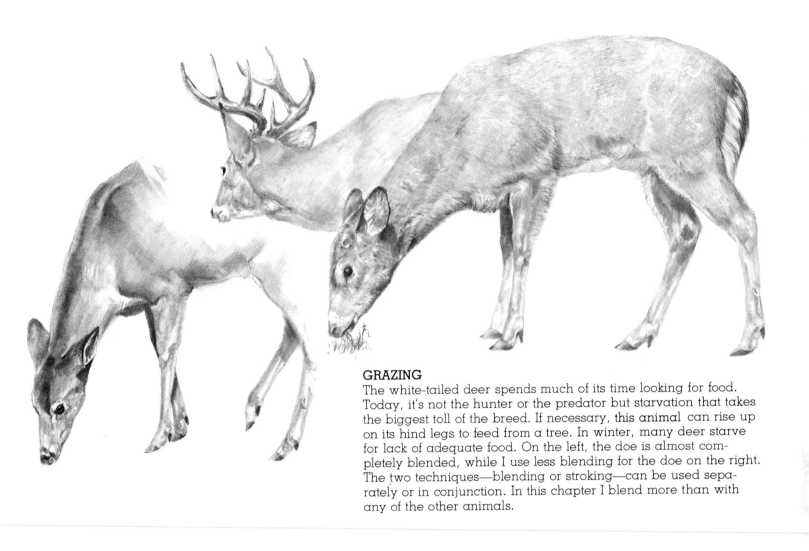

GRAZING

The white-tailed deer spends much of its time looking for food. Today, it's not the hunter or the predator but starvation that takes the biggest toll of the breed. If necessary, this animal can rise up on its hind legs to feed from a tree. In winter, many deer starve for lack of adequate food. On the left, the doe is almost completely blended, while I use less blending for the doe on the right. The two techniques—blending or stroking—can be used separately or in conjunction. In this chapter I blend more than with any of the other animals.

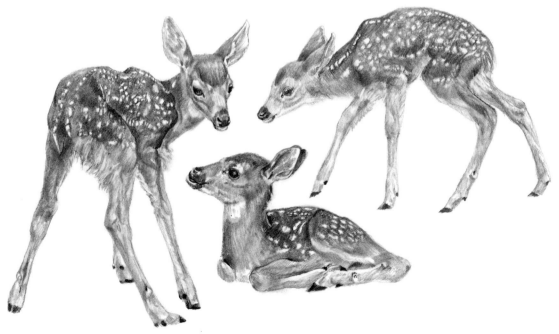

FAWNS

Fawns retain their white spots approximately five months. These spots serve as camouflage in the brush to protect the fawn when its mother leaves it to feed or attend to other business. Contrary to popular belief, a fawn left alone is not abandoned—the mother is usually close by. Fawns are leggy, appealing little creatures, but anyone who out of kindness removes them from the woods is doing the animals a terrible disservice, since they will be happier in their own environment. I use an eraser to pick the spots out on these fawns.

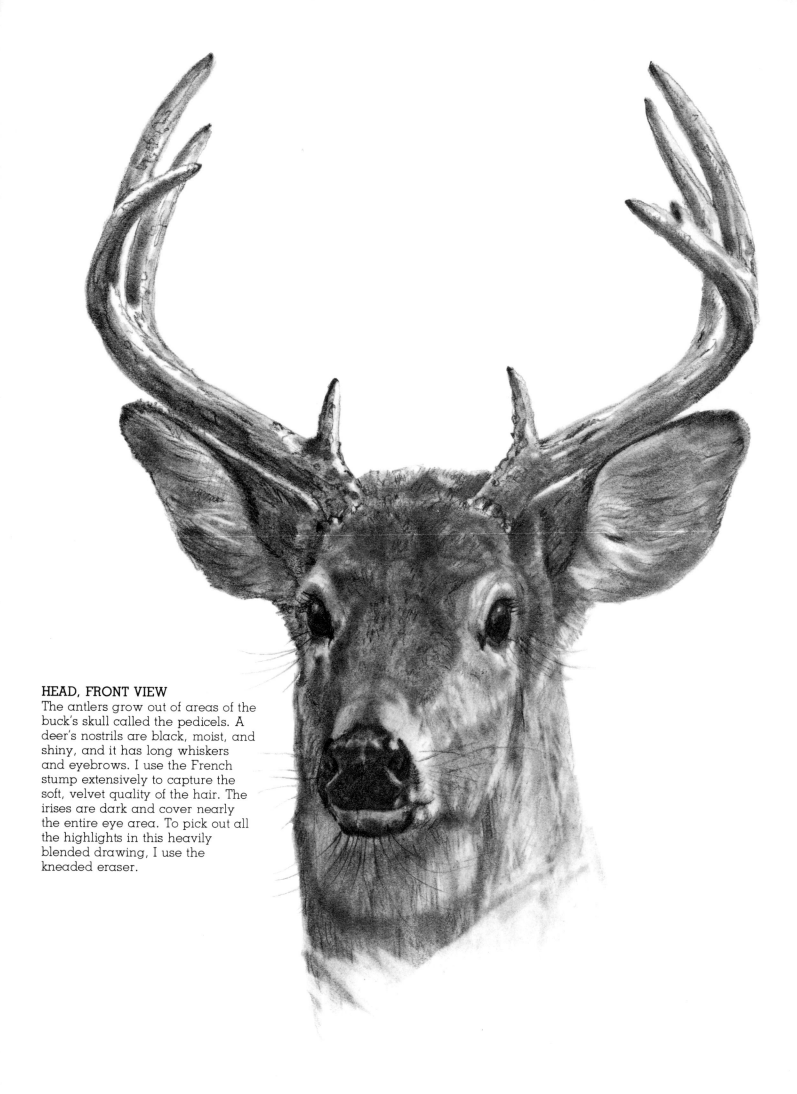

HEAD, FRONT VIEW

The antlers grow out of areas of the buck's skull called the pedicels. A deer's nostrils are black, moist, and shiny, and it has long whiskers and eyebrows. I use the French stump extensively to capture the soft, velvet quality of the hair. The irises are dark and cover nearly the entire eye area. To pick out all the highlights in this heavily blended drawing, I use the kneaded eraser.

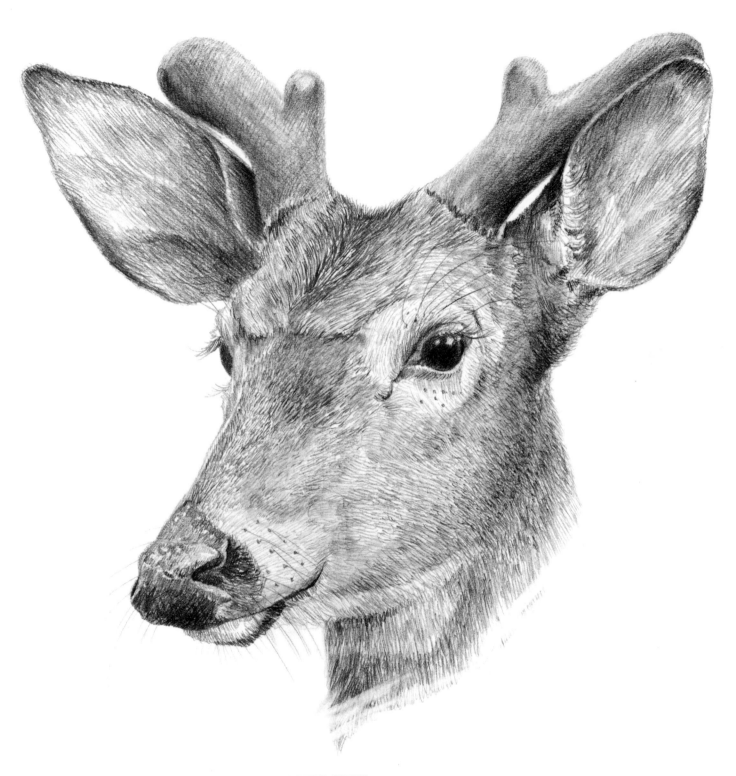

HEAD, THREE-QUARTER VIEW

In contrast with the drawing on page 78, I only use stroking here, but I blend with the French stump on the velvety antlers. To depict the hair tracks on the animal's head and upper neck, I use short strokes of various pressures. I show the long eyelashes and the roots from which the whiskers and eyebrows grow. I include the white spots on the muzzle. On the forehead I draw the division of hair that quite abruptly changes directions and assumes a different character from the hair on the nose. Knowledge of such minute detail can only be acquired by close and thorough study.

AMERICAN ELK

This magnificent animal is one of the most powerful members of the deer family. Bulls weigh as much as 1,000 pounds and stand over five feet tall at the shoulders. The bull has a shaggy mane and a rack of antlers sometimes over five feet. The cow is hornless and somewhat smaller. To draw this couple, I use the stroking method pressing down heavily in such areas as the mane and the underbelly. Essentially, the elk's shape differs only minimally from the white-tail, being heavier boned and muscled; the elk has been known to leap to a height of ten feet.

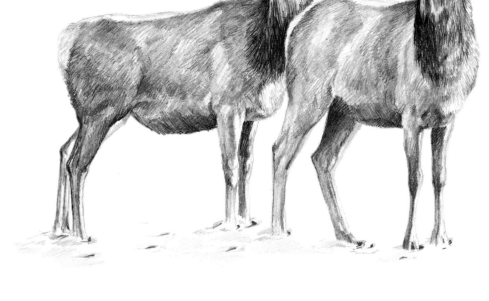

MOOSE

The moose is the largest of the American deer—a bull can weigh more than 1400 pounds. Its horns are broad and heavy, backs are humped, and muzzles long and pendulous. The bull also has a "bell" or pouch of skin and hair dangling from its throat. I use lots of dark accents all around the bull's body, blend them with a stump, then with the pencil, I add dark strokes into the blended areas. With a kneaded eraser, I pick out the highlights. The antlers of the bull moose are enormously long and heavy; a spread of six-and-a-half feet has been recorded.

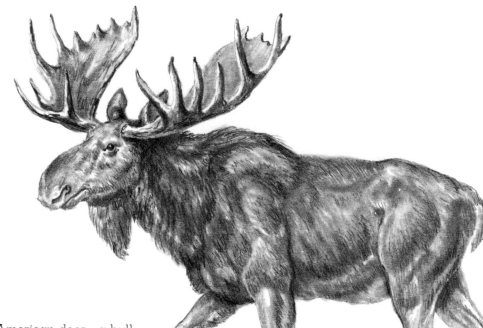

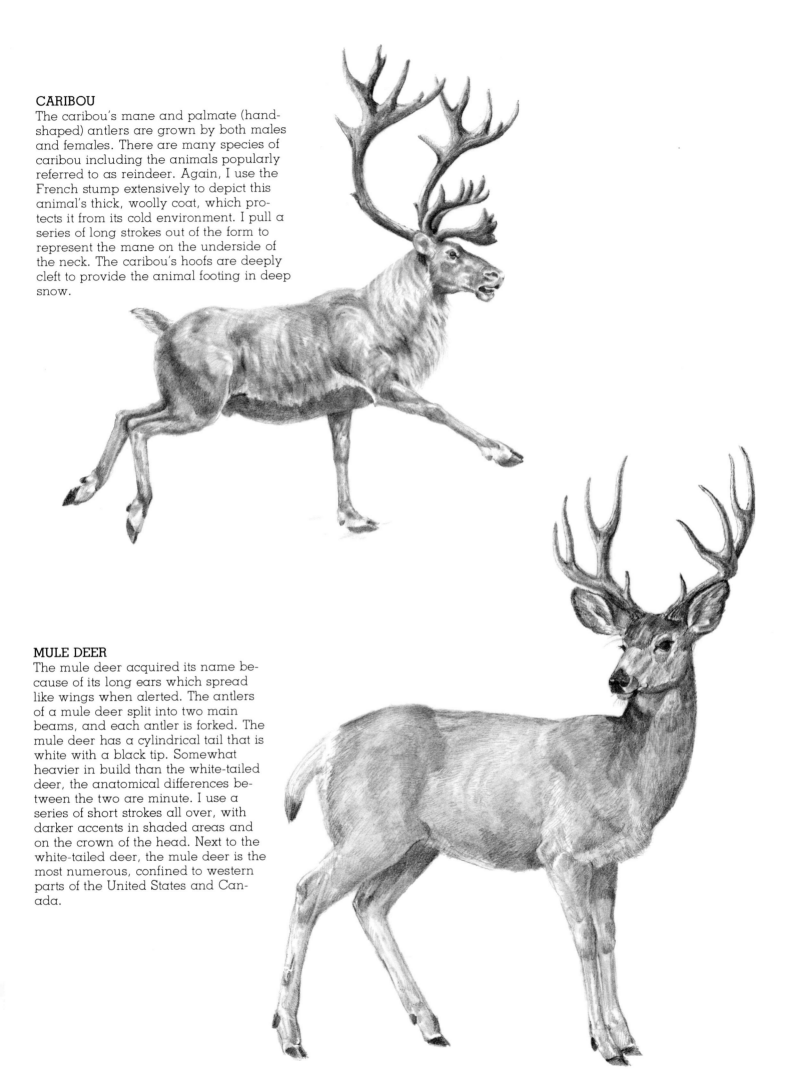

CARIBOU

The caribou's mane and palmate (hand-shaped) antlers are grown by both males and females. There are many species of caribou including the animals popularly referred to as reindeer. Again, I use the French stump extensively to depict this animal's thick, woolly coat, which protects it from its cold environment. I pull a series of long strokes out of the form to represent the mane on the underside of the neck. The caribou's hoofs are deeply cleft to provide the animal footing in deep snow.

MULE DEER

The mule deer acquired its name because of its long ears which spread like wings when alerted. The antlers of a mule deer split into two main beams, and each antler is forked. The mule deer has a cylindrical tail that is white with a black tip. Somewhat heavier in build than the white-tailed deer, the anatomical differences between the two are minute. I use a series of short strokes all over, with darker accents in shaded areas and on the crown of the head. Next to the white-tailed deer, the mule deer is the most numerous, confined to western parts of the United States and Canada.

SHEEP

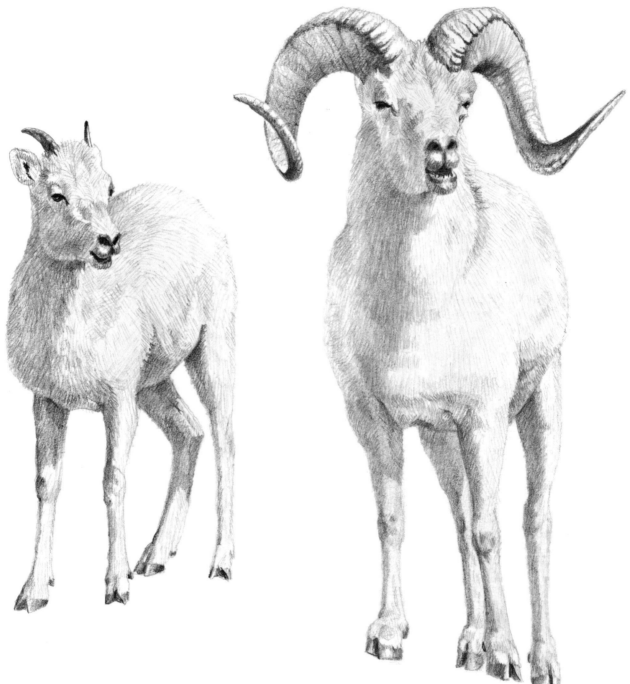

FRONT VIEW

Between male and female Dall sheep, there is quite a disparity in size. In this drawing of a ram and ewe, the ewe's modest horns are an obvious difference. The ram uses his massive horns to defend his harem of perhaps 50 ewes. Dalls are white except for some brownish hairs on the back or in the tails, and their horns are amber-colored. The only real dark accents on these animals are their eyes, hoofs, and nostrils. I leave lots of blank or nearly blank paper, and light, widely interspersed strokes to capture this high-key effect.

Sheep belong to the same family as cattle, deer, goats, antelopes, gazelles, etc. They are all bovids, part of the order known as even-toed ungulates. Bovids have permanent un-forked horns, long skulls, and no upper front teeth but a horny pad against which the lower incisors shear off the vegetation they have torn away.

The Dall sheep, which I use to illustrate this chapter, is a native of the mountains of Alaska and northern Canada. The Dall is related to the legendary bighorn which it closely resembles, though the Dall is smaller and has lighter skin color. It is white-colored and remains so the year round, and it stands up to three-and-a-half feet at the shoulders and weighs up to 200 pounds. Other wild sheep native to North America include the Stone, the Desert Bighorn, and the Rocky Mountain Bighorn. A sheep's age can be estimated by the number of rings encircling its horns. The ram's horns are curved and massive; the ewe's are short and spiky. In time of rut, rams conduct fierce butting duels as they fight for control of mates. Dalls, like other mountain sheep, are superb climbers. Only mountain goats share their ability to maintain balance on the most precarious peaks and ledges.

SIDE VIEW

In this drawing of a ram and young sheep, the variations within the Dall's coat are much more evident. In an all-white animal, these variations are only those of value and of hair texture, not of color. To show them, I merely change the direction of the hair tracks and folds of skin created by an action or by some depression or protuberance in the animal's form, such as the indentation in the ram's hind legs next to the stifles (knees).

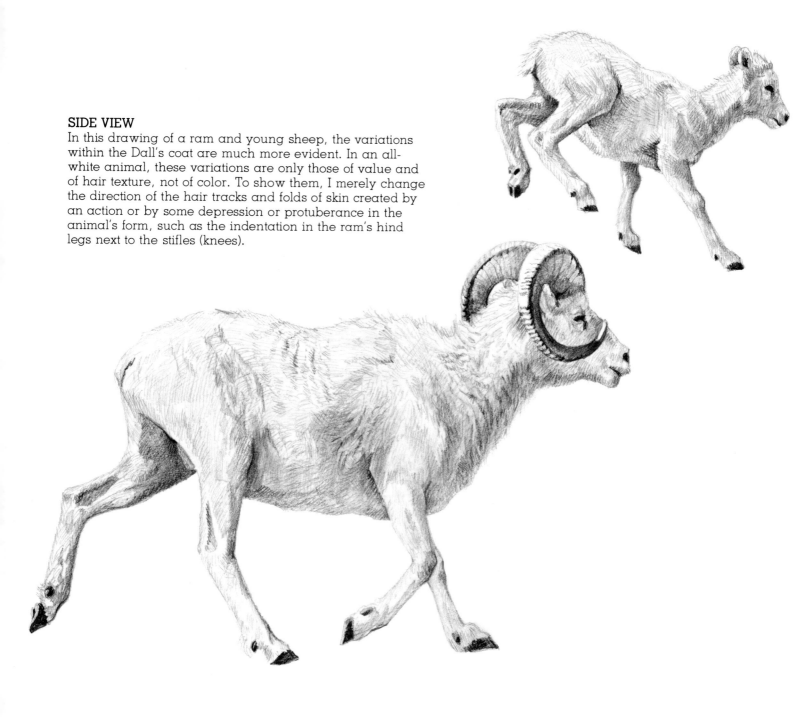

84

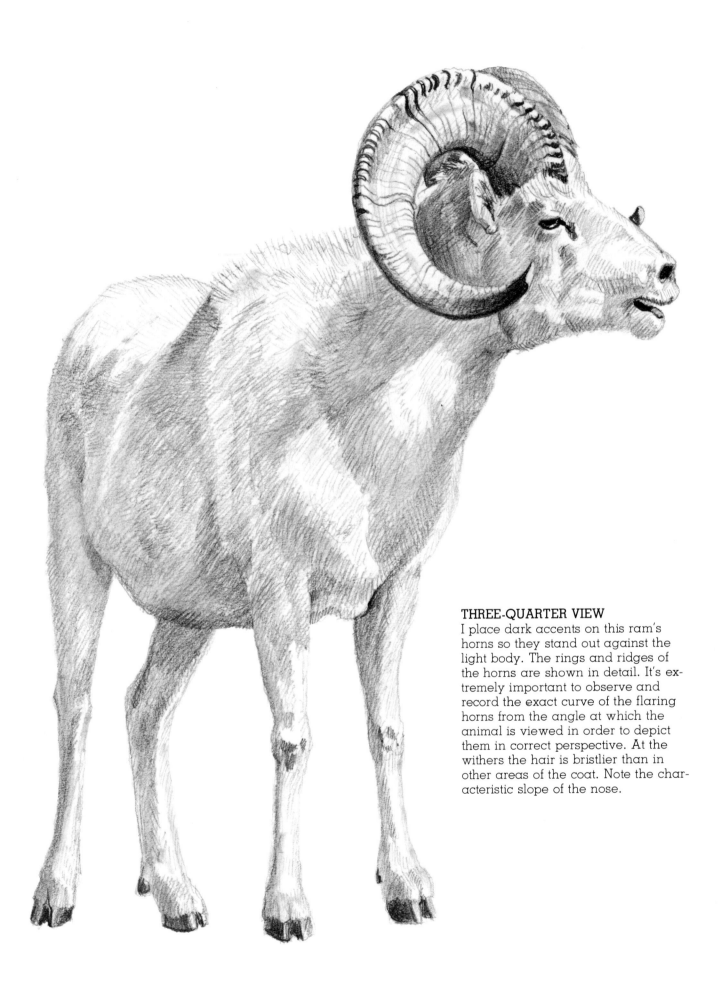

THREE-QUARTER VIEW
I place dark accents on this ram's horns so they stand out against the light body. The rings and ridges of the horns are shown in detail. It's extremely important to observe and record the exact curve of the flaring horns from the angle at which the animal is viewed in order to depict them in correct perspective. At the withers the hair is bristlier than in other areas of the coat. Note the characteristic slope of the nose.

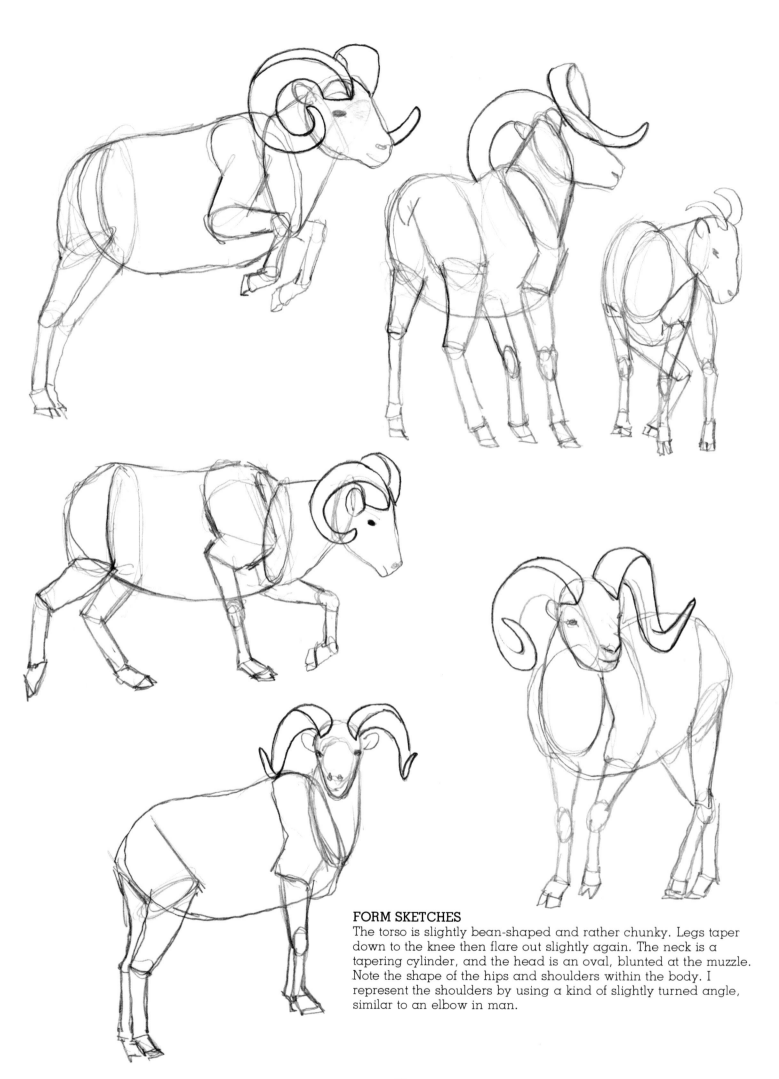

FORM SKETCHES

The torso is slightly bean-shaped and rather chunky. Legs taper down to the knee then flare out slightly again. The neck is a tapering cylinder, and the head is an oval, blunted at the muzzle. Note the shape of the hips and shoulders within the body. I represent the shoulders by using a kind of slightly turned angle, similar to an elbow in man.

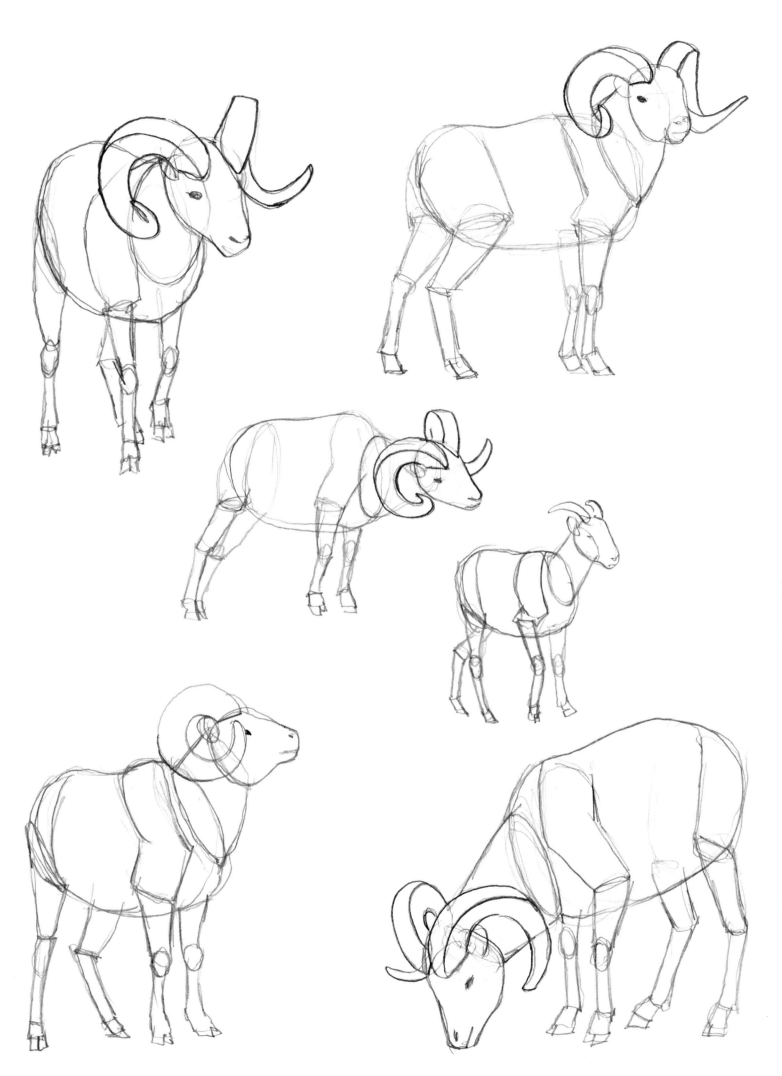

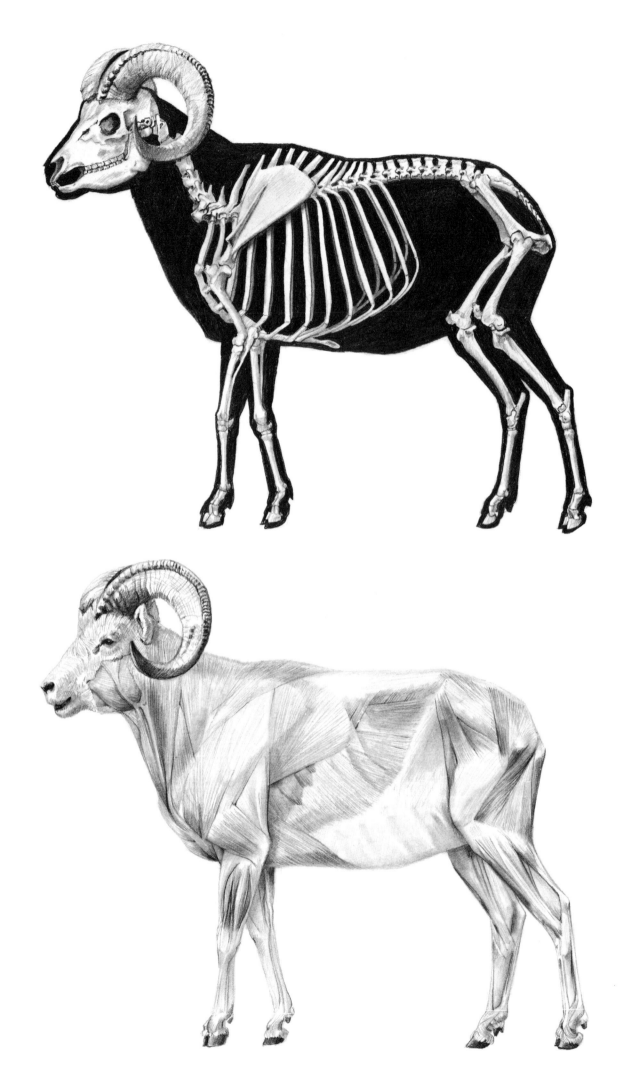

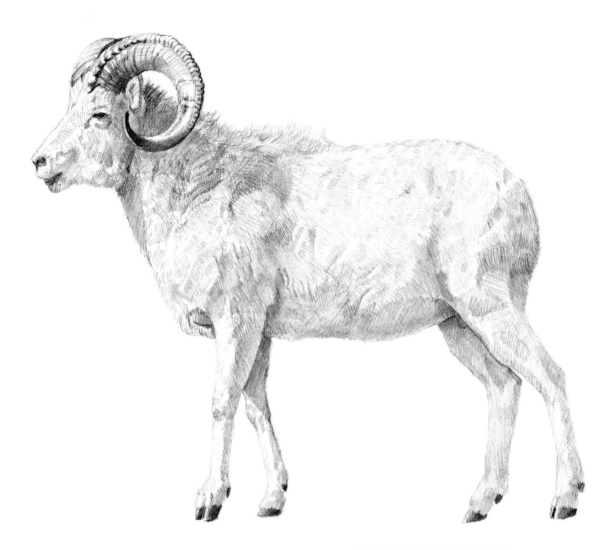

SKELETON (ABOVE LEFT)
The Dall is not unlike a miniature ox in skeletal structure. It is a rugged, powerfully boned animal with a body designed for climbing, leaping, and maintaining perfect balance on seemingly inadequate perches. A Dall uses its legs to uncover food buried under deep snow. There is a wide gap between their front and back teeth in their lower jaws.

SURFACE ANATOMY (ABOVE)
On the Dall's trunk, hair runs in several directions at once in areas such as the withers, the girth, the throat, the brisket, and the rump. A Dall's hair isn't long but apparently it's thick enough to protect it from the arctic blasts under which it flourishes. Its tail is very short. The eyes are yellow or gold colored.

MUSCULATURE (LEFT)
Dalls spend all, or nearly all, their time in the mountains. They have perfect coordination and eyesight, and enormous muscular strength, along with a remarkable endurance that allows them to survive in the most primitive and harsh environment.

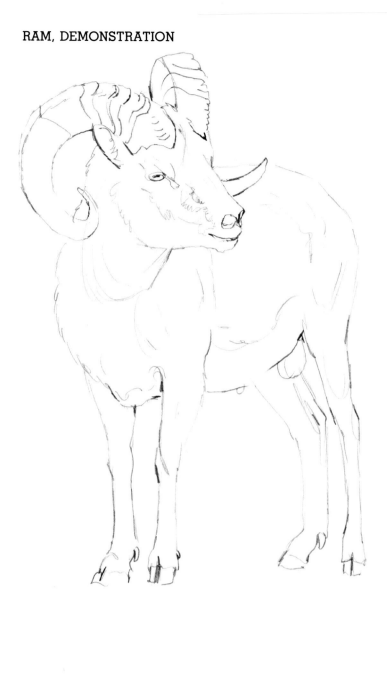

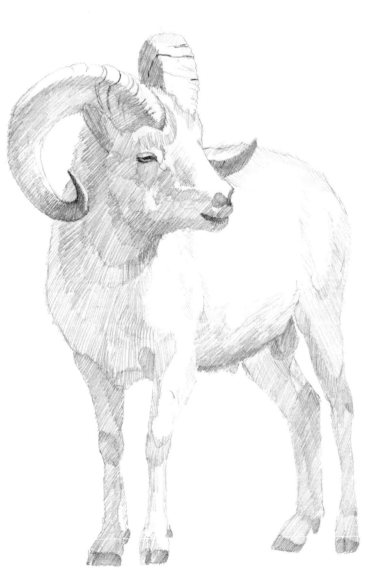

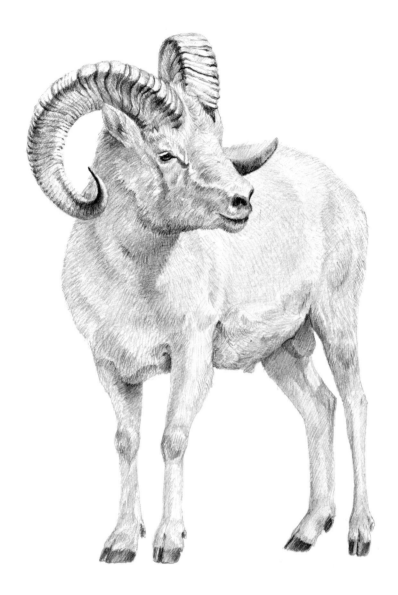

STEP 1. *(ABOVE LEFT)*
Anxious to draw attention to the ram's magnificent horn configuration, I catch him in a pose that accentuates the horns' curl and sweep. Having drawn the animal's complete outline, I define his eyes, nostrils, mouth, hoofs, and arc of the neck. I place the contour lines of the spine lightly since they ultimately will be feathered. Marks are placed to spot areas where the form either indents or projects.

STEP 2. *(LEFT)*
The angle of illumination is such that the sides of the horns and the front of the sheep are in shadow. With light strokes—never forgetting that this will emerge a high-key drawing—I place all the darks in the form. I reserve my darkest darks for the hoofs, nostrils, mouth, and the tips of the horns. Note how the strokes flow downward from the head into the arms. All the light areas on the animal are left blank for the moment.

STEP 3. *(ABOVE)*
I indicate the growth rings on the horns. Softly, I shade in all the light areas. To capture the feel of the hair, I shorten up on my strokes. On the belly, I show the hair tracks varying their direction somewhat. The texture there is a bit rougher than that above it. On the legs the strokes are a mixture of vertical and lateral. All the darks are strengthened and redefined. The animal's hoofs have straight edges and are cleanly divided. They are important to the drawing because they are largely responsible for keeping the Dall alive in his precarious environment. The darks of the horn tips help set them apart from the white coat.

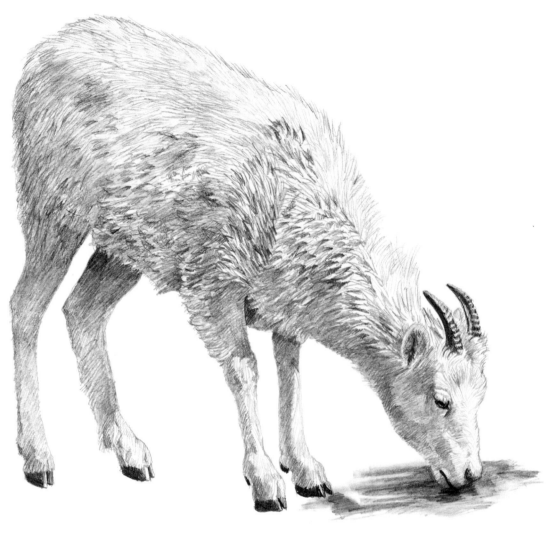

GRAZING *(LEFT)*

The Dall ewe is much smaller and slighter than her male counterpart. With her straight little horns, she resembles the domestic goat. To depict the rough, spiky quality of her coat, I use a lot of short, choppy strokes. Note the differences of direction of the hair, a factor caused partially by the stooping action. The horns are as dark as the ram's and contain similar rings and ridges.

BUTTING *(BELOW)*

These two-year-old rams are practicing up for the time when they will reach maturity and must challenge some old ram for mastery of his harem. Note the differences in the coats of the two animals. I bear down on the pencil and use choppy strokes for the ram on the left. For the smoother-coated animal, I shade lightly, in some areas barely touching pencil to paper.

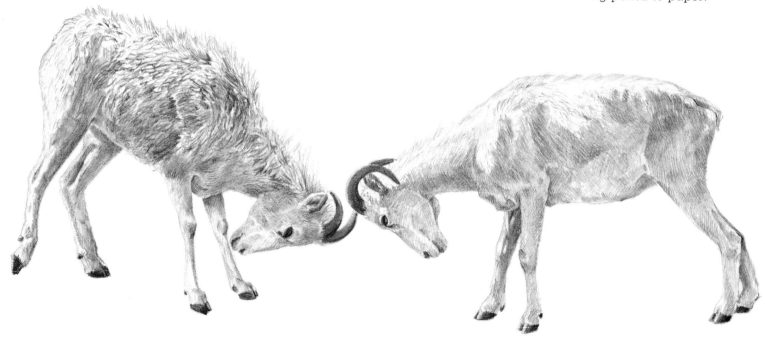

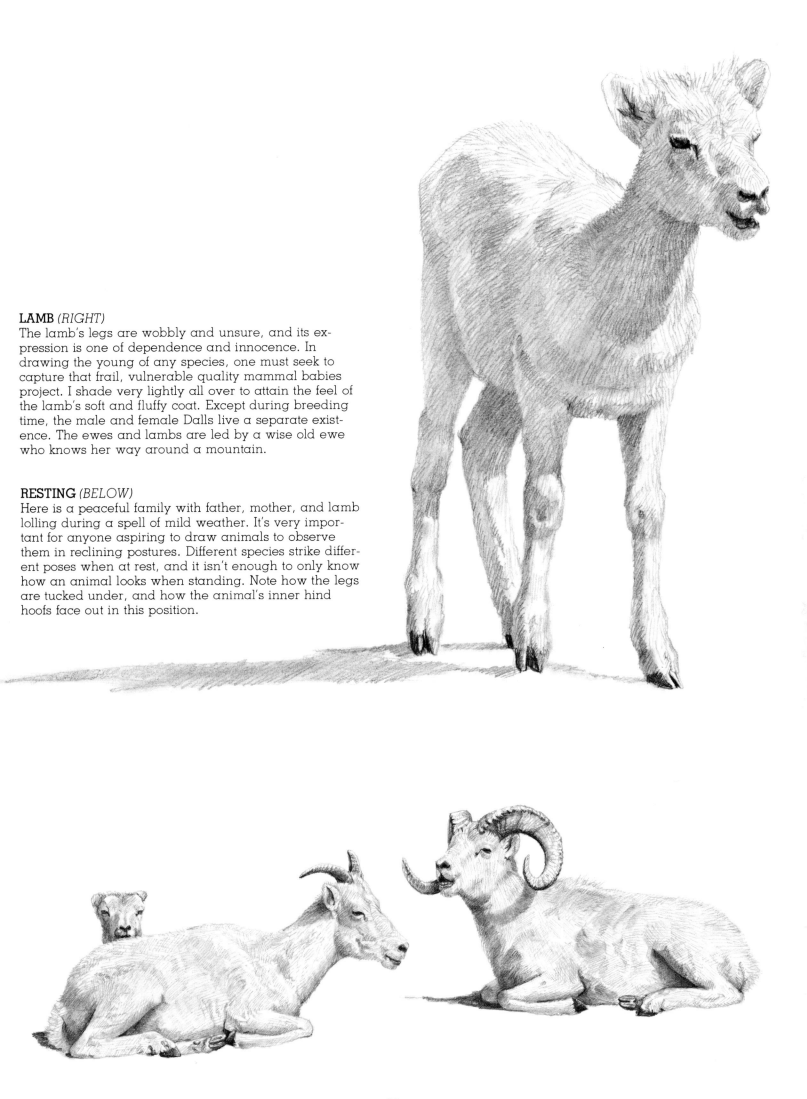

LAMB (RIGHT)

The lamb's legs are wobbly and unsure, and its expression is one of dependence and innocence. In drawing the young of any species, one must seek to capture that frail, vulnerable quality mammal babies project. I shade very lightly all over to attain the feel of the lamb's soft and fluffy coat. Except during breeding time, the male and female Dalls live a separate existence. The ewes and lambs are led by a wise old ewe who knows her way around a mountain.

RESTING (BELOW)

Here is a peaceful family with father, mother, and lamb lolling during a spell of mild weather. It's very important for anyone aspiring to draw animals to observe them in reclining postures. Different species strike different poses when at rest, and it isn't enough to only know how an animal looks when standing. Note how the legs are tucked under, and how the animal's inner hind hoofs face out in this position.

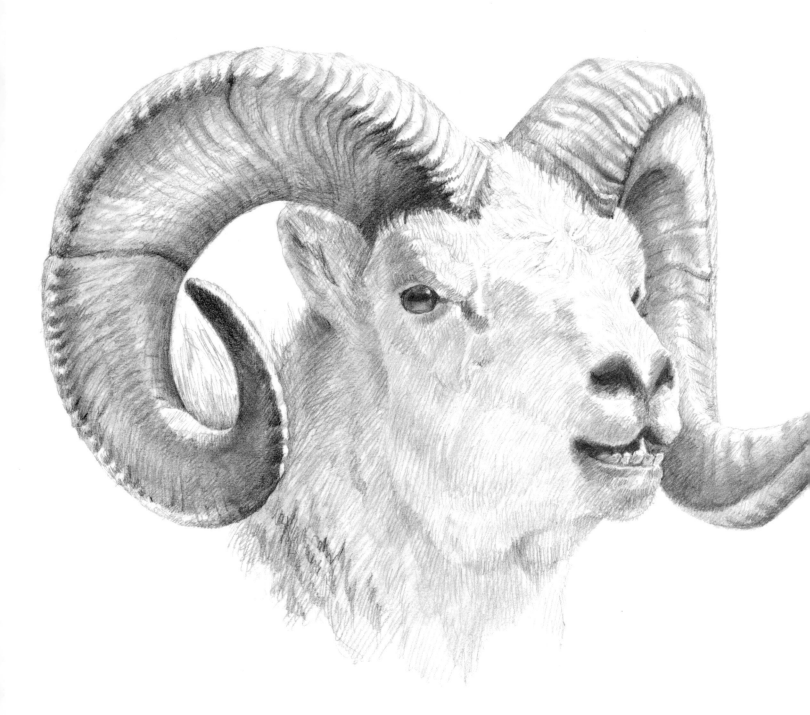

HEAD, THREE-QUARTER VIEW
Each year around December, the ram enters the period of rut and stops feeding. His horns also cease growing and a deep ring is formed on them that is deeper than the seasonal rings. In addition, the ram's neck swells.

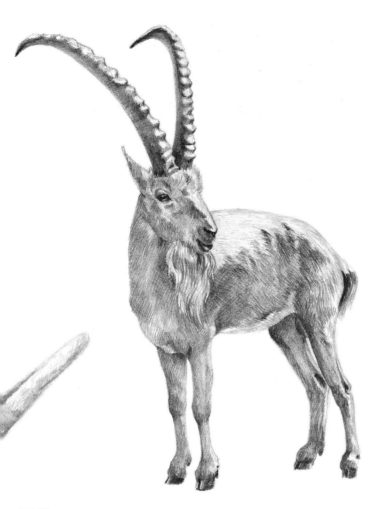

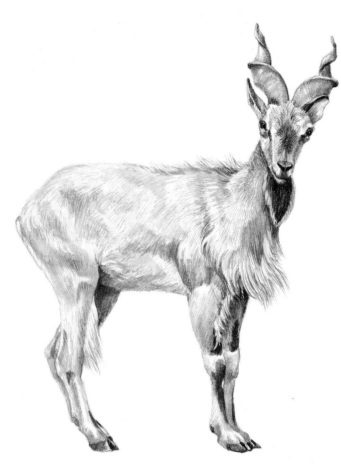

IBEX
The ibex is a wild goat that has a beard and long, curved horns, which I emphasize in the drawing. There are several species of ibexes. I use short strokes and the French stump to keep the body relatively simple; and long, flowing strokes for the beard. To run a uniform dark tone on the shadowed side of the horns, I use the French stump. Then I draw in the sharp accents of the ridges in strong contrasts of lights and darks.

MARKHOR
I draw this young markhor with a pixyish, quizzical expression. The adult markhor has spiraling horns that may reach nearly five feet. Both sexes have beards, but those of the male are longer and more luxuriant. Note the distinct black markings on the front legs. Because of the magnificent horns, markhors are close to extinction except in remote areas of the Himalaya mountains. The beard is black with white edges. I draw the animal's fringe with long strokes going away from the body.

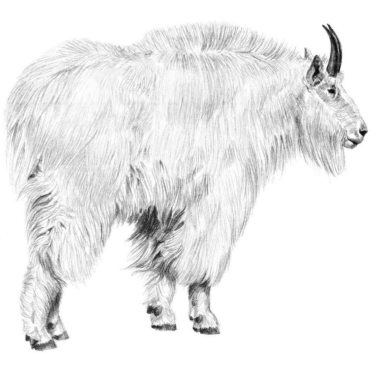

ROCKY MOUNTAIN GOAT
This hardy native of North America is a favorite of mine. Its dense shaggy coat keeps it warm in the frostiest weather. This animal can nearly walk up a perpendicular wall. With dark accents I separate his long-fringed body fur from the smoother face and lower legs. Note how the hair seems divided along the animal's spine. I reserve my darks for the horns, eyes, ears, mouth, and nostrils. In drawing a white animal such as this, use the blank paper as one of the tones of the coat. One example is the belly area where it meets the dark of the front right leg.

PRIMATES

FRONT VIEW
This is a front view of a mature chimp
seated, but in the process of rising.
This action is evident in the left arm
and the knuckle upon which the torso
is balanced, with the left arm serving
as the lever about to propel the body
upward. The chimp's right foot and
hand are also used to assist in the
maneuver. I darken the areas behind
the right palm and accentuate the
spaces between the fingers to make
the hand seem to come forward. The
body area has an overall gray tone
with the natural hair patterns super-
imposed in sweeping strokes that
follow the form. The facial hair is
shown in long, sweeping, unbroken
strokes that radiate out and away
from the face.

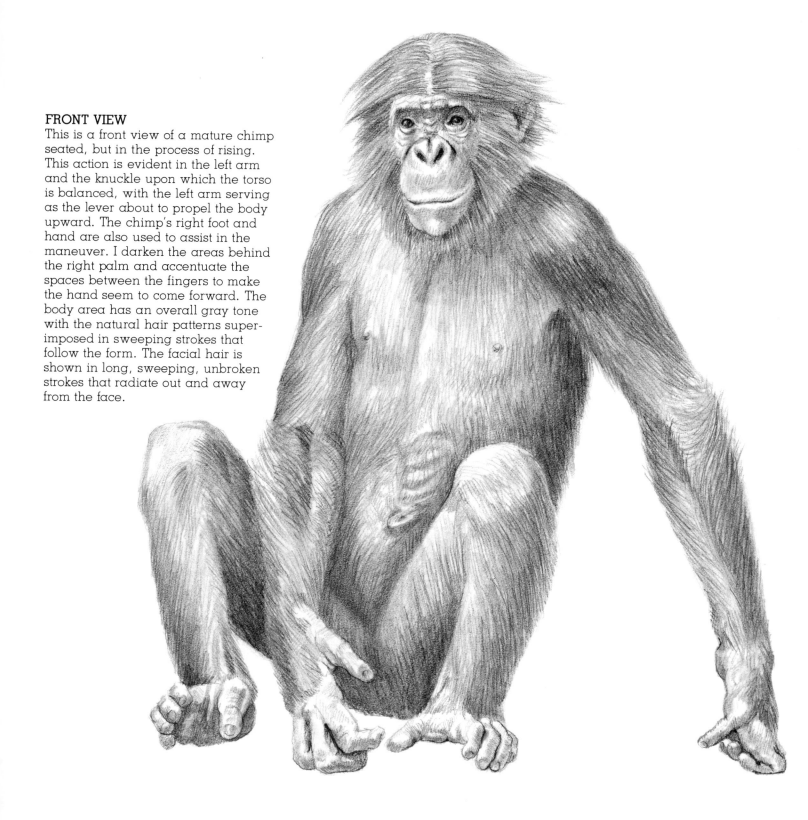

Primates include apes, monkeys, tarsiers, lemurs—and man. There are differences between primates. Apes have no tails; monkeys, tarsiers, and lemurs do. Apes are both arboreal and terrestrial; lemurs and tarsiers are strictly arboreal. Monkeys—with some exceptions—spend most of their lives in trees. Apes have flat faces, but lemurs and some of the monkeys have pointed, doglike snouts.

The shape of a primate is affected by its lifestyle. For example, if it lives in trees, it has hands and feet appended with fingers and toes equipped for climbing, gripping branches, and picking food. Apes have long, powerful arms, and shorter, weaker legs that are not adapted for standing erect on the ground or walking upright. When apes do come down out of the trees, they tend to move on all fours. Except for man, few primates are able to travel any distance on their legs alone.

Man has designated those primates which are most like him as the "highest" rung of the primate order. There are the great apes: the gorilla, the orangutan, and the playful chimpanzee. Since the chimp is so much like us, it is my chief model in this chapter. I have always found the chimp a joy to observe and a delight to draw in every conceivable pose and situation. In addition, I have included other primates to demonstrate the wide diversity of characteristics that mark the order.

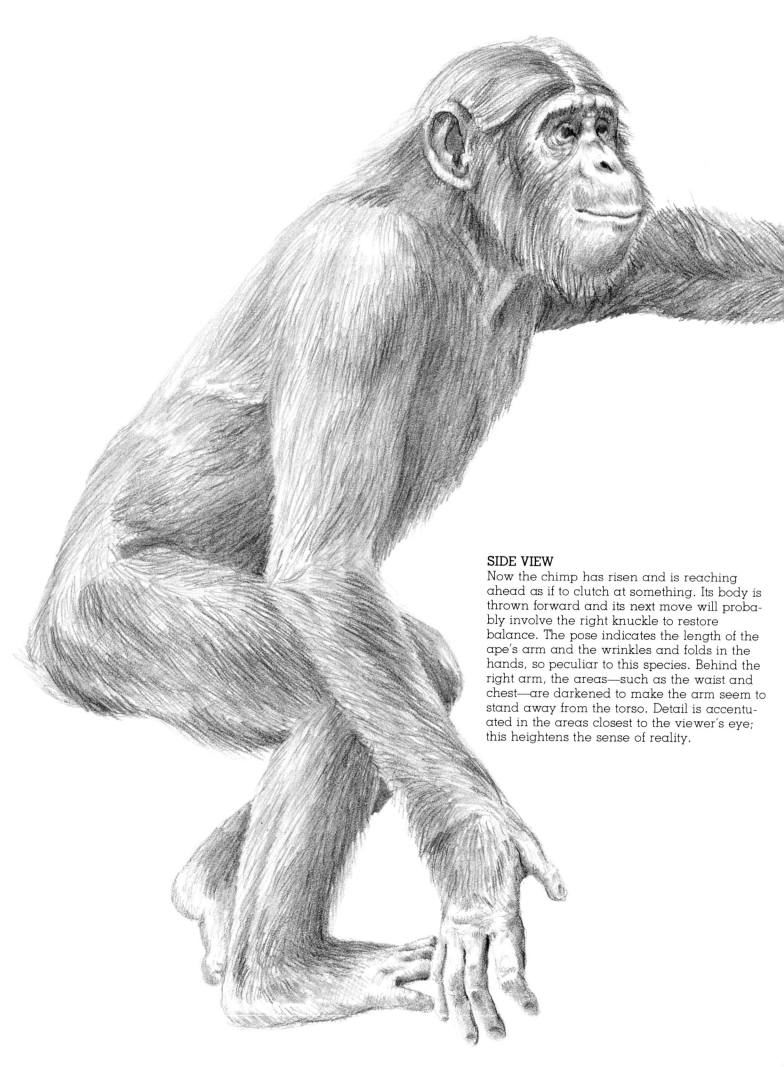

SIDE VIEW

Now the chimp has risen and is reaching ahead as if to clutch at something. Its body is thrown forward and its next move will probably involve the right knuckle to restore balance. The pose indicates the length of the ape's arm and the wrinkles and folds in the hands, so peculiar to this species. Behind the right arm, the areas—such as the waist and chest—are darkened to make the arm seem to stand away from the torso. Detail is accentuated in the areas closest to the viewer's eye; this heightens the sense of reality.

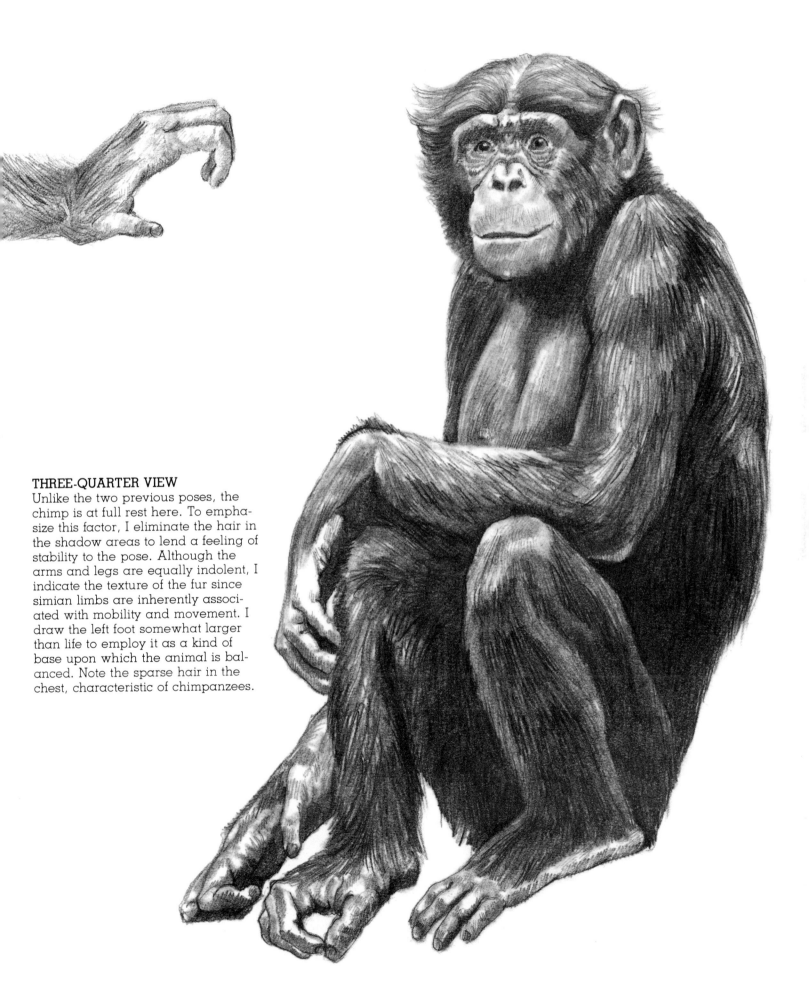

THREE-QUARTER VIEW

Unlike the two previous poses, the chimp is at full rest here. To emphasize this factor, I eliminate the hair in the shadow areas to lend a feeling of stability to the pose. Although the arms and legs are equally indolent, I indicate the texture of the fur since simian limbs are inherently associated with mobility and movement. I draw the left foot somewhat larger than life to employ it as a kind of base upon which the animal is balanced. Note the sparse hair in the chest, characteristic of chimpanzees.

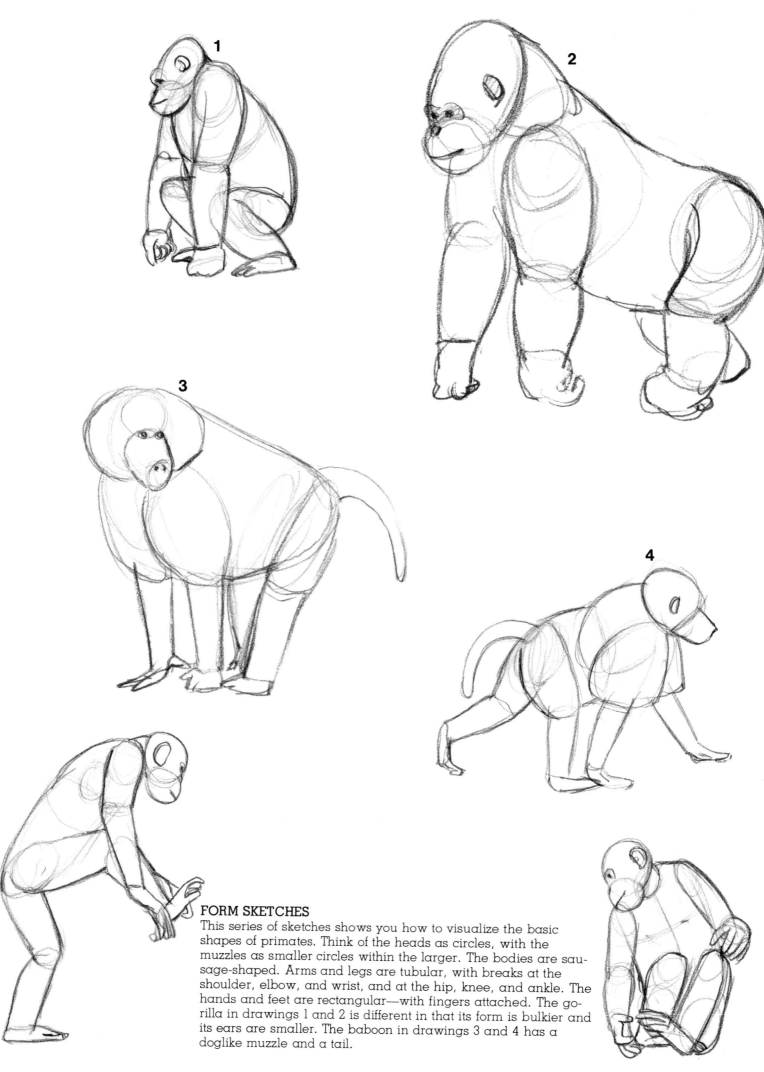

FORM SKETCHES

This series of sketches shows you how to visualize the basic shapes of primates. Think of the heads as circles, with the muzzles as smaller circles within the larger. The bodies are sausage-shaped. Arms and legs are tubular, with breaks at the shoulder, elbow, and wrist, and at the hip, knee, and ankle. The hands and feet are rectangular—with fingers attached. The gorilla in drawings 1 and 2 is different in that its form is bulkier and its ears are smaller. The baboon in drawings 3 and 4 has a doglike muzzle and a tail.

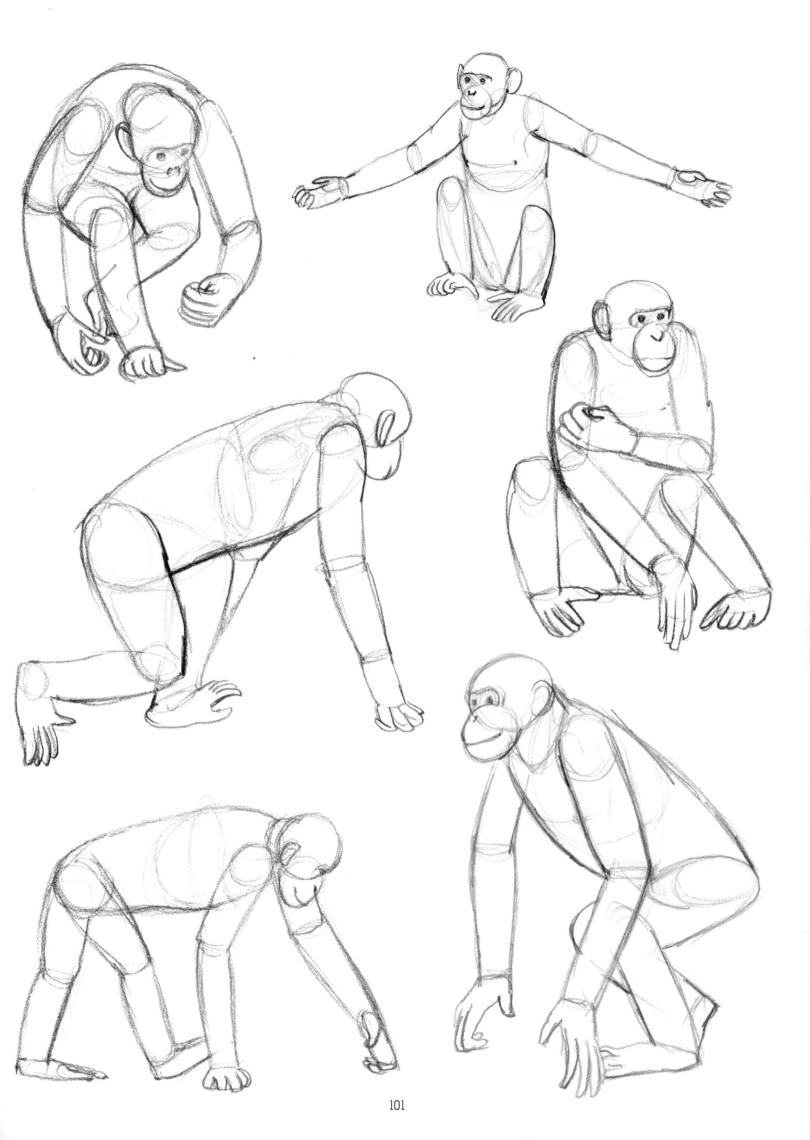

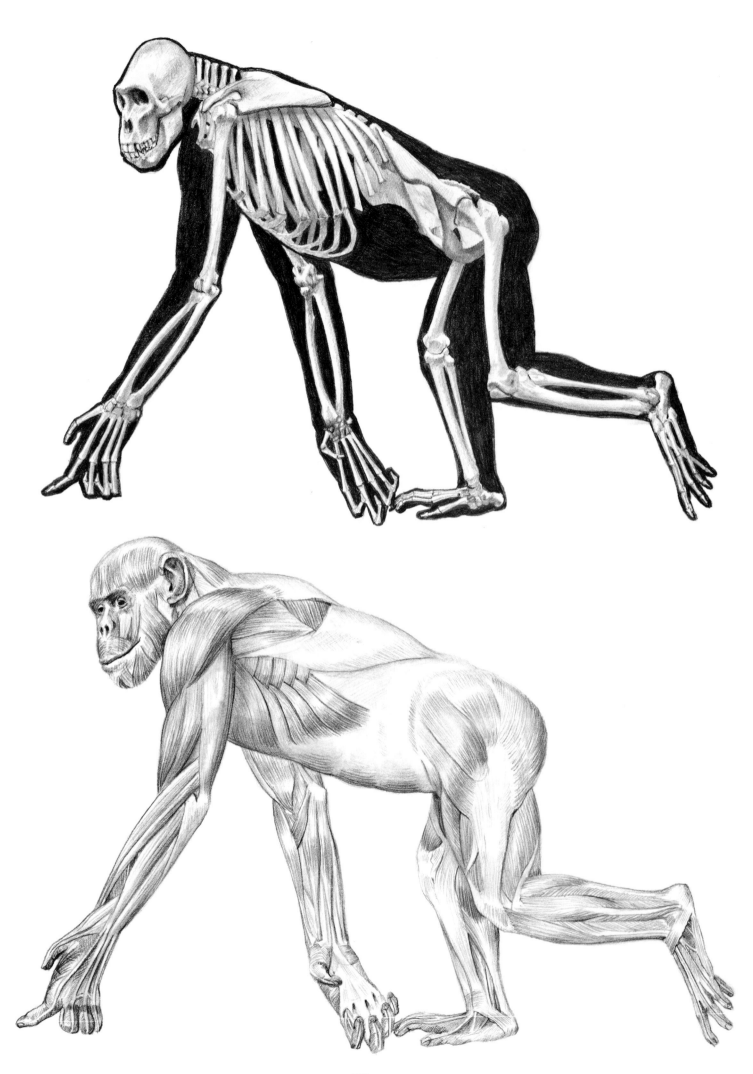

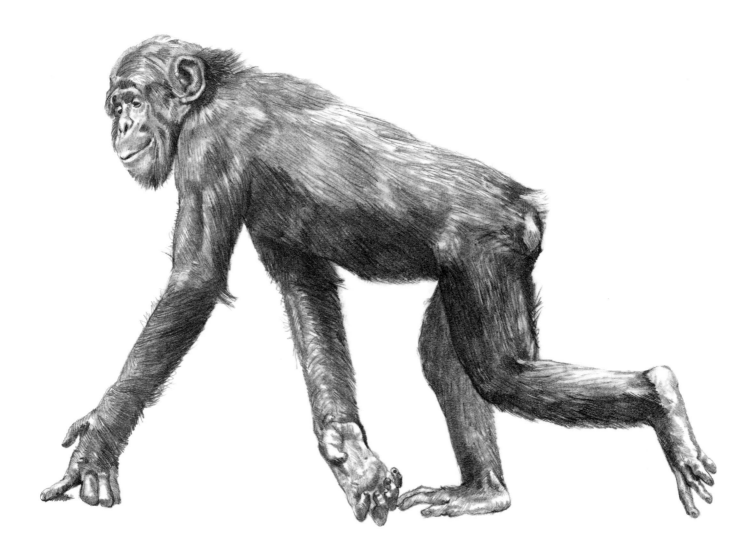

SKELETON *(ABOVE LEFT)*

A chimpanzee's skeletal development is similar to man's—with obvious variations in the proportions. In the chimp, as in the other great apes, arm length exceeds leg length. Forearms are particularly long in comparison with the upper arms. The same is true of the leg. Chimps have pronounced brow ridges and jutting jaws. Their upper torso development is quite massive and their hands and feet are large—considering that the average male chimp weighs approximately 150 pounds at maturity and stands perhaps four to four-and-a-half feet tall.

SURFACE ANATOMY *(ABOVE)*

This drawing shows the chimp in a similar position to the previous two drawings. It is employing its normal quadrupedal gait with the knuckles serving as auxiliary feet. Because of the way they use their knuckles, apes develop thick calluses or pads on the parts of their fingers that rest on the ground. Dark solids are drawn on the chimp's underside, which is farthest from the light. Tiny pencil strokes are used at the edges of the arms and the thighs to accentuate the effect of overall hairiness. Note the tufting at the elbows and the lack of hair on the palms and soles.

MUSCULATURE *(LEFT)*

The chimp is partially arboreal, so it is endowed with powerful upper body development to allow it to travel above ground, unlike man who requires powerful lower limb musculature to stand and walk. A feature common to all apes is that they lack the powerful calf and gluteal (buttock) muscles that man needs for walking, running, lifting, and raising the torso from the sitting position. The orangutan, who spends all his time in trees, has the weakest legs of the great apes; the gorilla, which is largely terrestrial, has the strongest. The chimp falls somewhere in between.

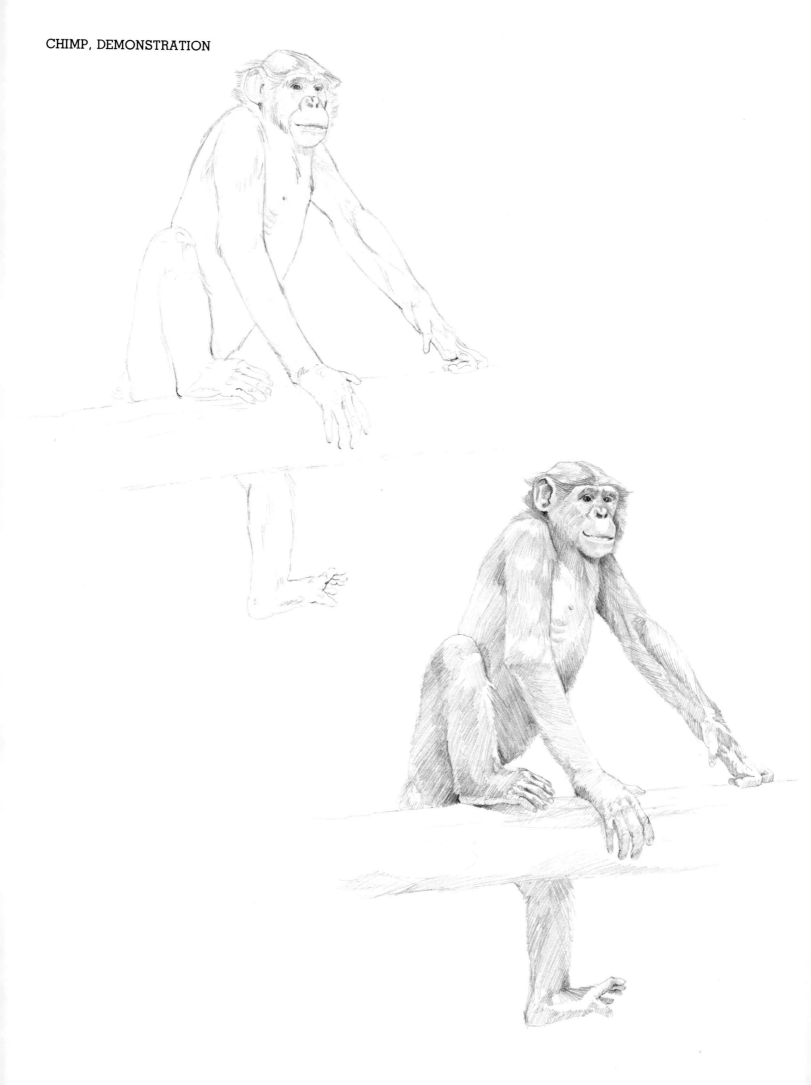

STEP 1. *(ABOVE LEFT)*
In this step-by-step demonstration, I show a chimpanzee in a characteristic gesture: climbing upward as it would when searching for food or for sleeping quarters. In this first step, I lightly indicate the animal's anatomy and facial expression, taking care to provide a solid foundation for the drawing. I avoid going too dark in my lines, since many of them will be changed or eliminated in the final stage.

STEP 2. *(LEFT)*
I start to build up the drawing and add tone to the linear outline. To indicate all shadow areas I apply pressure to the pencil. I increase the density of the darks by laying the strokes closer together as in the belly, upper arms, neck, hands, and feet. So far, the treatment is rough and imprecise, but everything is correctly placed. The darkest accents are reserved for the mouth, nose, and eyes.

STEP 3. *(ABOVE)*
In the completed drawing, the chimp is now firmly anchored on its perch. The naked face is accentuated by the dark ring of fur around it, especially along the left contour. To define the chin, I run dark strokes downward from the ear and below the chin. The tuft at the elbow is stroked upward from the forearm and downward from the upper arm. I bring the left arm forward by applying darks behind it. The ribcage is indicated with several light smudges to show the hollows between the ribs. I place the darkest accent at the point of contact between the rump and the tree limb. The entire fur texture is indicated with multiple short strokes that follow the contours of the muscles.

BEGGING

Chimps in captivity are notorious spongers, as this typical pose demonstrates. This drawing gives a good view of a chimpanzee's profile with its orbital crest, flat nose, and oversized ears. To emphasize the begging gesture, I darken the bottom of the upraised hand and lighten the body behind it. The thighs are darkened to make the forelegs stand out and to strengthen the impression of the seated pose. Wrinkles are drawn in lightly about the mouth to express the animal's expectant attitude as it pleads for a handout. The back of the chimp, which is less important to the pose, is softened so that the edge is lost.

SLEEPING

Animals in repose—particularly when asleep—assume different forms and attitudes. These must be captured effectively in the drawing. I seek to achieve this air of serenity by softening the contours of the head and by darkening the lower part of the body to anchor it securely to the ground. Note the way the chimp keeps its hands and feet closed when asleep. Except for the face, hands, and feet, there is little detail elsewhere in the drawing—a device that promotes the sense of vulnerability and total relaxation.

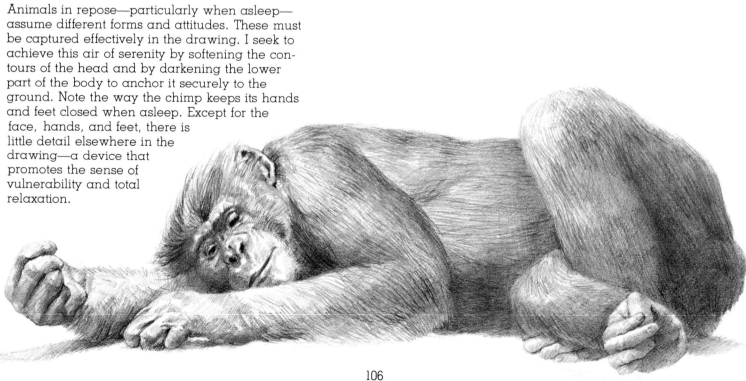

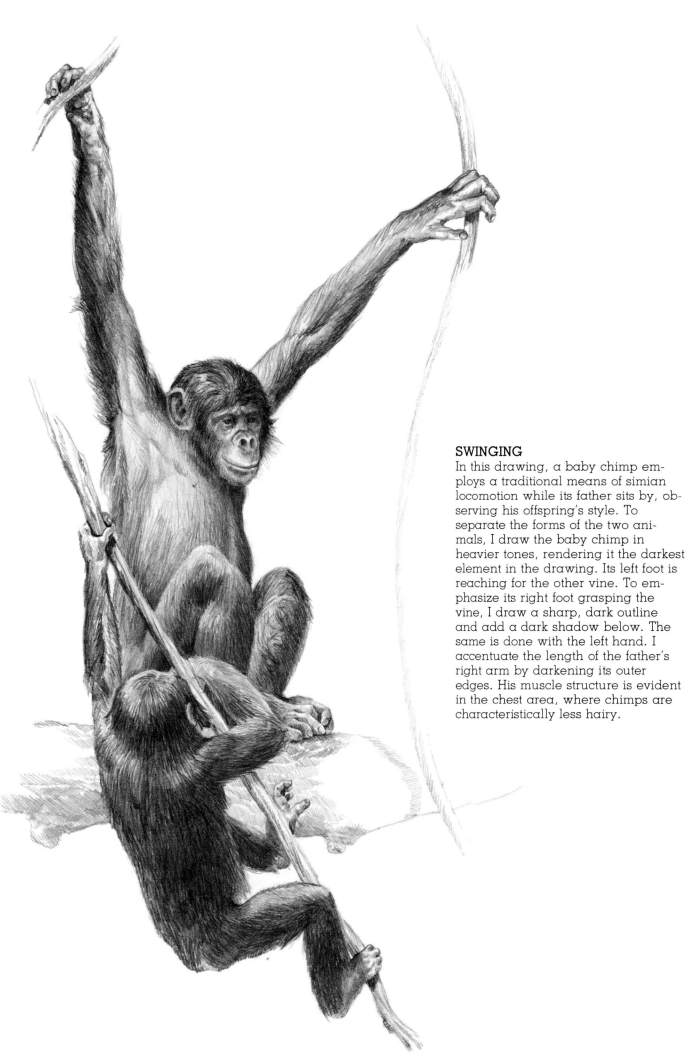

SWINGING
In this drawing, a baby chimp employs a traditional means of simian locomotion while its father sits by, observing his offspring's style. To separate the forms of the two animals, I draw the baby chimp in heavier tones, rendering it the darkest element in the drawing. Its left foot is reaching for the other vine. To emphasize its right foot grasping the vine, I draw a sharp, dark outline and add a dark shadow below. The same is done with the left hand. I accentuate the length of the father's right arm by darkening its outer edges. His muscle structure is evident in the chest area, where chimps are characteristically less hairy.

BABY CHIMPS

There is no more playful animal than the baby chimp. Like other young animals, the size of the head is comparatively large in comparison with the body. The baby chimp is soft and cuddly. In each of the three animals, I consciously seek the jovial, pensive, quizzical effect. To accentuate the gesture of the dangling chimp on top, I draw it darker than the other two. On the left, the chimp's eyes dart mischievously upward; its right arm is rendered darker to lend a sense of action to the pose. The chimp seated on the right seems to be contemplating some playful maneuver, as expressed by its slyly innocent hands and mouth.

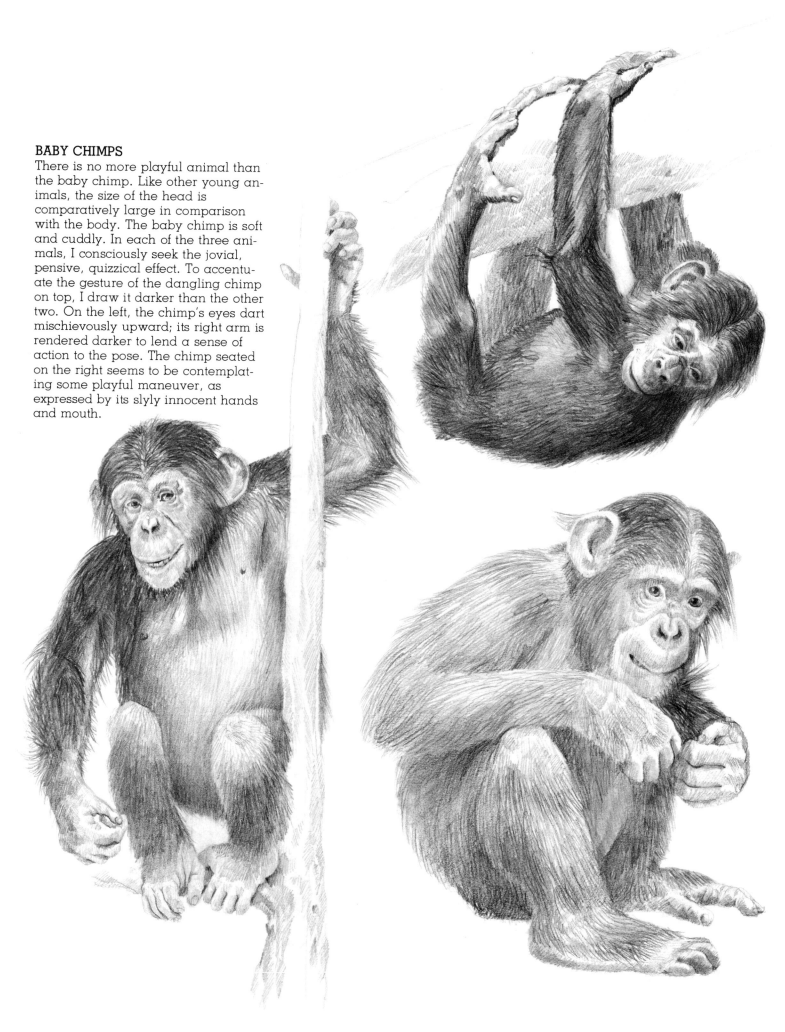

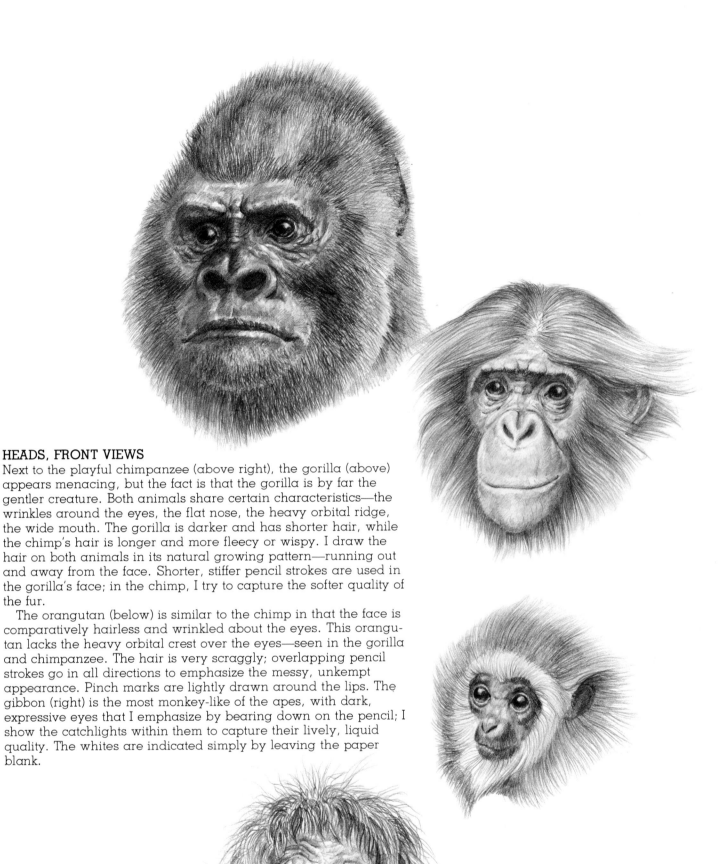

HEADS, FRONT VIEWS

Next to the playful chimpanzee (above right), the gorilla (above) appears menacing, but the fact is that the gorilla is by far the gentler creature. Both animals share certain characteristics—the wrinkles around the eyes, the flat nose, the heavy orbital ridge, the wide mouth. The gorilla is darker and has shorter hair, while the chimp's hair is longer and more fleecy or wispy. I draw the hair on both animals in its natural growing pattern—running out and away from the face. Shorter, stiffer pencil strokes are used in the gorilla's face; in the chimp, I try to capture the softer quality of the fur.

The orangutan (below) is similar to the chimp in that the face is comparatively hairless and wrinkled about the eyes. This orangutan lacks the heavy orbital crest over the eyes—seen in the gorilla and chimpanzee. The hair is very scraggly; overlapping pencil strokes go in all directions to emphasize the messy, unkempt appearance. Pinch marks are lightly drawn around the lips. The gibbon (right) is the most monkey-like of the apes, with dark, expressive eyes that I emphasize by bearing down on the pencil; I show the catchlights within them to capture their lively, liquid quality. The whites are indicated simply by leaving the paper blank.

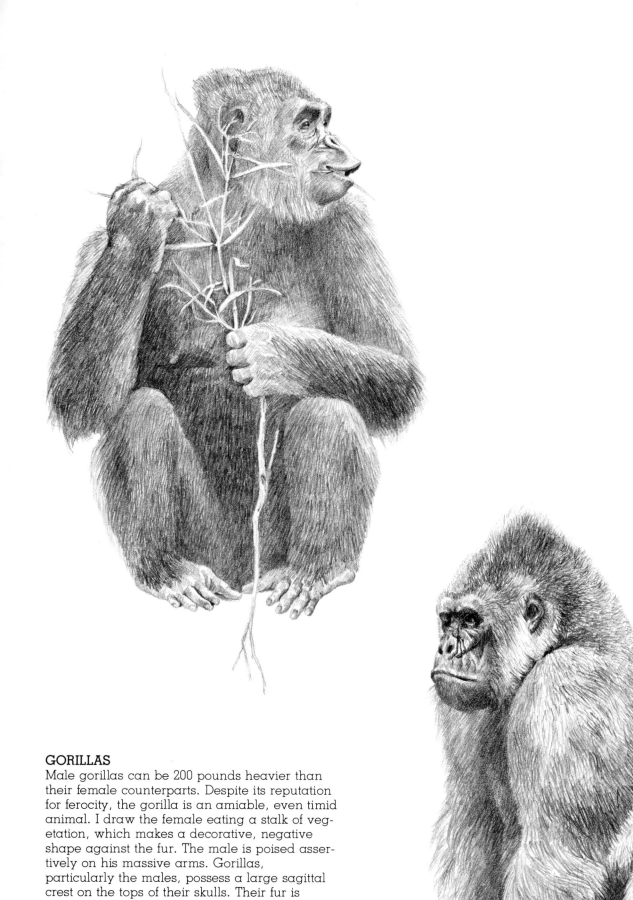

GORILLAS
Male gorillas can be 200 pounds heavier than their female counterparts. Despite its reputation for ferocity, the gorilla is an amiable, even timid animal. I draw the female eating a stalk of vegetation, which makes a decorative, negative shape against the fur. The male is poised assertively on his massive arms. Gorillas, particularly the males, possess a large sagittal crest on the tops of their skulls. Their fur is generally shorter than that of the chimps, except on their forearms, which is particularly evident in this male. The female's gentle nature is expressed by turning her toes inward and forming her mouth into a kind of half-smile.

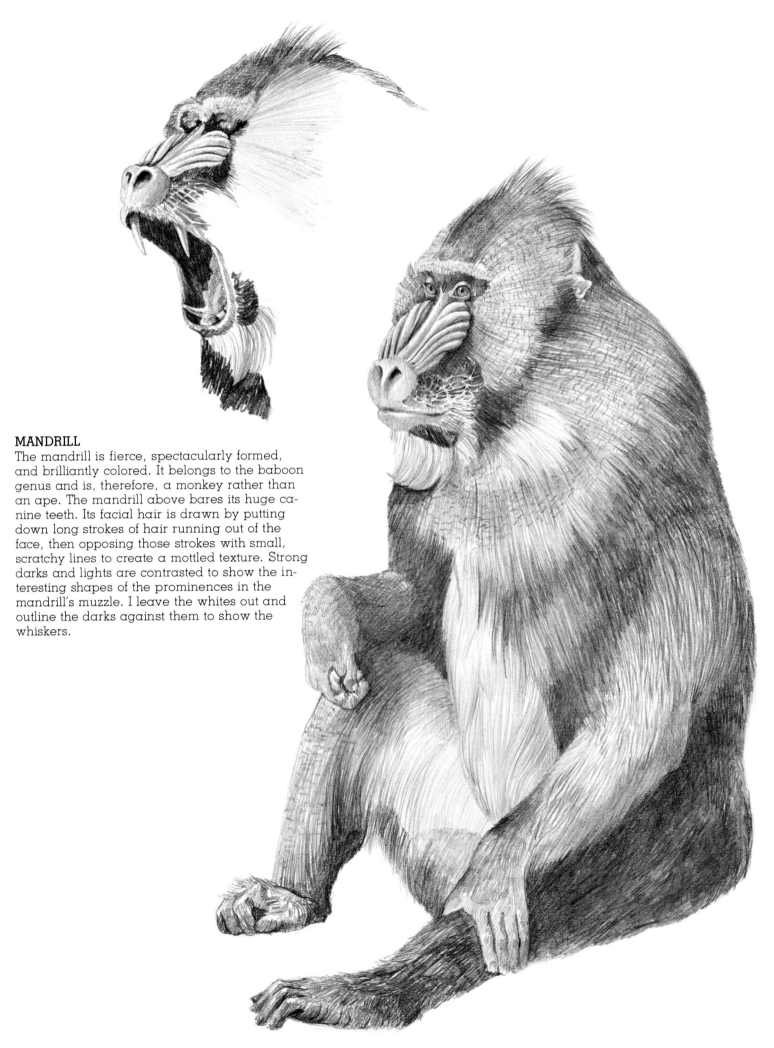

MANDRILL

The mandrill is fierce, spectacularly formed, and brilliantly colored. It belongs to the baboon genus and is, therefore, a monkey rather than an ape. The mandrill above bares its huge canine teeth. Its facial hair is drawn by putting down long strokes of hair running out of the face, then opposing those strokes with small, scratchy lines to create a mottled texture. Strong darks and lights are contrasted to show the interesting shapes of the prominences in the mandrill's muzzle. I leave the whites out and outline the darks against them to show the whiskers.

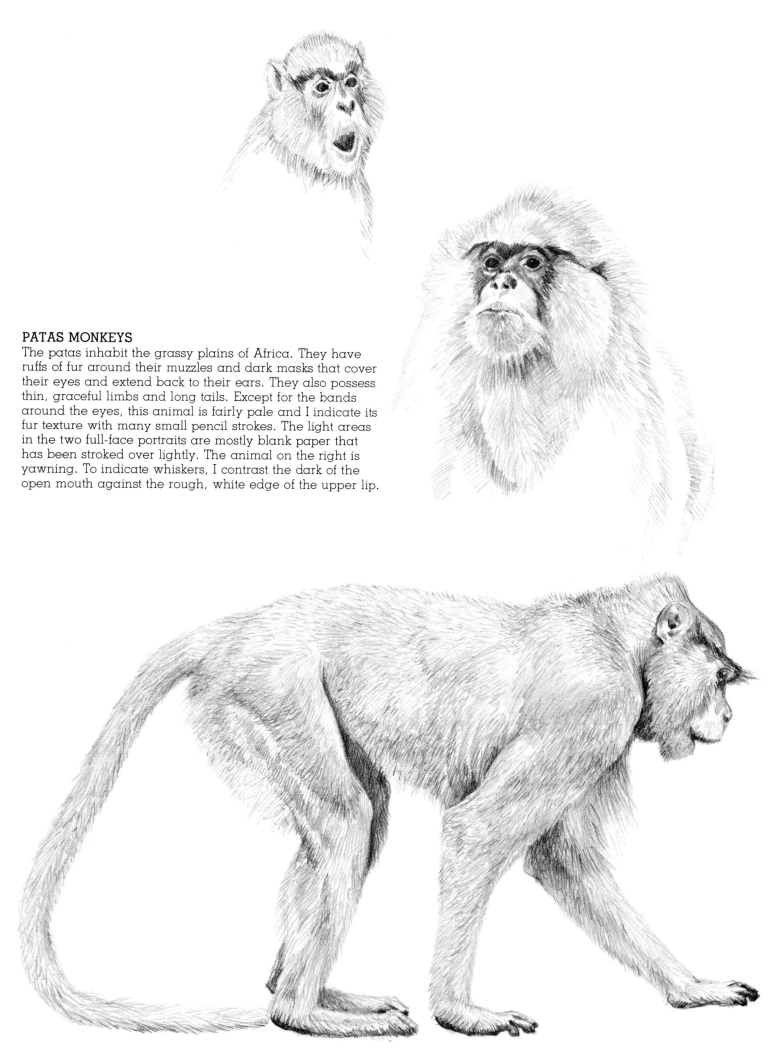

PATAS MONKEYS

The patas inhabit the grassy plains of Africa. They have ruffs of fur around their muzzles and dark masks that cover their eyes and extend back to their ears. They also possess thin, graceful limbs and long tails. Except for the bands around the eyes, this animal is fairly pale and I indicate its fur texture with many small pencil strokes. The light areas in the two full-face portraits are mostly blank paper that has been stroked over lightly. The animal on the right is yawning. To indicate whiskers, I contrast the dark of the open mouth against the rough, white edge of the upper lip.

ORANGUTAN

In captivity, these animals tend to grow grossly overweight. This orangutan's fur has become a tangle of snarls, which is a lot of fun to draw. The strokes can go every which way, but the pattern of the muscles must be followed accurately. The male orangutan has a huge throat pouch. He makes things easy for the artist because he is sedentary in captivity and is therefore an apt model. In the wild, he is basically arboreal and keeps a healthy distance from his deadliest enemy, man. Contrast this orangutan's face with the drawing on page 109.

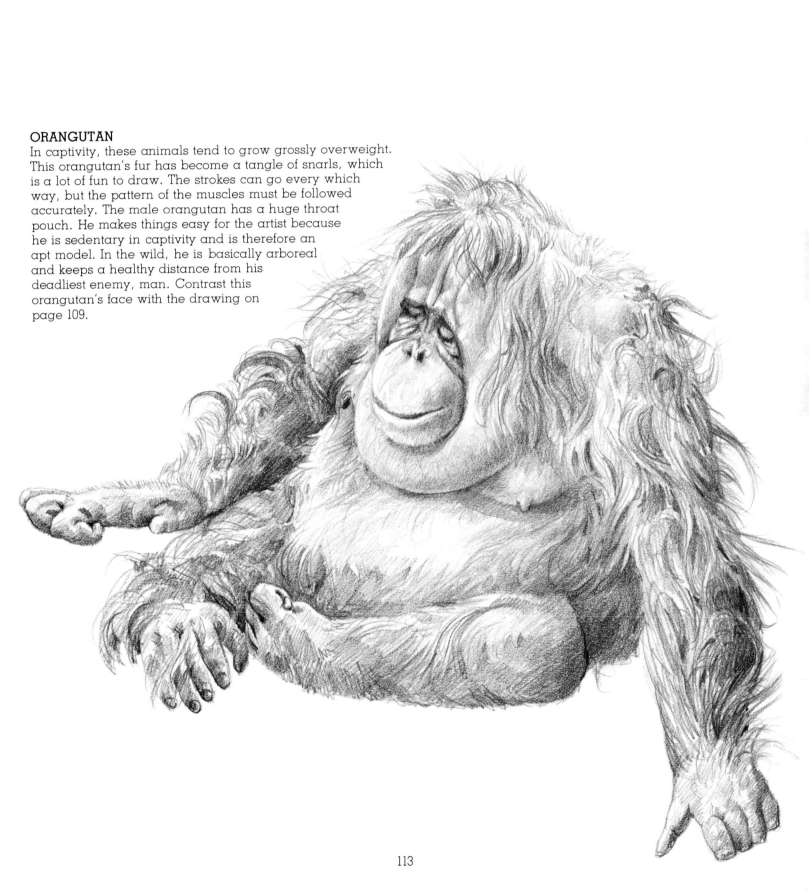

CATS

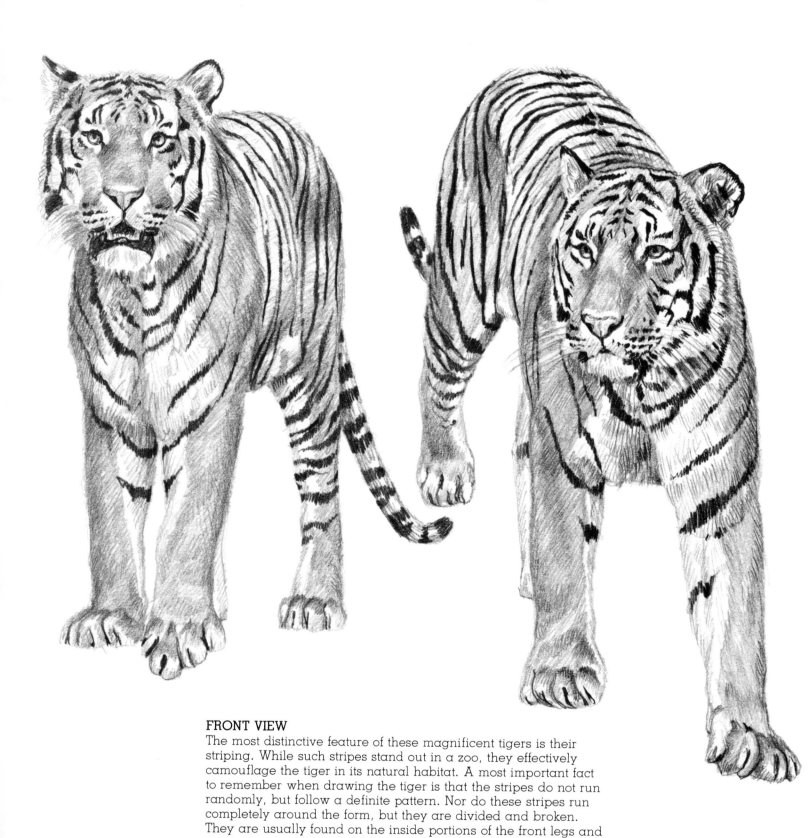

FRONT VIEW

The most distinctive feature of these magnificent tigers is their striping. While such stripes stand out in a zoo, they effectively camouflage the tiger in its natural habitat. A most important fact to remember when drawing the tiger is that the stripes do not run randomly, but follow a definite pattern. Nor do these stripes run completely around the form, but they are divided and broken. They are usually found on the inside portions of the front legs and on most areas of the rear legs. A cardinal rule is to always draw the outline and value patterns of an animal before putting in its markings, whether they are stripes, spots, or rosettes.

The cat family ranges from the male tiger, which may weigh up to 700 pounds and be 13 feet long from muzzle to tail, to the domestic house cat. All cats, however, share some common characteristics.

Being carnivores or meat eaters, they have short and powerful jaws and well-developed canine teeth that enable them to seize, hold, and pierce the flesh of their prey. In the course of evolution, cats have lost some of their original teeth, which accounts for their comparatively flat muzzles. Cats' jaws are able to move up and down but not sideways, since they do not grind their food, but tear and bolt it. Except for the cheetah, all cats are equipped to retract their sharp claws at will. Their legs and shoulders are well developed to provide the·instant power to leap at their prey.

The largest and now the rarest of the big cats is the tiger. There are variations in size and color among the half-dozen or so tiger races. The tiger's size and the beauty of its structure and markings induced me to feature it in the section on cats. In addition, I have also included a number of other wild cats in the chapter.

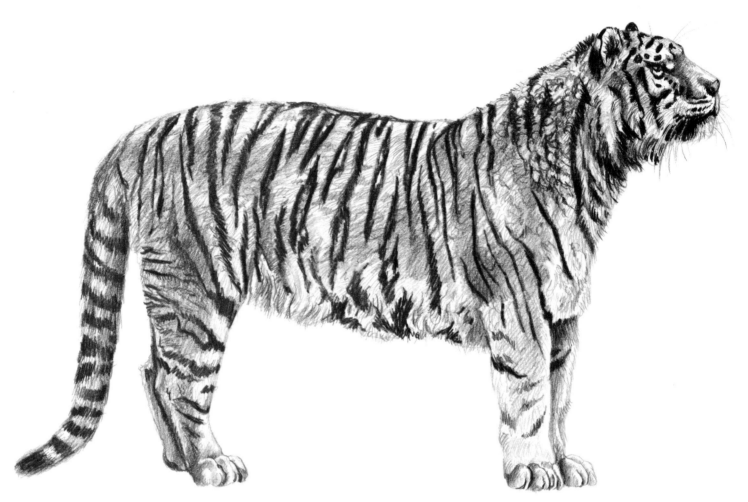

SIDE VIEW

The Siberian tiger is generally the largest of the species. Due to its cold environment, this tiger's coat is also shaggier and the density of the coat makes the stripes seem even more broken than they are. Where the fur is thickest on the belly, the stripes become almost masses of dark value. Note how the stripes of the leg shift direction as they go up the thigh to the hip, where they change from horizontal to vertical. The forelegs and the tail on this Siberian male appear even thicker and bushier due to the heavy shag of the fur. The tiger's breast, belly, and inner areas of its legs are normally white beneath the stripes.

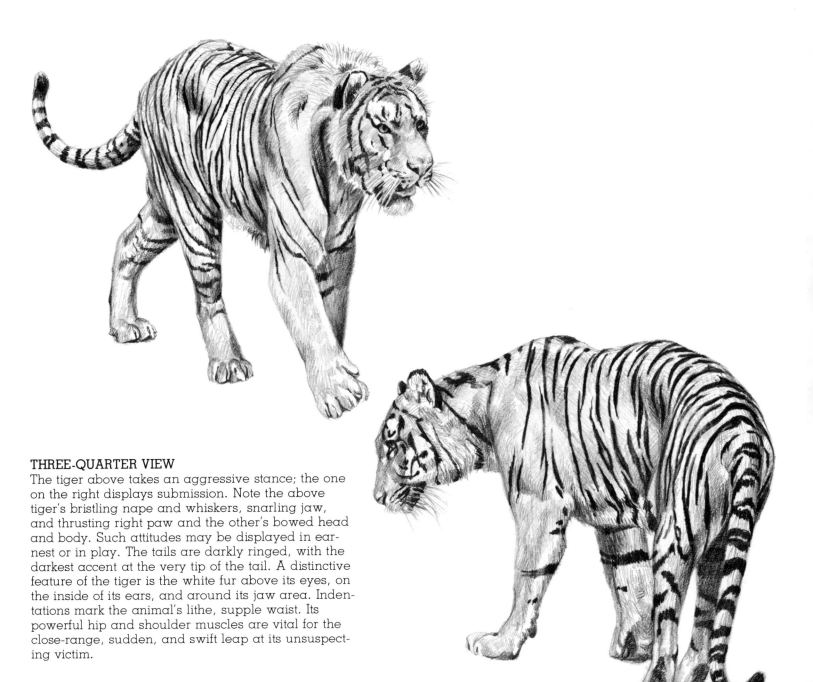

THREE-QUARTER VIEW

The tiger above takes an aggressive stance; the one on the right displays submission. Note the above tiger's bristling nape and whiskers, snarling jaw, and thrusting right paw and the other's bowed head and body. Such attitudes may be displayed in earnest or in play. The tails are darkly ringed, with the darkest accent at the very tip of the tail. A distinctive feature of the tiger is the white fur above its eyes, on the inside of its ears, and around its jaw area. Indentations mark the animal's lithe, supple waist. Its powerful hip and shoulder muscles are vital for the close-range, sudden, and swift leap at its unsuspecting victim.

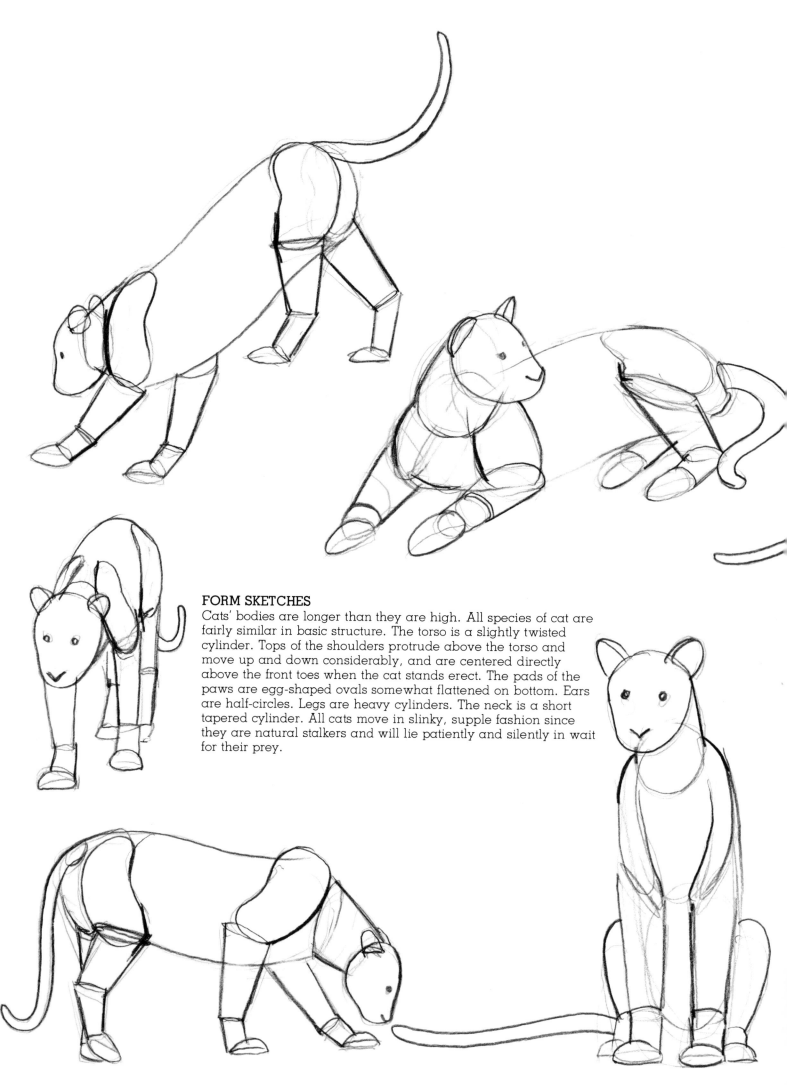

FORM SKETCHES

Cats' bodies are longer than they are high. All species of cat are fairly similar in basic structure. The torso is a slightly twisted cylinder. Tops of the shoulders protrude above the torso and move up and down considerably, and are centered directly above the front toes when the cat stands erect. The pads of the paws are egg-shaped ovals somewhat flattened on bottom. Ears are half-circles. Legs are heavy cylinders. The neck is a short tapered cylinder. All cats move in slinky, supple fashion since they are natural stalkers and will lie patiently and silently in wait for their prey.

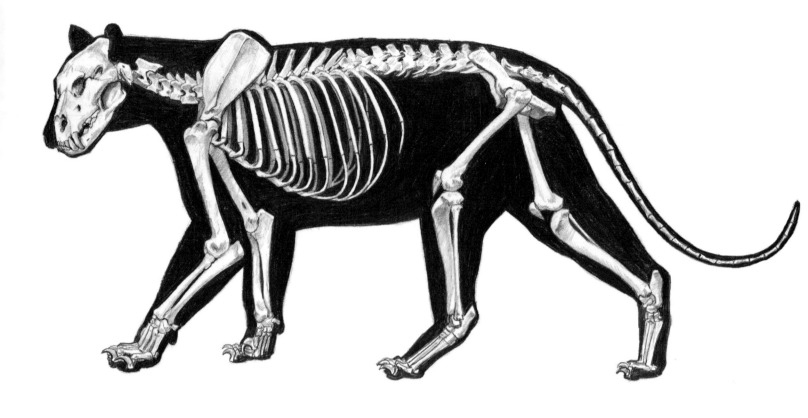

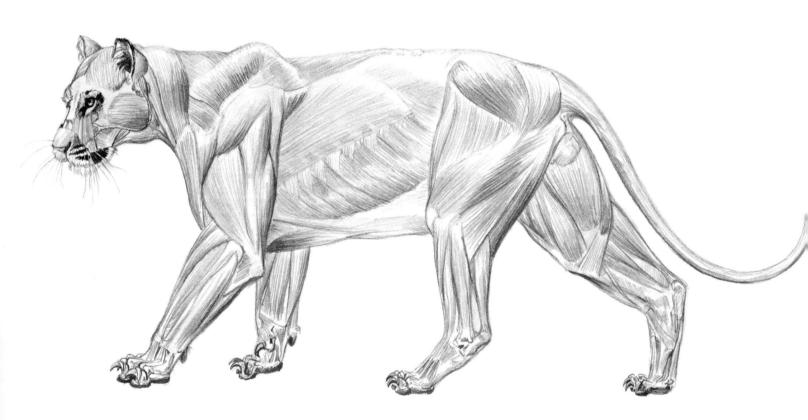

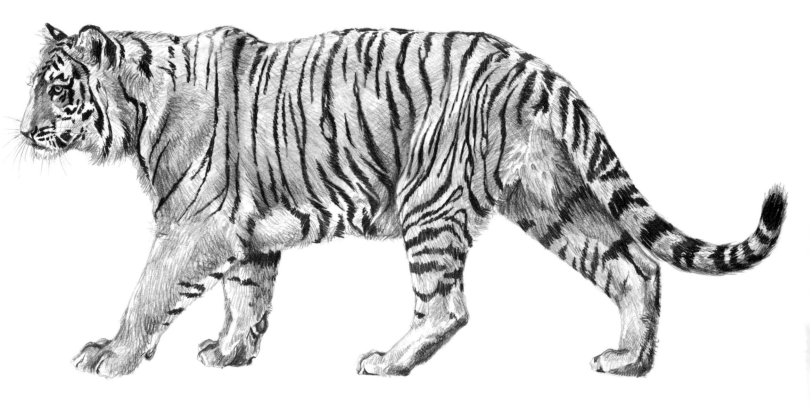

SKELETON *(ABOVE LEFT)*

The bones of a tiger (and most cats) are relatively not as massive as a bear's or an elephant's, but they are enormously powerful. Note particularly how high the shoulder blades thrust above the spine and how the long canine teeth overlap. The teeth are one of the cat's most effective offensive weapons. Of special interest is the sharp downward slant of the pelvic bone.

MUSCULATURE *(LEFT)*

The tiger's well-defined muscle patterns give proof of its ability as a deadly fighting machine. It is especially equipped for leaping and springing, but is not constructed for long-distance pursuit. Like all cats, the tiger's forte is the short burst of speed, since it stalks prey from a close distance. Even the traditionally swift cheetah can only maintain its speed for a brief period of time.

SURFACE ANATOMY *(ABOVE)*

The tiger is surely one of the most magnificent beasts on earth. Its grace, coloring, and markings leave the viewer breathless. With longer stripes of the pencil, I indicate the shaggy ruff in back of its cheeks. Except for a white flash, the back of its ear is black. There is always white above the eye. The whiskers are set within four noticeably dark streaks on the muzzle. A tiger's eyes are yellow except for the rare white tiger, which has blue eyes. A large male may stand higher than three feet at the shoulders.

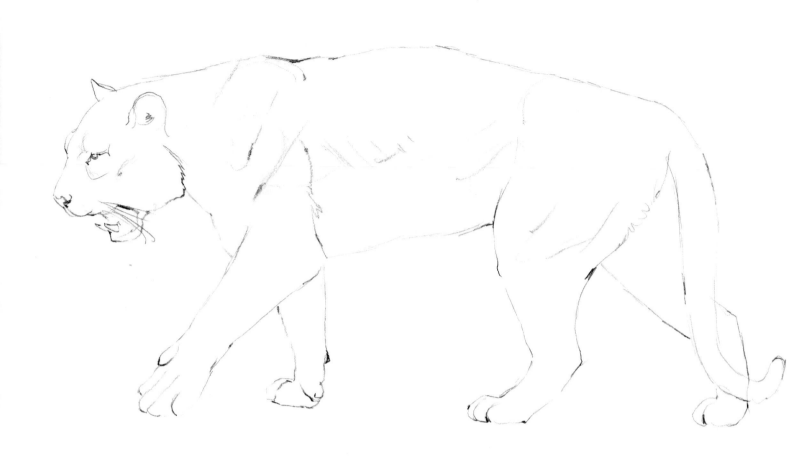

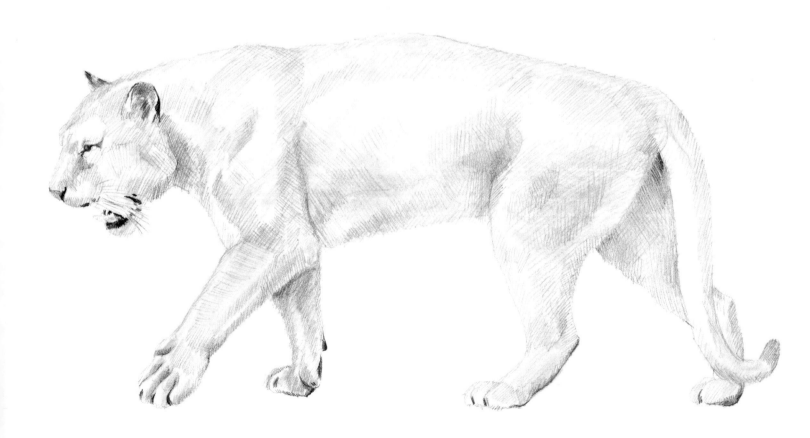

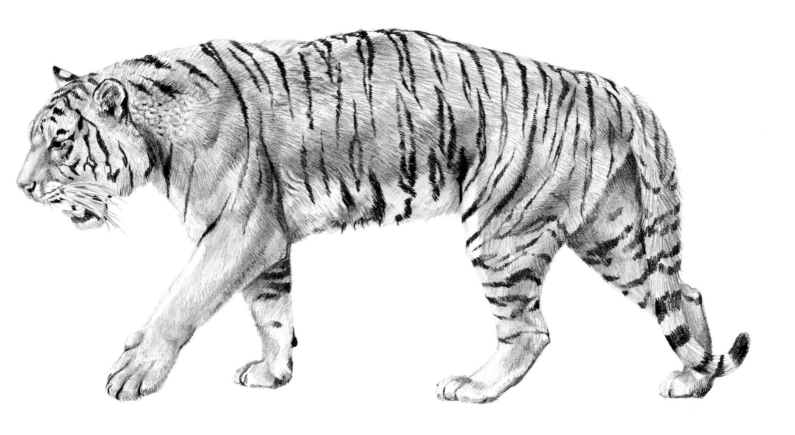

STEP 1. *(ABOVE LEFT)*
This tiger is pacing and showing its fangs in a snarl. I begin by drawing in the tiger's basic outline, taking care to capture the determined attitude the animal has assumed by extending its left foreleg as it moves ominously forward. I lightly note the indentations, marking the muscular stresses this gesture has produced in the shoulder, hip, and rib cage areas. I also show the open jaw and the exposed teeth.

STEP 2. *(LEFT)*
I lightly indicate the texture of the fur with strokes that follow the muscle patterns. I darken those areas that emphasize the action and attitude of the pose, such as the mouth, the eyes, the ears, and the toes. The pencil strokes must also represent the variety of coloring on the animal— where it is orange, they are darker; where it is white, they are lighter. At this stage, our tiger resembles a female lion.

STEP 3. *(ABOVE)*
The color and tonal values and textures of fur are darkened and strengthened all over. Note the little clumps in back of the ear where I fashion little islands of fur to indicate its soft, bunchy quality. To show the existence of fur, I rough the edges of the coat. The whiskers are presented as negative shapes—light areas set against darker tones behind them. In areas where separate forms come together, I contrast lights and darks. The final step is to put in the stripes; to do this I use short, dark strokes that are broken up to show the fur growing beneath and between them.

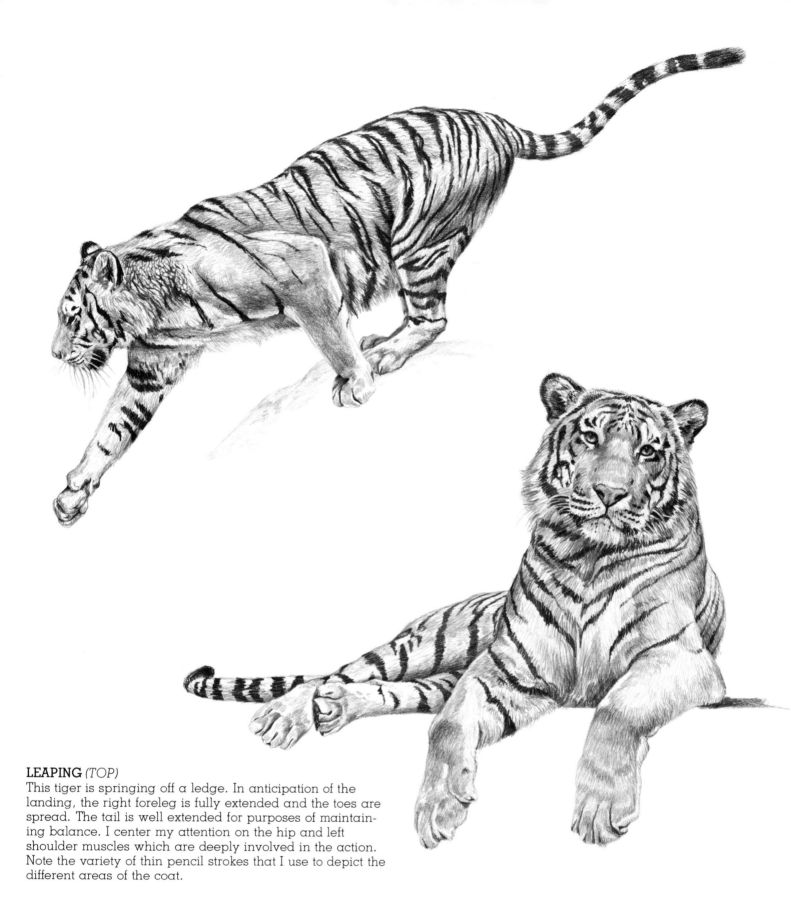

LEAPING *(TOP)*

This tiger is springing off a ledge. In anticipation of the landing, the right foreleg is fully extended and the toes are spread. The tail is well extended for purposes of maintaining balance. I center my attention on the hip and left shoulder muscles which are deeply involved in the action. Note the variety of thin pencil strokes that I use to depict the different areas of the coat.

RESTING *(ABOVE RIGHT)*

In this radically foreshortened drawing, the tiger seems uncomfortably close. Its head is cocked slightly in repose. Due to the close view, the anatomy of the paws is presented in lots of detail. I separate the head from the torso by darkening under the chin area to make the head seem to come forward. In the chin area, I cut with dark stripes into the white of the ruff, which I then pencil in lightly. The whiskers are again shown as negative forms. Note the distinct slant of the eyes—a characteristic feline feature, especially among the big cats.

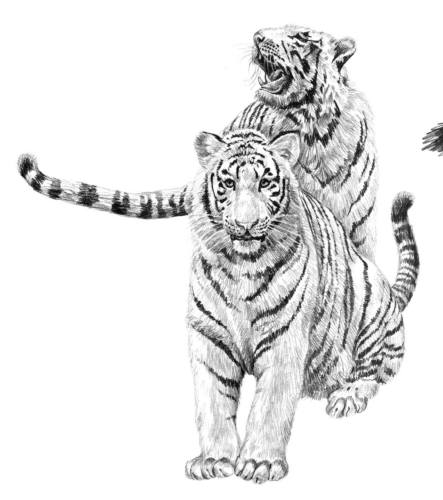

TIGER CUBS (LEFT)

A tiger matures sexually between the ages of three and four. Cubs stay under their mother's protection until they are two or three, even though they are able to kill their own prey as early as seven months old. In drawing these cubs I try to portray their youthful and still somewhat ungainly appearance. For instance, note how large their legs seem in relation to the body. Because cubs' whiskers are relatively light, I scratch them out with a razor from a dark background. (Note diagram)

PLAYING

Just like your house cat, tigers spend lots of time playing games that simulate their everyday activities. In this instance, a game of submission and domination is being acted out. The tiger assuming the aggressive role draws its ears back, fakes a snarl, and unsheathes its right foreleg claws while its playmate paws its head but with the claws well sheathed. On the head of the supine tiger, note how the stripes radiate from the center of the skull.

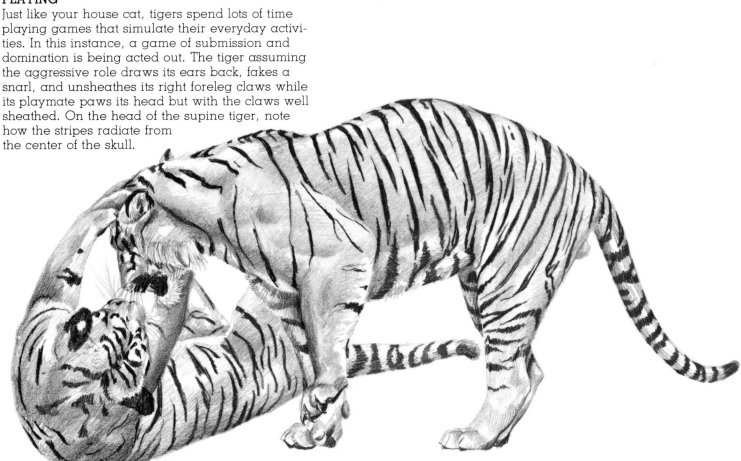

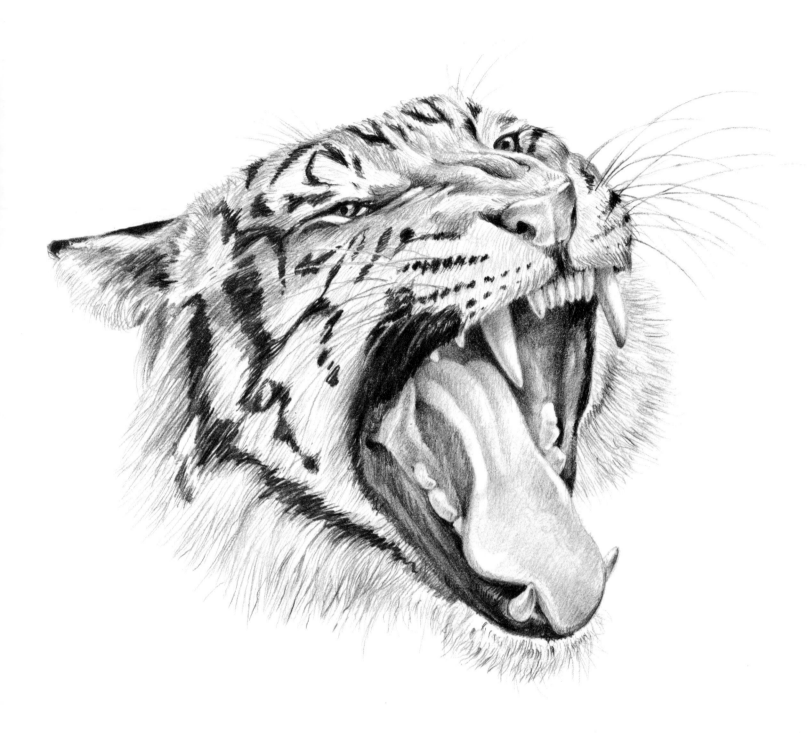

HEAD, THREE-QUARTER VIEW

A tiger has long upper canines that have six smaller incisors set between them. Its lower canines are set closer together and fit between, and in front of, the upper canines when the jaw is closed. The rims of the lips are quite dark. The wrinkles created by the yawn run from the nose toward the eyes, which are narrowed from the wide stretch of the jaw. Note that the eyebrows and whiskers are of a different texture from the animal's fur

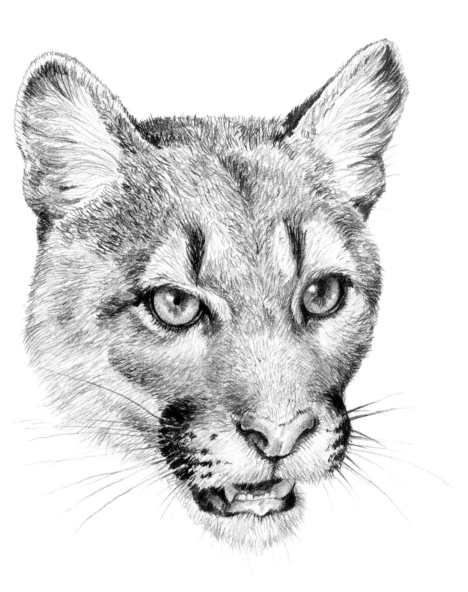

HEAD, FRONT VIEW

Excluding the obvious stripes, the chief differences between the tiger and the mountain lion (also known as the puma, cougar, panther, catamount, etc.) are: the tiger has a longer chin ruff, longer whiskers, and a flatter nose; the puma is somewhat slighter in structure and has distinctive black markings above the eyes. It's great fun to draw the long coarse whiskers of cats by pulling them out with long definite pencil strokes. Note the differences in the textures of both animals' fur—coarser here, smoother there; lighter here, darker there; straighter here, scragglier there. The pencil is the ideal tool to capture this variety.

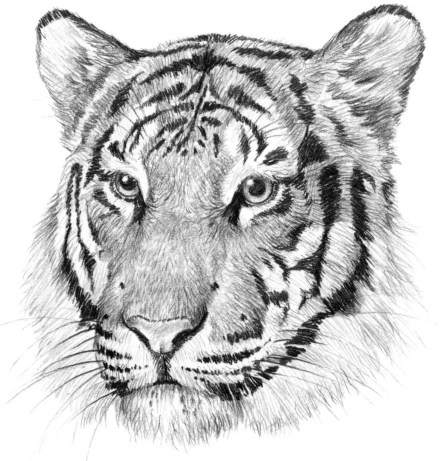

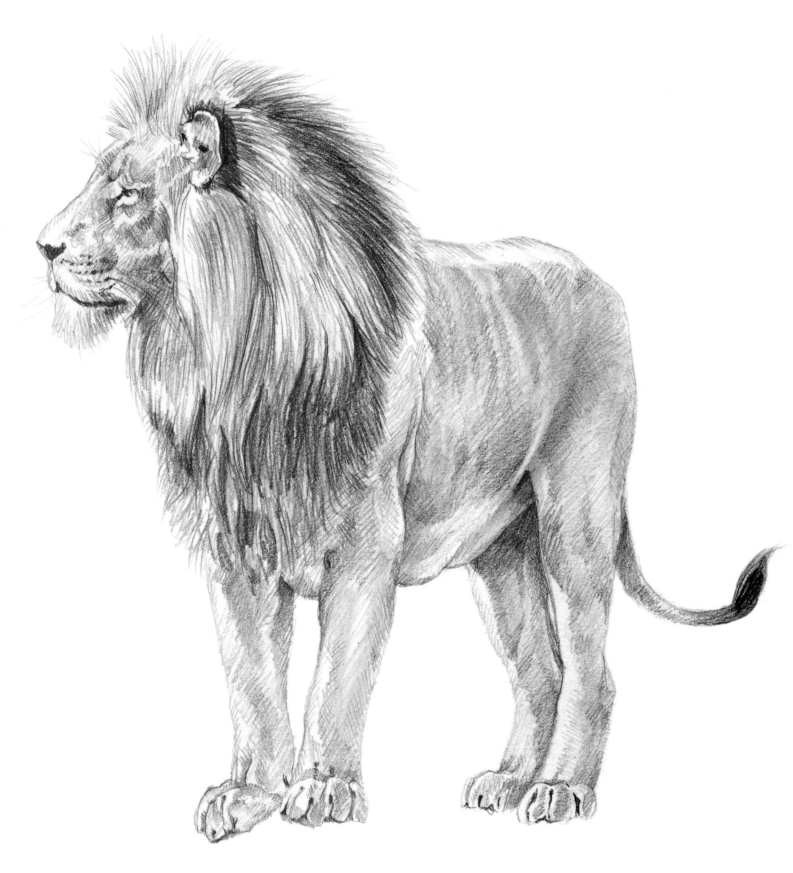

LION

This male's luxuriant mane represents the most striking feature of the drawing. I include a number of V-shaped accents in the lower part of the mane to emphasize the overlapping character of the hair, which lies in thick layers in that area. The toes are drawn somewhat uneven to demonstrate their flexibility—cats' feet must not be drawn as solid static shapes such as shoes. You can see the slits in the toes into which the claws retract. Note the difference between the male lion's ear and that of the tiger—the lion's ear seems more human-like. The dark tuft on the tip of the tail covers a pointy, hornlike spear.

OCELOT

The ocelot is one of my favorite animals to draw. This ocelot characterizes the typical feline expression in repose. Its markings are extremely complicated and must be carefully studied before you attempt to draw them. Each rosette on the torso must be placed, outlined, shaded, and accented separately. There are also individualistic dark stripes on the face and neck, and spots on the paws and tail. Unless these markings are diligently observed you will end up with an incomprehensible hodgepodge. As with every spotted animal, you must first draw the ocelot's shape, value, and color demarcations before proceeding to its intricate markings.

CHEETAH

Both the ocelot and the cheetah are more delicately built animals
than the lion and the tiger. The cheetah is long-bodied and
slender with a relatively small head and long thin legs. It is
spotted all over, with darker bands at the end of the tail and a
black stripe running from the eye to the mouth. I accentuate its
supple muscular structure by seeking to capture its leanness,
grace, and legendary running ability—which makes it the fastest
land animal on earth at short distances. Its spots vary in size. The
cheetah also possesses a characteristic crest on its forward spine,
which I indicate with several upward strokes of the pencil.

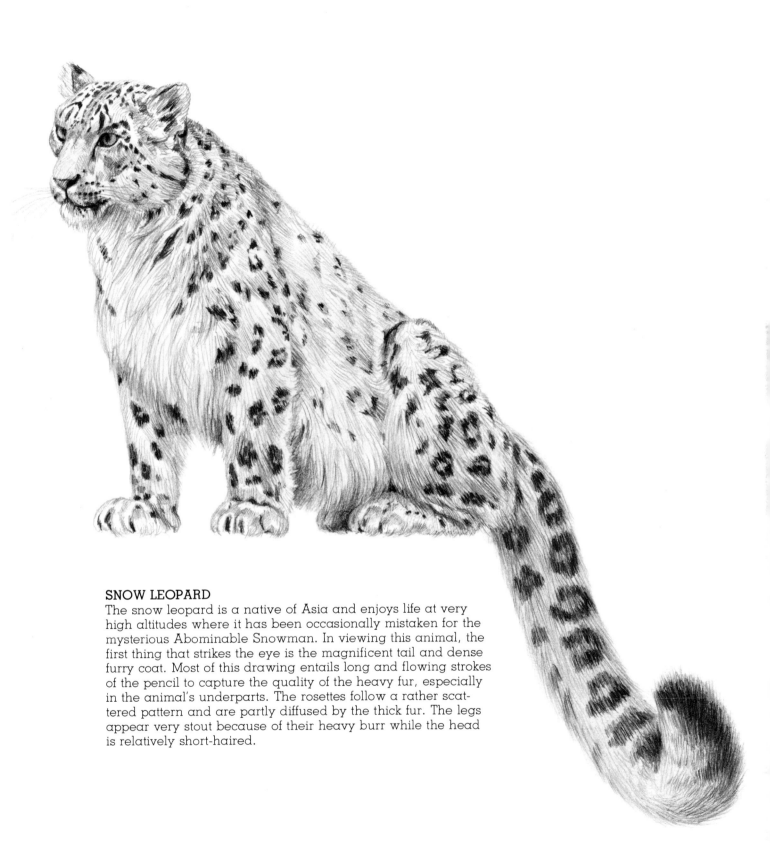

SNOW LEOPARD

The snow leopard is a native of Asia and enjoys life at very high altitudes where it has been occasionally mistaken for the mysterious Abominable Snowman. In viewing this animal, the first thing that strikes the eye is the magnificent tail and dense furry coat. Most of this drawing entails long and flowing strokes of the pencil to capture the quality of the heavy fur, especially in the animal's underparts. The rosettes follow a rather scattered pattern and are partly diffused by the thick fur. The legs appear very stout because of their heavy burr while the head is relatively short-haired.

DOGS

FRONT VIEW

The vizsla, also known as the Hungarian pointer, has a short, reddish-gold coat. It is lithe of build and extensively used for hunting. To promote the impression of forward motion, I extend its right forepaw in a grasping finger-like gesture and accent his right shoulder in darker tones. For its short coat, I use a multiplicity of short strokes which generally follow the direction of the form. The left side of the animal's neck is darkened to set it away from the shoulder. The left hind leg is also raised as part of the walking action. Basically, a drawing of a short-haired animal is one of value rather than of texture.

Dog and man formed a partnership that has flourished for 30,000 years. It has been an ideal relationship in which each party has contributed to the benefit and well-being of the other. Dogs are members of the canine family which includes wolves, foxes, coyotes, jackals, and dingoes. It's currently believed that dogs evolved from the Yellow Wolf.

Dogs, as everyone knows, come in various shapes, sizes, colors, and degrees of hirsuteness. They do, however, share characteristics such as great lung capacity, the fifth or dewclaw, and fore feet that are larger than the hind feet. Also, when their jaws are closed, their lower canines extend in front of their upper teeth. This factor is important to remember in drawing dogs' heads.

For purposes of classification, dogs are broken up into groups such as, Eskimos, sheepdogs, mastiffs, greyhounds, terriers, hounds, poodles, and spaniels. Other means of classification include categories such as: sporting, hounds, working, terriers, toys, non-sporting.

Over the years, man has used the dog as a protector, guide, hunting companion, beast of burden, draft animal, shepherd, entertainer, gladiator, war animal, tracker, sleuth, and pet. It always pleases us to learn more about such an old and devoted friend.

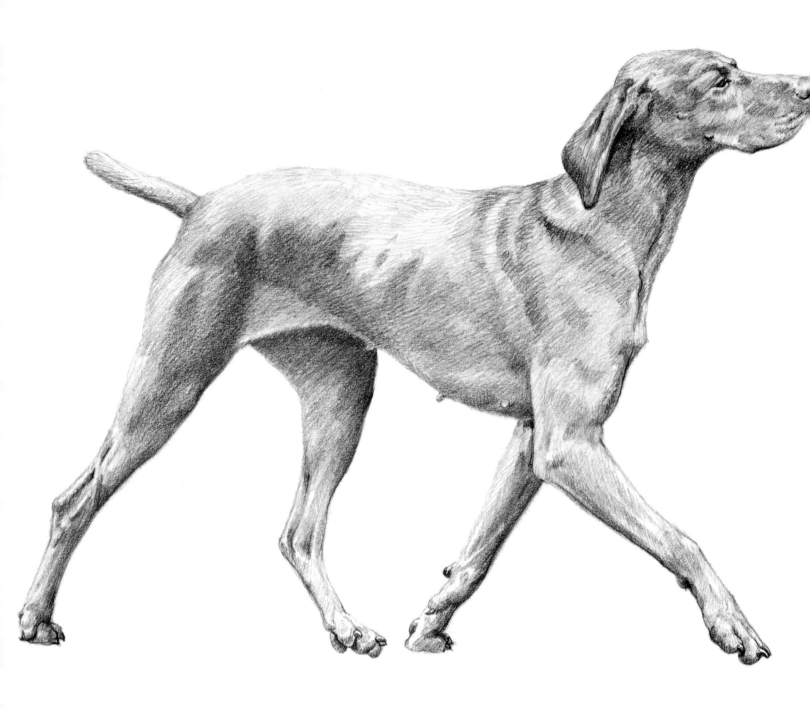

SIDE VIEW

Here we see the same action as in the previous drawing, but viewed from a different angle. The light from above is designed to accentuate the vizsla's short glossy coat. Note how the fold of skin known as the groin flap is stretched by the gesture between the thigh and the belly. I kept it light to illustrate its thin, almost translucent nature. The toes of the left forefoot are flexed to their utmost as the dog bears down upon them just before pushing off from the ground. Also note the veins and tendons just above the tensed right hind hock—they emphasize the breed's sinuous appearance. This animal seems built for speed.

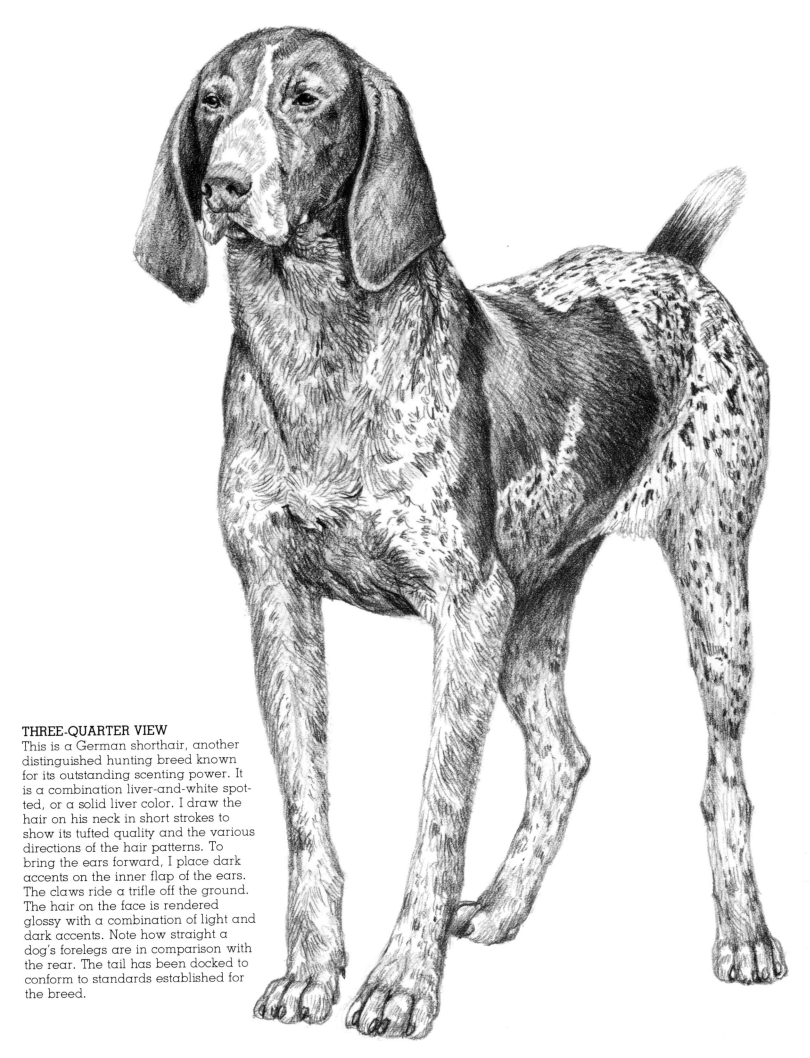

THREE-QUARTER VIEW
This is a German shorthair, another distinguished hunting breed known for its outstanding scenting power. It is a combination liver-and-white spotted, or a solid liver color. I draw the hair on his neck in short strokes to show its tufted quality and the various directions of the hair patterns. To bring the ears forward, I place dark accents on the inner flap of the ears. The claws ride a trifle off the ground. The hair on the face is rendered glossy with a combination of light and dark accents. Note how straight a dog's forelegs are in comparison with the rear. The tail has been docked to conform to standards established for the breed.

135

FORM SKETCHES

A dog's torso is somewhat bean-shaped, with a deeper chest and a taper at the hips. The head is a circle from which the muzzle extends; the muzzle is a cylinder flattened at the end. I show some of the animals with jaws open since dogs spend much of their existence this way. The legs are tapered cylinders and the feet are half circles. The shoulder and hipbones are represented as inverted kidney shapes.

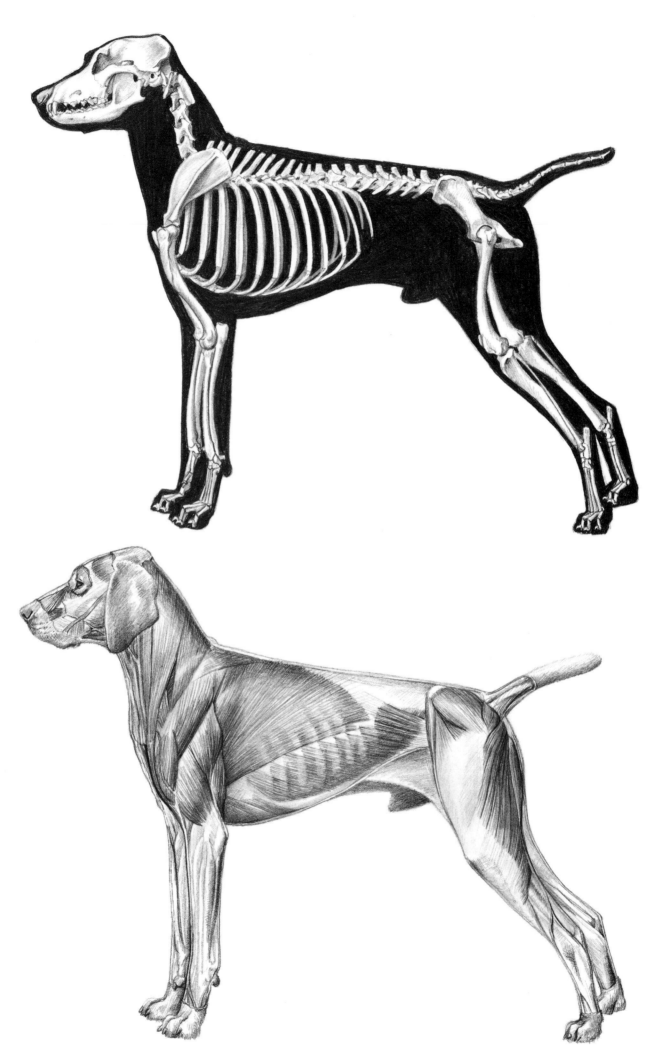

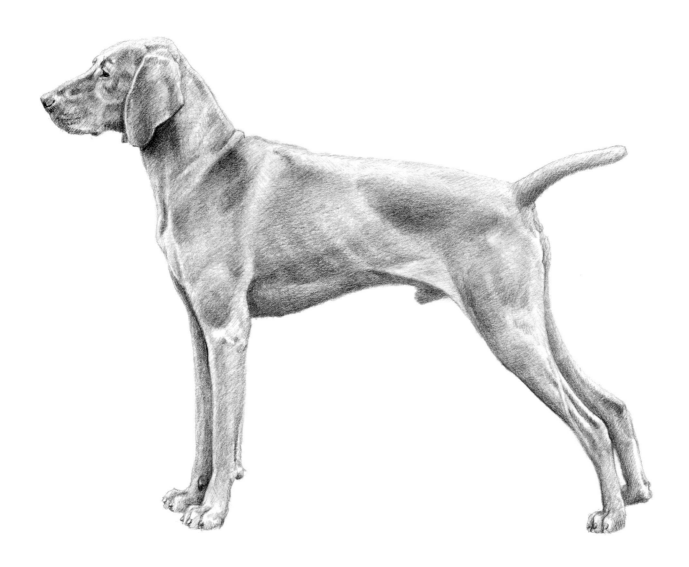

SKELETON (ABOVE LEFT)

The skeletal shape of all the animals in this book is basically similar. The large differences lie in the length and width of the various parts and in the massiveness of the bones. A dog has relatively thin legs and a short neck. It is designed for speed and agility rather than for pushing or pulling power. Naturally, the greyhound is leaner and has longer legs than the dachshund, though the little dachshund can run rather fast when it has to.

MUSCULATURE (LEFT)

By nature, the dog is a lithe, muscular creature which relishes and requires strenuous exercise. Note how sleek and long its muscles are—more like those of a swimmer or runner than those of a weightlifter. The heavier, more powerful muscles are evident in its chest and shoulders.

SURFACE ANATOMY (ABOVE)

In drawing short-haired dogs, fur texture is suggested by the use of values. Lighting from above helps accentuate this vizsla's glossy coat. The leanness of the animal is accentuated by revealing its ribcage. To lend solidity to the form, the dog's underparts are darkened. The head shows an alert expression typical of the pointer breed. Dark accents are placed beneath the ear to make it stand out from the head. Note the fold of loose skin at the withers.

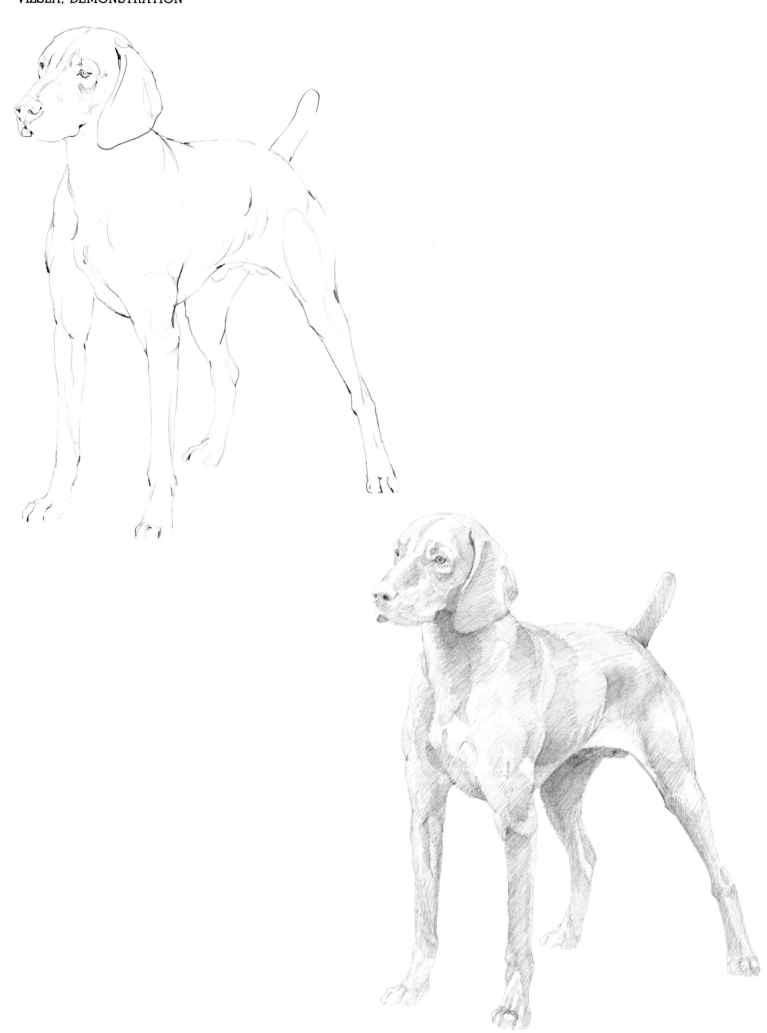

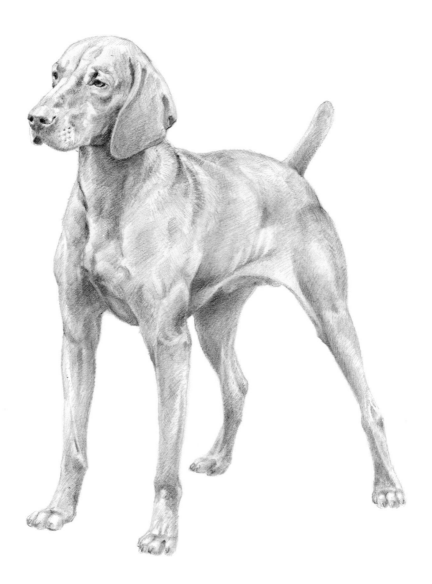

STEP 1. *(ABOVE LEFT)*
Here is the hunting animal on the job—with tail cocked, nose alert for scents, muscles tensed for constant action. I begin by completely drawing in the dog's outline and indicating its more important muscle, tendon, and bone structures in the torso and legs. At this stage, I am most concerned about getting the animal's shape, proportions, and attitude as correct as possible.

STEP 2. *(LEFT)*
Now, I turn my attention to the factor of value. Since this is a short-haired dog, these values will be closely related to the animal's muscular forms rather than to the shapes and directions of the fur. I place dark tones on the inside of its hind thigh and fill in the tail to make it stand out. To accent the darkest areas of the head and body, I use choppy strokes. The rib cage is visible, due to the dog's lean, tight physique.

STEP 3. *(ABOVE)*
Everything is darkened, strengthened, and defined all over. The many contrasts of light and dark are intended to portray the dog's glossy short coat. A furrier breed would reveal much less of the underlying anatomy. I use a minimum of individual strokes. Instead, I use strokes that flow together to conform with the character of the coat. I do not draw whiskers but show the indentations from which they would emerge. Note the straining veins and tendons in the animal's tensed legs.

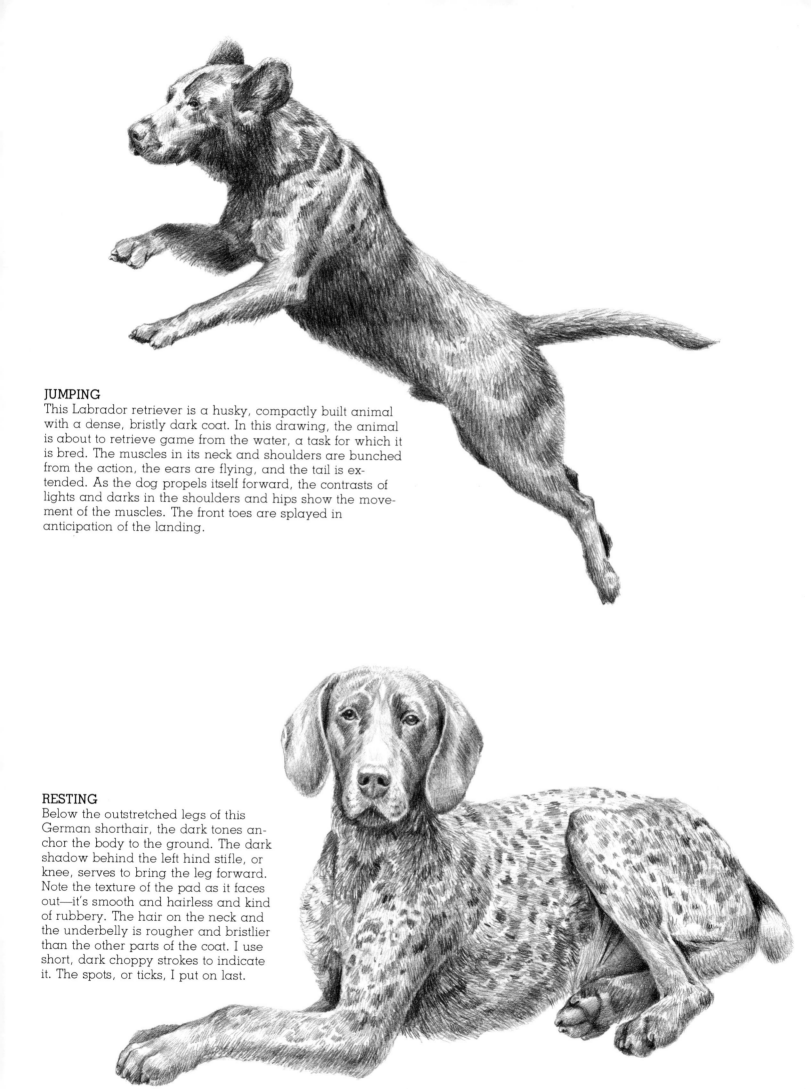

JUMPING

This Labrador retriever is a husky, compactly built animal with a dense, bristly dark coat. In this drawing, the animal is about to retrieve game from the water, a task for which it is bred. The muscles in its neck and shoulders are bunched from the action, the ears are flying, and the tail is extended. As the dog propels itself forward, the contrasts of lights and darks in the shoulders and hips show the movement of the muscles. The front toes are splayed in anticipation of the landing.

RESTING

Below the outstretched legs of this German shorthair, the dark tones anchor the body to the ground. The dark shadow behind the left hind stifle, or knee, serves to bring the leg forward. Note the texture of the pad as it faces out—it's smooth and hairless and kind of rubbery. The hair on the neck and the underbelly is rougher and bristlier than the other parts of the coat. I use short, dark choppy strokes to indicate it. The spots, or ticks, I put on last.

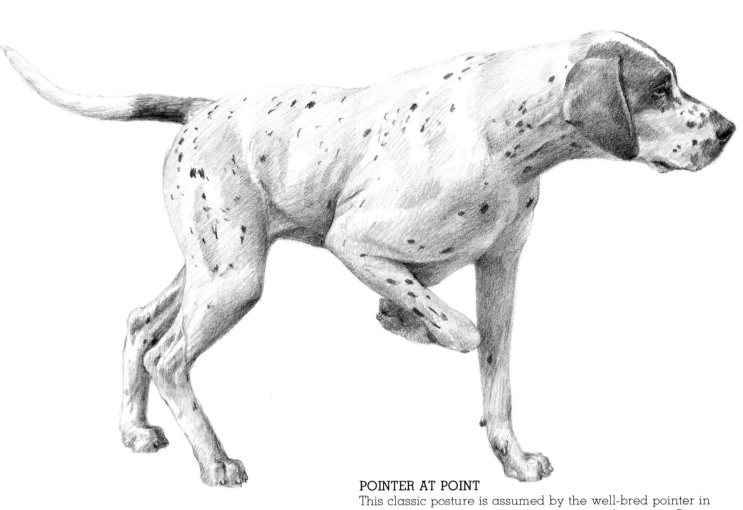

POINTER AT POINT

This classic posture is assumed by the well-bred pointer in the field directing its master's attention to the game. Some of this breed have been known to maintain this position for over an hour. In this drawing, the dog's nervous energy and dedication to its task are evident. Because of its rather light overall coloration, I have kept this a high-key drawing, reserving the darks for the face, tail, skin folds, and for the underlying areas of the torso and the raised leg.

PUPPY

There is probably nothing more cuddly or lovable than a pup, and I try to capture this youngster's soft, ungainly quality. Its head, ears, and paws are disproportionately large and they add to the pup's vulnerable air. I render the folds of the tender skin in the chest by using highlights that terminate in a short series of strokes. Note the fold formed by the position of the sprawled hind legs.

143

HEAD, FRONT VIEW

This German shorthair's fur is rougher textured than the vizsla's and I indicate this characteristic with darker, thicker strokes to show the animal's rather bristly quality. Observe the happy alert expression—the eyes are bright and expressive, the mouth appears to be smiling. Note how the hair tracks seem to begin at the nose and travel up and around the skull. Highlights are placed above the eyes, and in the lower eyelids. Using a razor blade, I scratch out the whiskers. Veins are placed in the ears to promote the feeling of authenticity.

HEAD, SIDE VIEW

This pose is more serene and relaxed than the preceding drawing. Dogs are emotional and, like people, their faces reflect their feelings. To draw animals well, one should become familiar with their moods. For this white dog, I reserve the dark accents basically for its eyes and nose. The texture of the dense hair on the ear is depicted with long, flowing, and alternately dark strokes of the pencil.

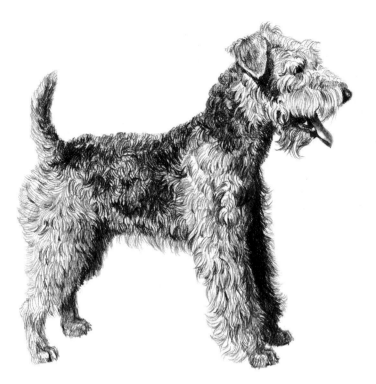

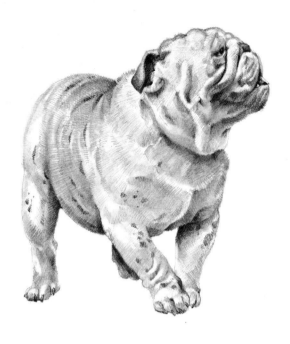

AIREDALE TERRIER
This breed has a coat of rough, wiry hair with a softer, shorter undercoat, and a topknot of lighter, finer-textured hair. I bunch little groups of fur by using masses of curved pencil strokes for each, then proceed to form other clumps adjoining, but running, in another direction. I darken the left front and hind legs to set them back in perspective. There is not a hard edge to be seen in any of the contours; they are all achieved with strokes pointing away from the body. In rendering a dog as shaggy as this, it's necessary to be familiar with its anatomy.

BULLDOG
This squat, husky fellow is noted for its courage gained from generations of ancestors trained for the sport of bull-baiting. Today's specimens of the breed make gentle, agreeable pets. Its main physical characteristics are the squashed muzzle, the wideset front legs, and the many folds and wrinkles of its smooth coat. It's important to know where these folds fall and to understand how they relate to the form underneath. I show the glossy, loose coat with light, short strokes that run toward the rear and around the body.

IRISH SETTER
This proud, handsome breed features a long, glossy coat of reddish-golden hair. It is the ideal show dog. To depict its luxuriant coat, I carefully plan the placement of each plane of hair before beginning the drawing. To capture the sheen of the hair, a variety of highlights is necessary. I use the French stump freely to smooth the values on the form (note diagram). I am careful to note the directions of the fringed hair on the animal's legs and belly to make sure they conform with the shapes of the body before laying the strokes.

SMALL ANIMALS

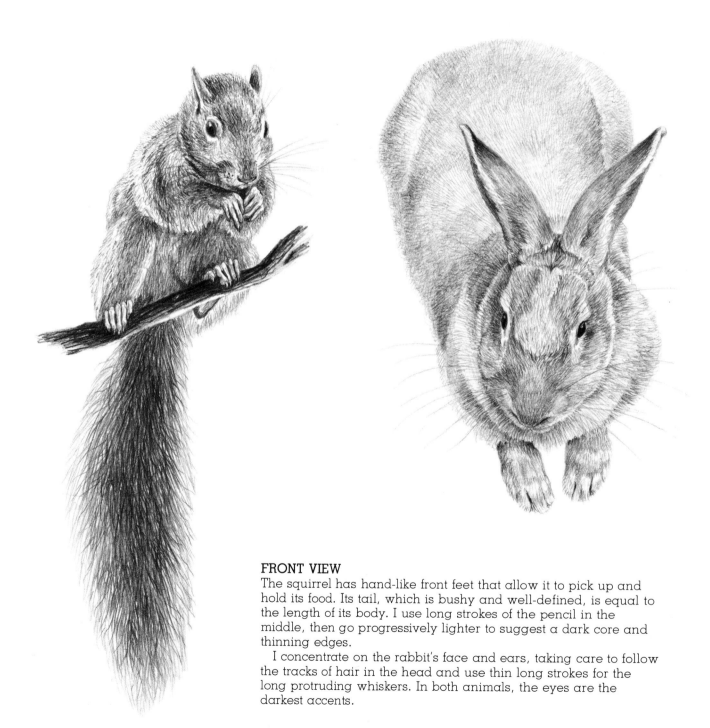

FRONT VIEW

The squirrel has hand-like front feet that allow it to pick up and hold its food. Its tail, which is bushy and well-defined, is equal to the length of its body. I use long strokes of the pencil in the middle, then go progressively lighter to suggest a dark core and thinning edges.

I concentrate on the rabbit's face and ears, taking care to follow the tracks of hair in the head and use thin long strokes for the long protruding whiskers. In both animals, the eyes are the darkest accents.

Rabbits are lagomorphs and squirrels are rodents, but I have lumped them in a single chapter because they are both small, furry animals that present some similar aspects and artistic challenges.

Rabbits and their close relatives, hares, are found nearly throughout the entire world. Altogether there are 52 species of hares and rabbits. Squirrels are also widely distributed in hundreds of species.

For my main characters I chose the common cottontail rabbit and the gray squirrel. I also included four relatives to round out the chapter. The cottontail has survived because of its prodigious breeding propensities despite being vigorously hunted and trapped for its fur and flesh. Cottontails are up to 15 inches long and weigh up to three pounds. The gray squirrel measures up to 18 inches long including its bushy tail, and weighs about two pounds. Some people find their flesh a delicacy.

Neither the cottontail nor the gray squirrel are in any immediate danger of extinction. They seem to have learned how to live alongside man, and they are likely to continue to do so. Squirrels contribute to the environment by burying nuts that subsequently grow into trees. When allowed to live, cottontails have a life span of eight years and gray squirrels live up to 15 years.

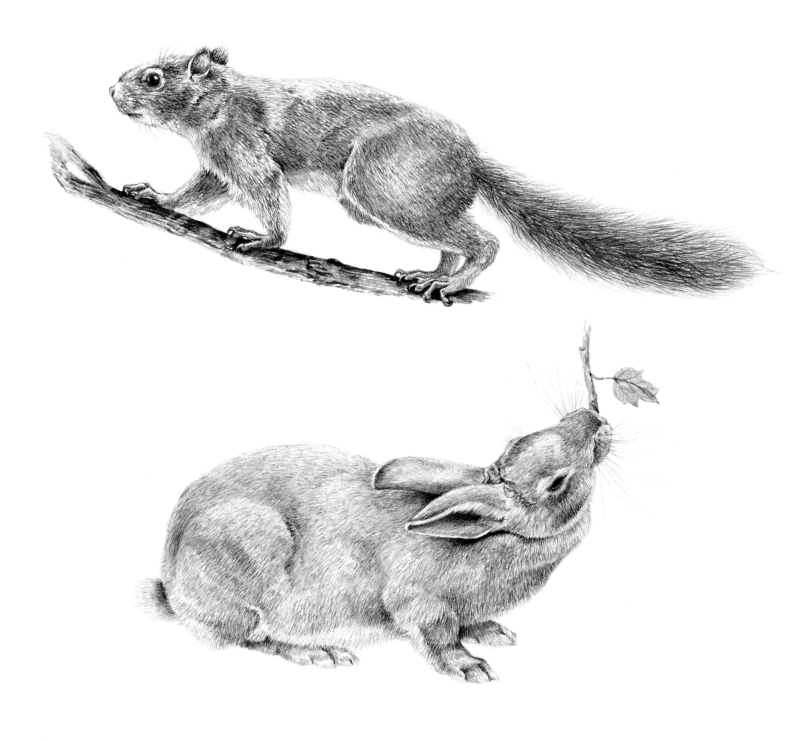

SIDE VIEW
The squirrel is a rodent, which is most evident in this drawing—
one can see many physical resemblances to the mouse and rat
family. The squirrel's tail acts as a stabilizer to maintain balance
as it races along high off the ground.

The rabbit's fur is soft and very fine. Its tail is brown above and
white below. The hind legs are much larger than the front ones. I
use many short strokes to capture the feel of the rabbit pelt.

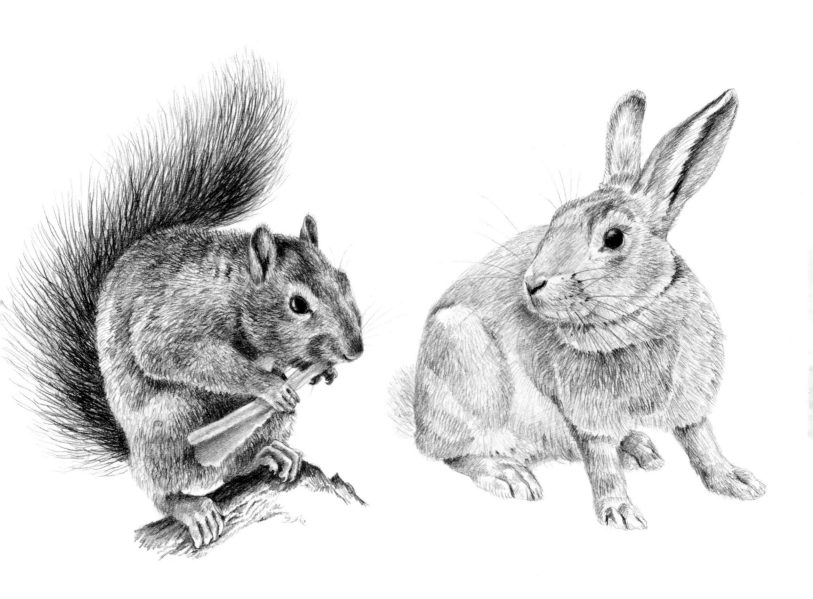

THREE-QUARTER VIEW
When resting or sitting up, the squirrel is apt to place its tail over its body. Note how coarse the squirrel's coat is in comparison with the rabbit's. I accent its long digits.

In the rabbit, I darken the folds in the neck and body to accentuate the turns and twists of the head and torso. The pupil is a dark circle with a highlight to lend it roundness and project its shiny, translucent quality.

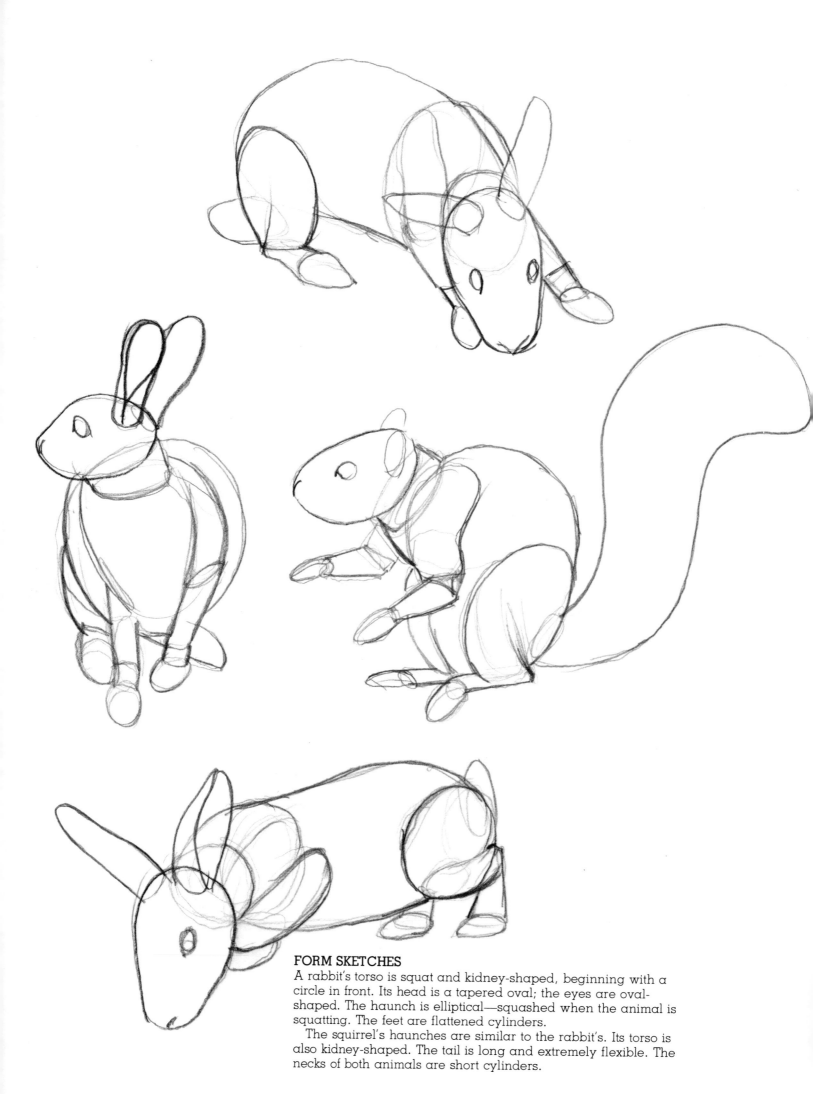

FORM SKETCHES

A rabbit's torso is squat and kidney-shaped, beginning with a circle in front. Its head is a tapered oval; the eyes are oval-shaped. The haunch is elliptical—squashed when the animal is squatting. The feet are flattened cylinders.

The squirrel's haunches are similar to the rabbit's. Its torso is also kidney-shaped. The tail is long and extremely flexible. The necks of both animals are short cylinders.

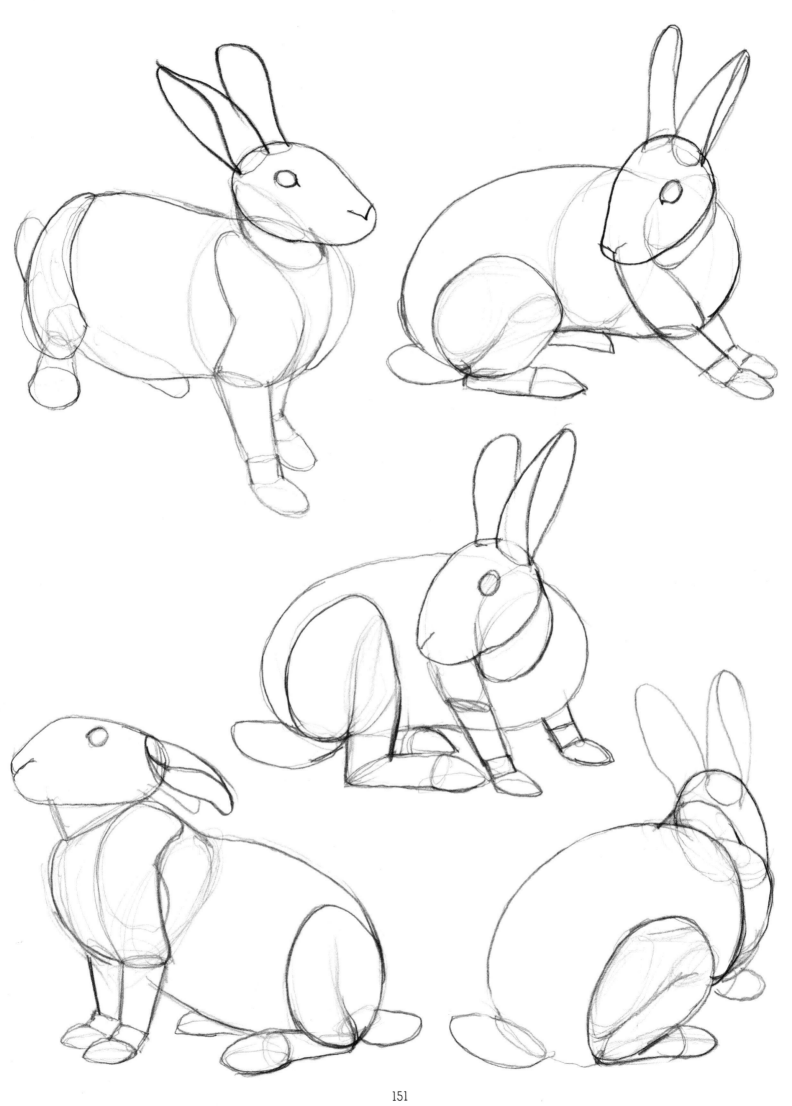

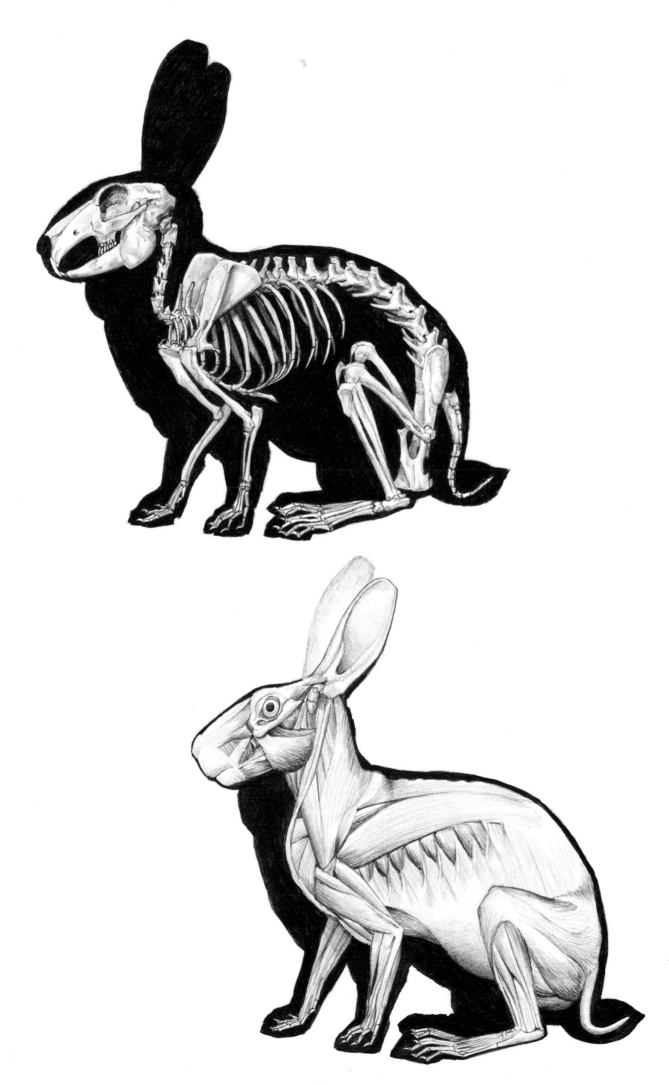

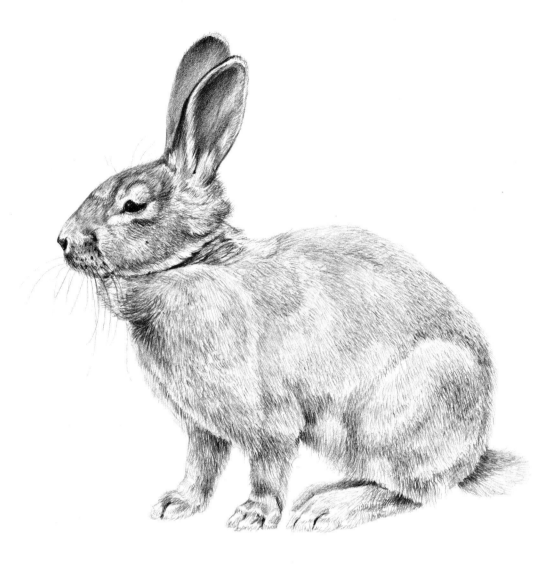

SKELETON *(ABOVE LEFT)*
The rabbit's hind legs are much longer than its front ones. This allows him to hop as well as run. Normally, they are held in a bent position. The head is relatively large with big, chisel-like incisors that constantly keep growing. A cottontail is capable of great speed, but only for very short distances. Unlike most species, the female, or doe, is larger than the male, or jack.

MUSCULATURE *(LEFT)*
The lightly-muscled rabbit's main defense against enemies is flight. Its muscles, therefore, are long and supple rather than heavy and bunched. The cottontail is also designed to make sudden, rapid, twisting turns that will often befuddle a pursuing animal. For such maneuvers, supple, springy muscles are required.

SURFACE ANATOMY *(ABOVE)*
Note the pouch beneath the rabbit's chin. I make sure that the light, short pencil strokes follow the animal's form. If you compare this drawing with that of the cottontail's skeleton, you will see how much of the animal's bulk consists of flesh and fur—it is basically very slim and fragile. I place a strong dark to outline the rabbit's left ear. Also note the white patch around its eye.

COTTONTAIL, DEMONSTRATION

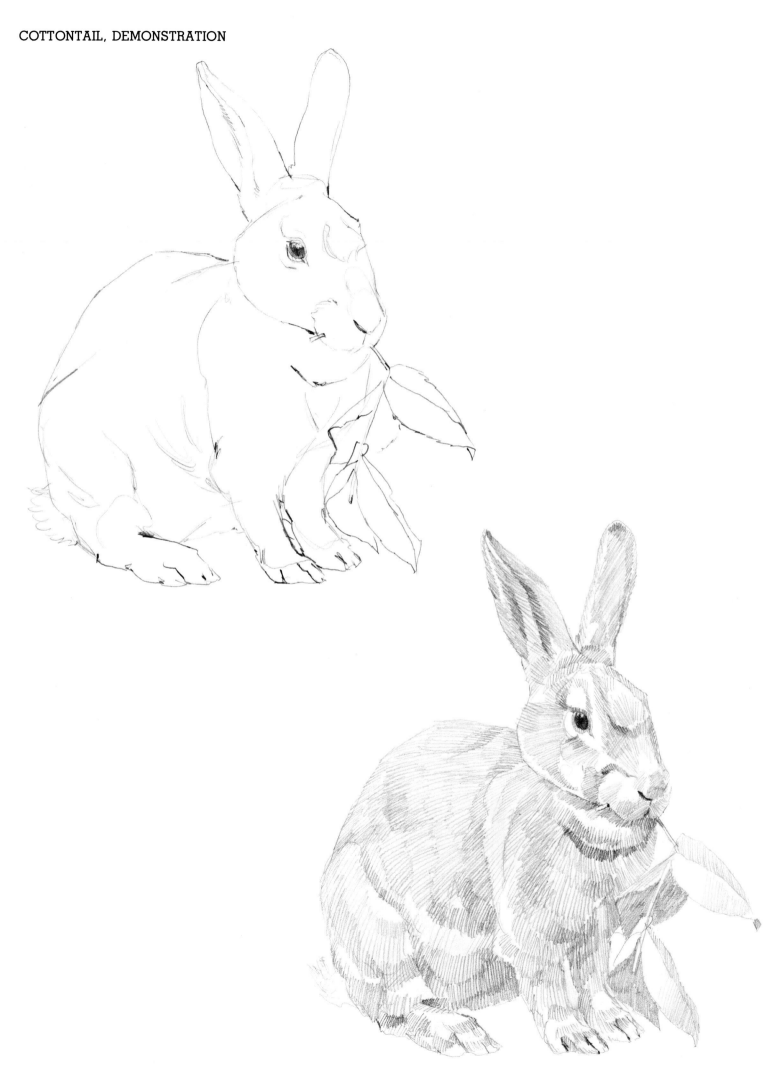

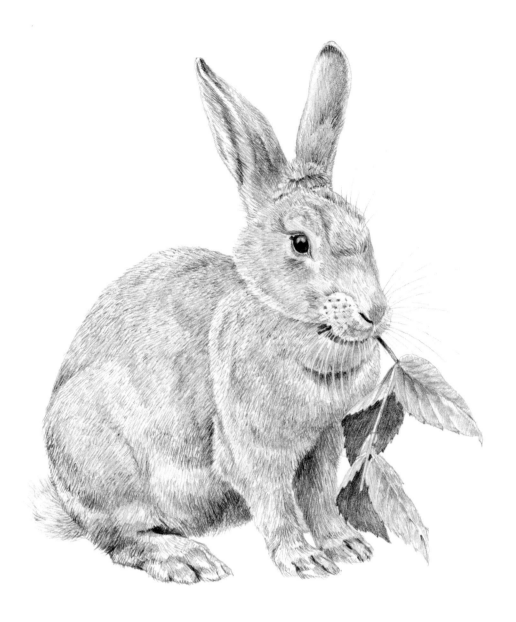

STEP 1. *(ABOVE LEFT)*
I draw the outline of the rabbit as it squats in a very alert position, so it can feed without being disturbed. All lines pertaining to the animal's proportions and actions are included. The eye is somewhat more finished off than the rest of the features. To indicate folds and breaks in the form, I use dark strokes.

STEP 2. *(LEFT)*
With short, brisk strokes, I shade in all the fur making sure to follow the patterns of the forms and muscles. There are no hard edges anywhere in accord with the rabbit's soft, puffy coat. I include some darker accents in the eyes, chin, tips of the ears, and below the pouch under the chin. Light areas are left at the junctures of the limbs to the torso.

STEP 3. *(ABOVE)*
Now the character of the lines is refined to shorter, lighter strokes. This provides the salt-and-pepper effect I am after. In rendering the whiskers, I draw the ones running outside the body by stroking out from the muzzle, while the ones seen against the form are shown as negative shapes. I leave the eyelids blank and place a strong catchlight in the dark, luminous pupil. Light, irregular strokes are put down to show the fluffy, cottony tail. Note how the hair changes direction in the rabbit's topknot.

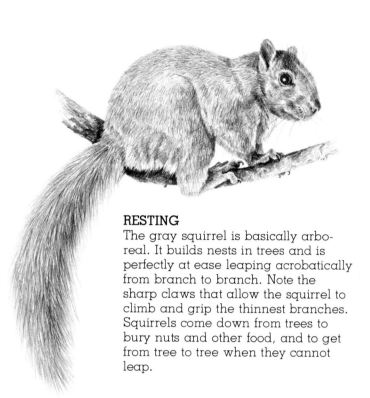

RESTING

The gray squirrel is basically arboreal. It builds nests in trees and is perfectly at ease leaping acrobatically from branch to branch. Note the sharp claws that allow the squirrel to climb and grip the thinnest branches. Squirrels come down from trees to bury nuts and other food, and to get from tree to tree when they cannot leap.

FEEDING

The rabbit is quite capable of sitting up on its hind legs. In this pose, it brings to mind the actions assumed by the squirrel. Note the difference in size between the front and the hind paws. To further the impression of the sitting gesture, I run the strokes on the torso in a vertical, downward direction. The cast shadow beneath the animal helps anchor it firmly to the ground.

RUNNING

The rabbit spends much of its time in flight. Note how this action flattens the ears. I separate the toes on the front right leg as they prepare to hit the ground, and I strongly outline the hind legs. Because we usually see the rabbit in a squatting position, these rear legs are seldom revealed to us, being concealed by the torso. Because of its plumpness and quantity of fur, the rabbit's skeletal and muscle forms are not easily discernible.

HEAD, SIDE VIEW

A gray squirrel's eye is all pupil and almost perfectly round. The inside of the ear is lightly toned to show its thin translucent tissue against the light coming from above and somewhat to the rear. I accent the tip of the nose. The squirrel, like the rabbit, has long, abundant whiskers. In this drawing, I try to depict the animal's vulnerable, appealing quality.

HEAD, FRONT VIEW

To show the animal's light, fluffy coat, I place the strokes fairly far apart. The rabbit's whiskers and eyebrows are very pronounced and I draw them with long, unbroken lines paying careful attention to their root, or base, in the head. Note the absence of a bare, dark area on the tip of the nose as seen in most other mammals. The eyelashes are quite long. By changing the character of the strokes in various areas, I show the softness of the fur.

BABY COTTONTAIL

The young cottontail is a very cute and appealing animal. Its eyes are the darkest accents against a coat that's much lighter than its parents'. Cottontail fur is downy and as yet not fully developed. To see a young cottontail nearly motionless except for its twitching nostrils is a most pleasureful experience. I keep my strokes light and spread apart to produce this essentially high-key drawing.

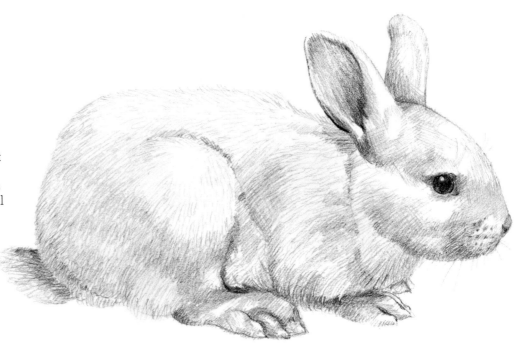

PATAGONIAN CAVY

This rodent looks like a cross between a hare and a small deer. Its long legs allow it to escape from predators. It has a pale grayish coat, a white rump, and a bit of a tail. To represent the coat's salt-and-pepper effect, I use many short dark pencil strokes. I draw the claws with much attention to detail. The whiskers and eyebrows are long, the ears stand up like the rabbit's. The cavy also has long eyelashes to protect its eyes since it enjoys taking sun baths.

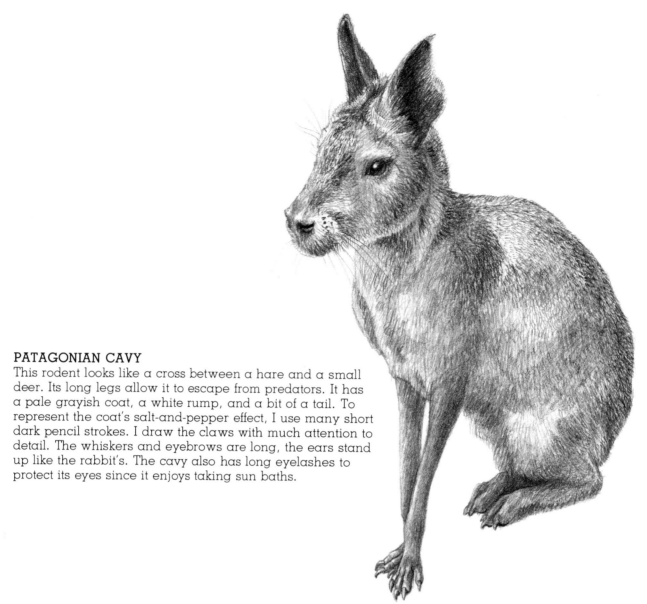

PRAIRIE DOG

The prairie dog is a member of the rodent family and has the typically large, prominent incisors. It has a long body, short legs, large front claws for digging, and cheek pouches in which the animal transports food for storage in its underground burrow. When challenged, the prairie dog can be a formidable fighter. I show its glossy, short fur with crisp short strokes of the pencil and lots of highlights. A number of folds in the skin are formed by the action the animal has taken.

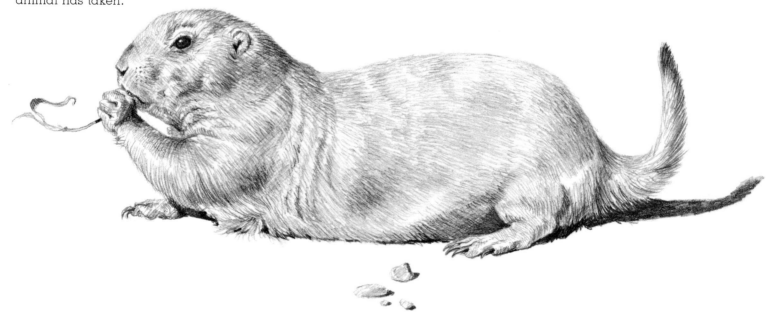

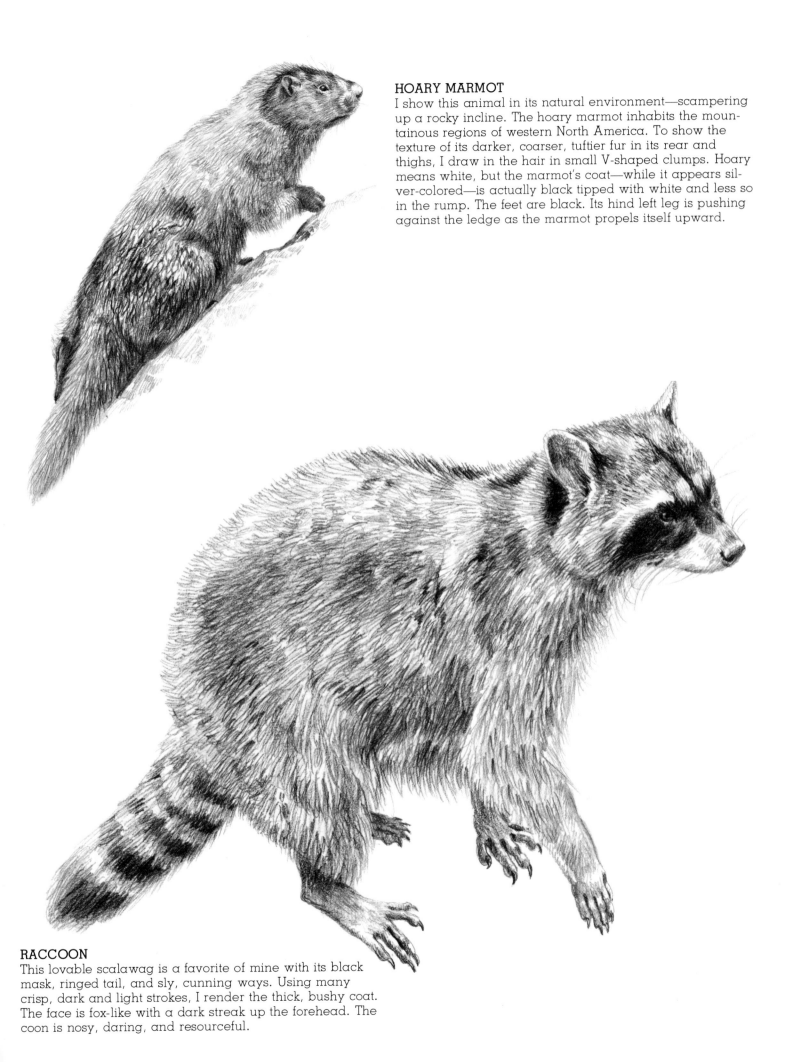

HOARY MARMOT
I show this animal in its natural environment—scampering up a rocky incline. The hoary marmot inhabits the mountainous regions of western North America. To show the texture of its darker, coarser, tuftier fur in its rear and thighs, I draw in the hair in small V-shaped clumps. Hoary means white, but the marmot's coat—while it appears silver-colored—is actually black tipped with white and less so in the rump. The feet are black. Its hind left leg is pushing against the ledge as the marmot propels itself upward.

RACCOON
This lovable scalawag is a favorite of mine with its black mask, ringed tail, and sly, cunning ways. Using many crisp, dark and light strokes, I render the thick, bushy coat. The face is fox-like with a dark streak up the forehead. The coon is nosy, daring, and resourceful.

159

Edited by Donna Wilkinson
Designed by Jay Anning
Set in 10/11 Memphis Light